VĀRUA TUPU

NEW WRITING FROM FRENCH POLYNESIA

Frank Stewart
Kareva Mateata-Allain
Alexander Dale Mawyer

EDITORS

MĀNOA: A PACIFIC JOURNAL
UNIVERSITY OF HAWAI'I PRESS
2006

UE! A HIÒ NA, PA'I, TEIE MARARA......

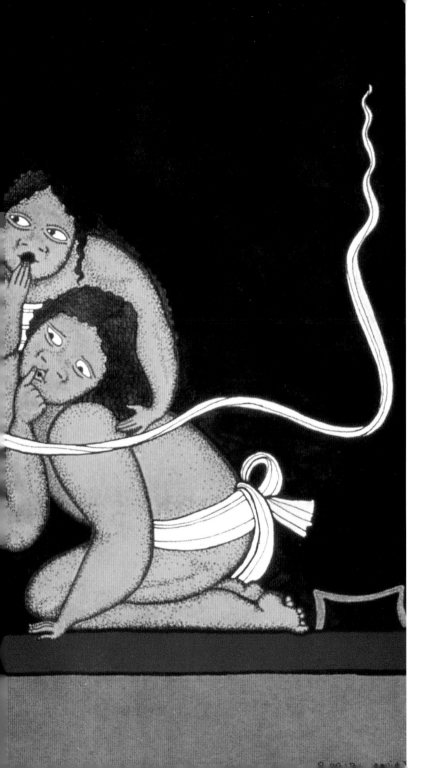

CONTENTS

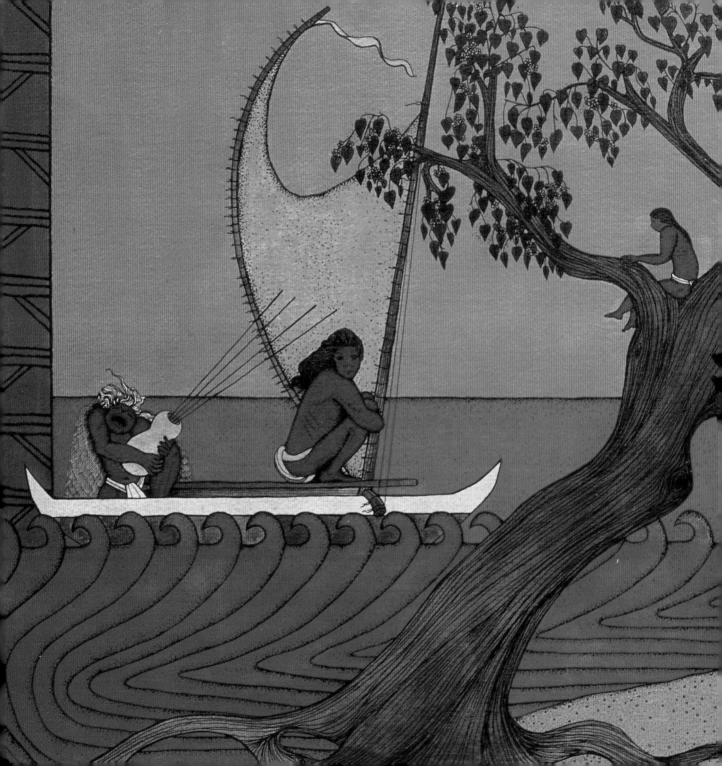

RURUTU

TE AO MĀʻOHI

AN OVERVIEW

For the world at large, the names Tahiti and French Polynesia conjure up a rich palette of imagery, drawn from sources as varied as the mutiny aboard HMS *Bounty*, Herman Melville's flight into Taipivai valley on Nuku Hiva, and Paul Gauguin's descent into "nativism" on Hiva ʻOa. Unfortunately, yesteryear's fictions—perpetuated by sailors, rogues, Hollywood directors, and other passers-by—have held these Islands captive to romanticized fantasies and inauthentic tales. Until very recently, it has been difficult to find in literature the emotions, intelligence, and daily lives of the Islands' indigenous people. Many false notions have been conjured up, and many true things have been omitted. *Vārua Tupu* is intended to offer English-speaking readers the works of a Polynesian literary community that has been growing in strength since the 1960s. By doing so, *Vārua Tupu* represents the first opportunity for the Anglophone world to experience the region through the voices of the French Polynesian literary community.

Though the fantasy image of Tahiti has long been dominant around the world, the region is far more diverse, culturally rich, and deserving of our attention than even the most exotic accounts by visitors and sojourners suggest. French Polynesia is a vast oceanic realm, over twice the size of the Mediterranean Sea, but with a total land area a third the size of Connecticut. The 118 islands and atolls have been grouped into five geologically, historically, and culturally distinct archipelagos. The largest are the Society, Austral, and Marquesan archipelagos, each consisting of high islands with steep inland valleys. To the southeast is the Gambier archipelago, a handful of much smaller high islands, the largest of which is Mangareva. Between the Gambiers and the Marquesas are seventy-eight sparsely populated atolls—each only a few meters above sea level and surrounded by its own coral-spanceled lagoon—which comprise the Tuamotu archipelago.

In 2003, the total population of these islands was just over 260,000. More than

OPPOSITE
Rurutu (detail)
A center of the traditional arts, Rurutu is in the Austral Islands. Here, two men are engaged in *amoraʻa oʻaʻi*, a contest to lift stones weighing as much as 300 pounds. The women are weaving pandanus leaves. BOBBY HOLCOMB

half of the people, about 150,000, reside on the islands of Tahiti and Moʻorea, where the urban and governmental centers are located. On these islands, many homes have DSL internet; more people have cell phones than not; and consumers compete to buy the latest CDs, DVDs, and SUVs. Global consumerism has indeed arrived. In regard to demographics, French administrators and expatriates make up only a small minority of the total population of the Islands, about four percent; local people of mixed Polynesian and European ancestry are about six percent; and Chinese comprise about twelve percent. The majority of the population, about seventy-eight percent, is Polynesian.

The name for the Polynesian people that appears most frequently in *Vārua Tupu* is Māʻohi, used generally by the populace to indicate the indigenous residents of the Society Islands (Tahiti, Moʻorea, Huahine, Bora Bora, Raʻiātea, and Tahaa). The Tuamotus, the Australs, the Marquesas, and the Gambiers of Eastern Polynesia sometimes go by this name, but often refer to themselves according to their own notions of identity. Poet and scholar Turo a Raapoto explains the word "Māʻohi" thus:

Ohi *refers to a sprout which has already taken root, securing itself with a certain autonomy of life, all the while being linked to the mother stem. From a sprout, an* ohi, *tracing back its roots, one always gets to a trunk. Māʻohi is the community of all those who claim to be of the same past, culture and language, which constitute the common trunk and which still have the same destiny.*

The Māʻohi world as a whole is sometimes referred to as Te Ao Māʻohi, rather than French Polynesia, and the phrase has been suggested as a replacement for the current name if France ever gives up its claims to the Islands. Commonly, however, many people continue simply to refer to the entire region as Tahiti—a convenient but serious misnomer.

This emphasis on names and naming is not trivial. The contemporary struggle of Māʻohi writers to re-empower language in the service of truth and dignity has been fraught with obstacles, but in the last fifteen years the works of a host of local authors have been published, including poetry, fiction, memoir, drama, and mixed genres. *Vārua Tupu* presents some of this contemporary work, as well as photographs and paintings that further illuminate the region's creative expression. Our title for this collection, *Vārua Tupu*, is meant to suggest the growing reconnection

Te Ao Māʻohi

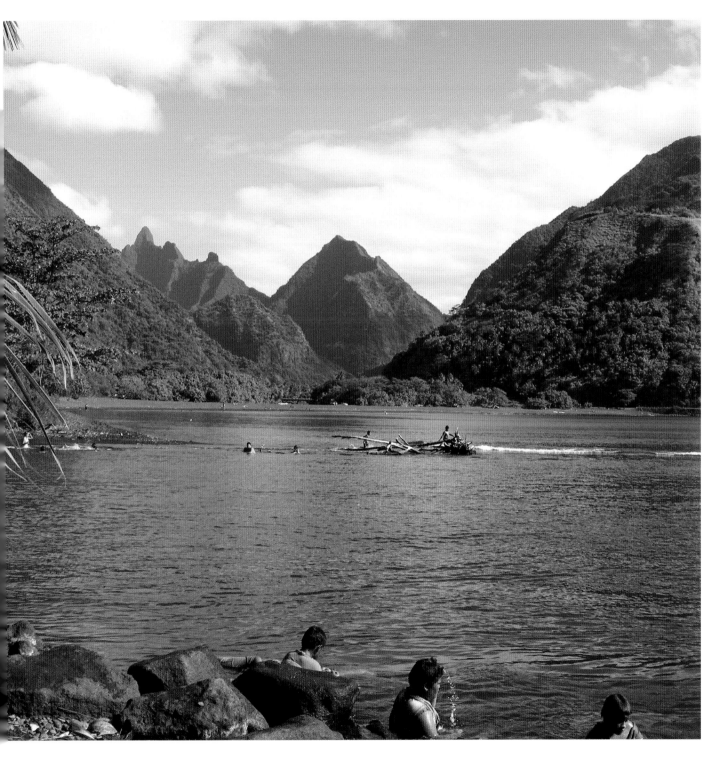

of the indigenous people with the powerful and ancient Polynesian spirit, which has been alive in the Islands for millennia and is emerging from the shadows of nearly two centuries of European cultural and political domination.

French colonial administration may be the least important factor that unifies the territory today. Far more profound and timeless cultural legacies continue to unite the people of Eastern Polynesia, even as they have created significant distinctions among them. Without a doubt, the most important unifying element is a shared history of astonishing transpacific voyaging. Here in the Eastern Pacific, where the distances seem boundless and the great winds and currents confounding, the achievements in navigation and seafaring by Polynesians—whose common origins have been traced to the coast of Southeast Asia—are breathtaking. Over the centuries, as each island cluster was settled by people with common origins, the settlers developed distinctive social, linguistic, and cultural forms. Among certain groups, communication and interaction were maintained. Long before the first sustained European contact, Islanders developed highly stratified chiefdoms and sophisticated kingdoms, land divisions, agriculture, religion, and cultural practices.

Beginning in the late-eighteenth century, however, Western contact brought critical changes. Perhaps the most tragic was the decimation of many island populations—mainly a result of introduced diseases such as smallpox, measles, and tuberculosis. In the Marquesas, Gambiers, and some Tuamotuan atolls, populations declined by as much as ninety-nine percent over the course of a few decades. Such rapid and catastrophic depopulation was one of the factors that made the Islands vulnerable to colonization. It also hastened a radical break in the generation-to-generation transmission of cultural knowledge, since much of that knowledge depended upon oral instruction and apprenticeship practices. The devastation during this era was keenly felt and lamented even by foreigners who were present at the time. Today, the consequences of these losses are still being assessed, digested, and given expression by the islands' artists, writers, teachers, historians, and leaders.

The decline of indigenous languages in French Polynesia did not occur immediately after European contact. In fact, the process was slowed for most of the nineteenth and early twentieth centuries by missionary and state institutions, which frequently preferred to work with and in the local languages. The first books using a

written version of Tahitian were printed in 1817 by British missionaries. And for a time at least, Islanders across the region continued to speak their local languages, often to the exclusion of French, and with the addition of Tahitian—one of more than five Polynesian languages—as a lingua franca and administrative tongue. After World War II, however, the decline of indigenous languages accelerated to such an extent that it caused serious disenfranchisement of much of the population with regard to secular, sacred, and civil matters. By this time, the school systems had adopted a policy intended to discourage the use of local languages altogether, and pressures to force everyone to speak French continued on some islands well into the 1970s. Punishment for lapsing into the local languages took different forms in school. Tahitians have described being made to repeat "I shall not speak Tahitian" over and over again, while others recall suffering a crack on the knuckles. Such measures are remembered as especially humiliating for Islanders who traveled to find work on Tahiti, where the cultivation of French standards in language and social behavior was, and still is, common. Nevertheless, even on Tahiti, French has never entirely replaced the local language, *reo māʻohi.*

The end of World War II also brought with it a larger French military presence and massive construction projects, including airports and infrastructure. During the military build-up, French became the standard language of government, business, and labor. Soon, the French presence became a de facto military occupation as thousands of troops and technicians flooded into the region. The motive became clear in 1963, when President Charles de Gaulle selected the atolls of Mururoa and Fangataufa as sites for French nuclear testing. Although Pacific nuclear tests had been halted by the U.S. and Britain by this time, the French Centre d'Expérimentation du Pacifique exploded nearly two hundred nuclear devices on, over, and near the Islands. International protests and local riots increased until the French abandoned nuclear experimentation in the Pacific in January 1996. By this time, however, opposition to the tests had radicalized people throughout French Polynesia. Local activists had begun a proto-nationalist and anti-nuclear political movement, and because the movement was decidedly anti-French, the Tahitian language was often used to state the principles of the opposition and demand the return of indigenous autonomy.

Notable among the activists in the movement were several accomplished poets, among them Turo a Raapoto, who proclaimed, "We will be Māʻohi or we will not

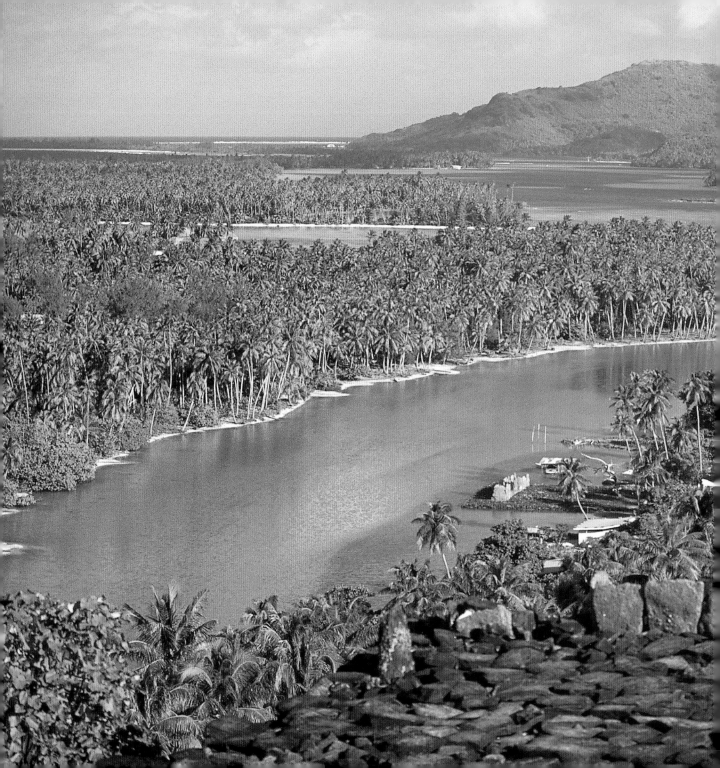

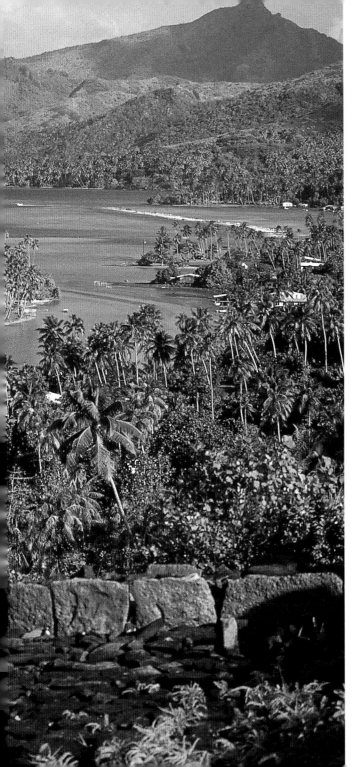

Marae of Mahaiatea Rahi,
traditionally the most sacred place
on Huahine. CLAIRE LEIMBACH

be anymore. But I have faith in life. We will not die. We will be." Fellow poet Henri Hiro was particularly articulate in promoting the reassertion of Māʻohi cultural practices, including domestic living arrangements, language, dress, and ways of thinking. In addition, Hiro urged Māʻohi to take up their pens and write: "For this renewal to continue, Polynesians must write. . . . It doesn't matter what language they use. . . . The important thing is that they write, that they *do it!*"

Many French expatriates and even many local Tahitians were unaware that during the 1980s and 1990s, a community of writers had answered Hiro's compelling plea, and that in fact a literary movement was growing. Not least among the obstacles the authors faced was a lack of publishers willing to support literature that had contrary stories to tell. In addition, much of it was written in Tahitian or a style of French that was deliberately meant to defy the rules of what author Chantal Spitz has called "the net of the conqueror's language," "the trap of francophony." French publishing houses openly refused to acknowledge this literature, and the few books that were published in Tahiti by local authors were not widely accessible or affordable. In 1997, when the editors of *Vārua Tupu* began gathering works for translation, books by the leading Māʻohi writers were very difficult to find. In the spring of 2002, the editors were told by academics at the Université de la Polynésie Française that no local literature existed, aside from the writings of a handful of avant-garde artists.

Even as these discouraging statements were being made, however, local writers were establishing a literary journal called *Littérama'ohi*, booksellers were registering an increased demand for books by Māʻohi authors, and the first Salon des Livres was being organized. Some French expatriates responded to the emerging literature by dismissing it in terms of quality, veracity, and nuance. Several French social scientists suggested that Tahitians were not "philosophical" enough to produce literature. Another commentator complained that local writing tended to display egregious errors of style, a lack of grace, and an absence of "true French substance."

The reality was that the authors—some of them presented here for the first time in English—had been writing for years, often sharing their work with one another and establishing their own publishing networks. And, contrary to the assumptions of their detractors, they were neither novices nor lacking in literary "substance."

During the early years of this cultural renaissance, most of the published Mā'ohi works consisted of poetry written in *reo mā'ohi* by male poets such as Henry Hiro, Charles Manutahi, Hubert Brémond, and Turo a Raapoto; Flora Devatine also was publishing poetry, under the pen name Vaitiare. *Reo mā'ohi* was introduced only into elementary schools in 1982 but not officially into the middle and high schools until 1996 and was belatedly recognized as an official language alongside French. At the same time that writing was being embraced as an expressive medium, traditional arts were being revived. For instance, the culturally important practice of tattooing, outlawed by the London Missionary Society in 1819, was revitalized, and traditional dance and music were taught in schools as part of a movement to promote Mā'ohi arts and culture across the Islands.

Many would say that Henri Hiro was among those most responsible for these changes. Hiro advocated not only for an indigenous literature, but also for the reemergence of a Mā'ohi consciousness. Working in poetry, film, theatre, and music, he was also a pastor, a mentor, an intellectual, and a spokesman who led by example. Most of all, he encouraged his people to regain their history, dignity, and identity. The interview with Hiro included in *Vārua Tupu* was recorded just days before his untimely death in March 1990 at the age of forty-six.

Mā'ohi women authors are responsible for much of the literature produced since 1990. Among them are Flora Devatine, who published one of the first books of Mā'ohi poetry, *Humeurs*, in 1980, under the pen name Vaitiare; one of her later books, *Tergiversations et rêveries de l'écriture orale / Te Pahu a Hono'ura*, published in 1998, is an extended, avant-garde ode to writing, mixing French with *reo mā'ohi*. Rai a Mai (Michou Chaze) published the first collection of vignettes and intertwined stories, *Vai: La rivière au ciel sans nuages*, in 1990. Chantal Spitz was the first to publish a novel, *L'Île des rêves écrasés*, in 1991. Louise Peltzer's haunting historical novel, *Lettre à Poutaveri*, and a book of poetry in French, *Hymnes à mon île*, were published in 1995. In 1999, Taaria Walker (Mama Pare) published *Rurutu: Mémoires d'avenir d'une île Australe*, a powerful memoir of growing up in the Australs. Célestine Hitiura Vaite was the first to publish a novel in English, *Breadfruit*, in 2000, followed by *Frangipani* in 2004. The youngest writer of this group, Titaua Peu, published her novel, *Mutismes*, in 2003. Set in the years leading up to the anti-nuclear riots of 1995, Peu's story unflinchingly describes such contemporary social problems as domestic

violence and drug abuse. Other women writers of note include Valérie Gobrait, Marie-Claude Teissier-Landgraf, and Danièle-Taoahere Helme.

These are only a few of the indigenous women authors in the region who are actively producing important literature and supporting the movement; the prominence of women in the fields of politics and academic scholarship is equally impressive. Clearly, when allowed to speak for themselves in their own voices, they defy the stereotypes of the passive *vahine* that have been perpetuated since European contact. "Of course we can't undo 150 years overnight," writes Titaua Peu in a recent interview, "but now that people are learning about their history and culture, they are becoming proud of their roots, they are losing their complexes. And the words are coming back."

There are also a number of prominent male writers who are making major contributions to the movement for an indigenous literature, some of whom have been named here already. Among other poets, playwrights, and authors of prose literature are Jean-Marc Teraʻituatini Pambrum, John Mairai, Philippe Neuffer, Jimmy Ly, Teuira Henry, and Jean-Marius Raapoto.

In addition to Māʻohi literature, *Vārua Tupu* also features the work of a Hawaiian artist, Bobby Holcomb, whose creativity and magic continue to make an impact on the French Polynesian Islands. Born in Hawaiʻi in 1947, Holcomb traveled the world, settling in Tahiti in 1976 and making his home in Huahine. He soon learned Tahitian and, with enormous creativity, produced playful and profound works that blended Island culture with local and international music, legends, and words. He was a painter, poet, composer, musician, singer, dancer, and sculptor. His death from cancer in 1991 was a tragedy in more ways than can be told. It is fitting that he was a son of both Tahiti and Hawaiʻi, embodying through his contemporary forms of expression the ancient and enduring kinship between these places. Two essays in *Vārua Tupu* describe his work and the impact it made in the Islands.

When the new president of French Polynesia, Oscar Manutahi Temaru, was in Honolulu in May 2005, he emphasized this kinship. He said, "We all belong to the Pacific, so we have to work on our relations with our brothers all over the Pacific, including Hawaiʻi. They are our closest cousins—brothers and sisters." It's our hope that *Vārua Tupu* will contribute to the work of reunifying the Polynesians, and will help increase understanding among everyone in this vast region.

Te Ao Māʻohi

A Note on Spelling and Orthography

Until contact with Europeans in the late eighteenth century, Tahitian was not a written language. When the London Missionary Society set up its presses and began translating the Bible in the early nineteenth century, the missionaries had to determine how spoken Tahitian might be rendered in written form. Some important features of the language—such as long vowels and glottal stops—proved very difficult for the British missionaries to hear and represent. The orthography was complicated further by the French, who colonized the Islands in midcentury, and who brought their own phonotactics. For example, where the British often could not hear glottal stops, the French heard /h/; where the British heard vowel combinations, the French heard dipthongs. And, naturally, the French applied their own diacritical marks over vowels. The two competing orthographies produced numerous variations in spelling.

Since the early 1970s, Te Fare Vānaʻa (l'Académie Tahitienne) in Papeʻete has been working on a standard orthography for Tahitian. But given the region's complicated linguistic history, Te Fare Vānaʻa faces a formidable task. Poets and writers of literary prose frequently draw on the entire range of the Islands' orthographical traditions—in some cases purposefully altering the standardized orthography of Te Fare Vānaʻa—in order to evoke various eras, styles, characterizations, settings, and pronunciations. Faced with multiple spellings of many Tahitian words, the editors of *Vārua Tupu* have in most cases preserved the orthography of non-English words as written by the original authors. In some cases, we have corrected obvious typographical errors, or inserted diacritical marks when certain words would be clarified by the alteration. For accuracy, we have relied upon Te Fare Vānaʻa dictionary, found on the internet at http://www.farevanaa.pf/dictionnaire.php.

Acknowledgments

The editors have many people to thank—in addition to authors, artists, and translators whose works appear in this volume—for helping to bring this project to completion. Among them are Denny Bales, Anne Beilby, Do Carlson, Ron Crocombe, Gay Davis, David Hanlon, Tea Hirshon, Takiora Ingram, Rob Kay, Robert Koenig, Dorothy Levy, Christophe Mauberret, Veronique Mu-Liepmann, Philippe Neuffer, Susan O'Connor, Christian Robert, Chantal Spitz, Jean-Yves Tréhin, Donna Vuchinich, and Jack Ward.

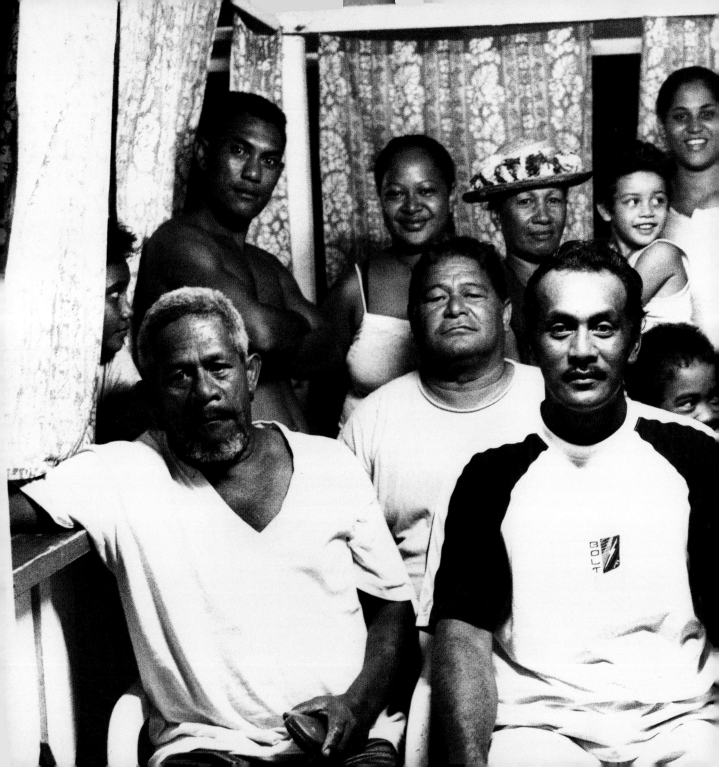

FA'A'Ā

MICHEL CHANSIN

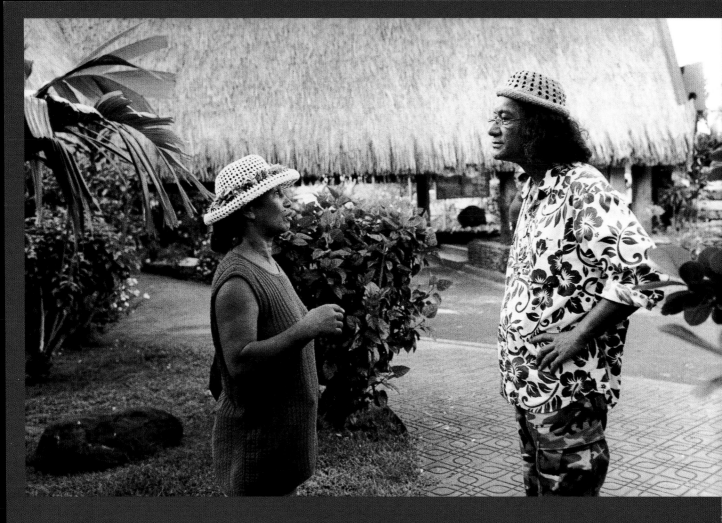

FAʻAʻĀ: With more than 28,000 people, Faʻaʻā has the largest population of any town in the Islands. A congested district that is the location of both the Tahiti-Faʻaʻā International Airport and many poor immigrant neighborhoods, Faʻaʻā is the port of entry where wealthy global tourism encounters scenes of economic displacement. It should not be surprising that Faʻaʻā has long been the center of social and political movements.

PAGE XXII

Community-association members of the Vaiava, "Sagéco," neighborhood of Fa'a'ā. March 2004.

OPPOSITE

Repeta Tiatia of Sagéco talks with Aimeho Charousset, initiator of a restoration project for disadvantaged neighborhoods. March 2004.

RIGHT

Near the entrance of Hotuarea, a neighborhood of Fa'a'ā. April 2004.

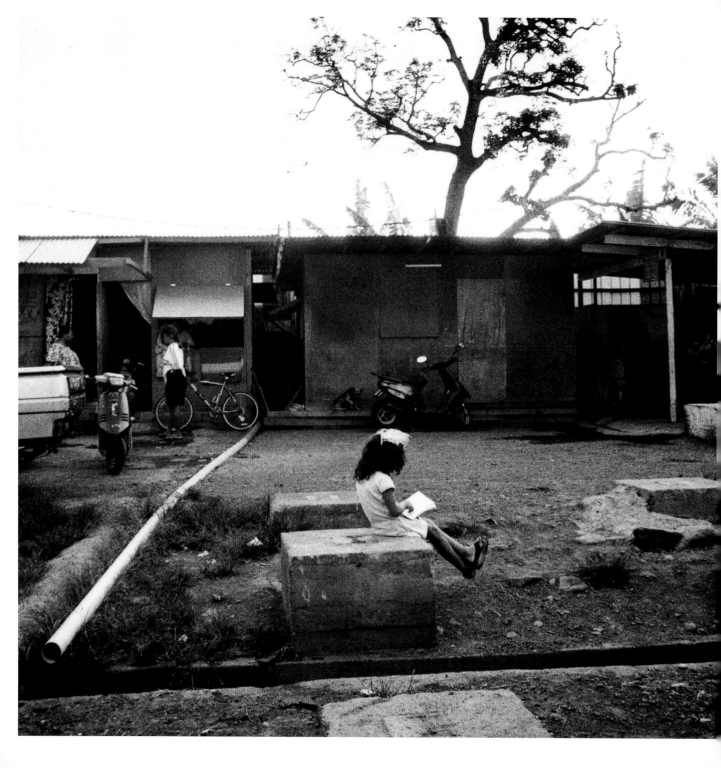

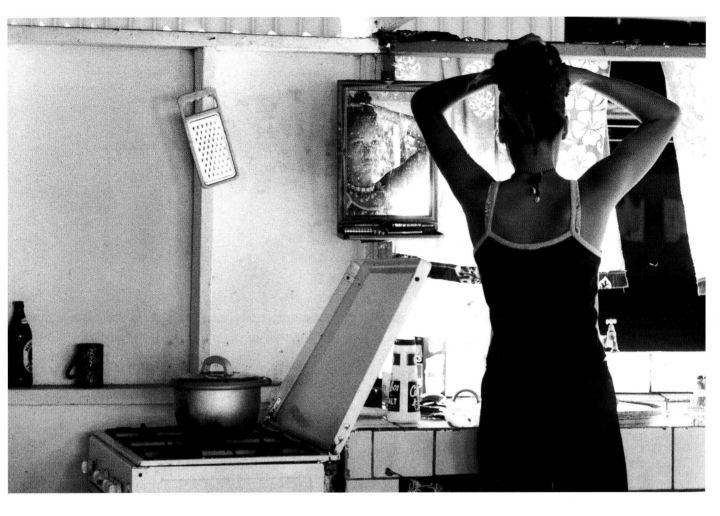

A schoolgirl sits reading in Vaiava
on the day the minister of housing,
Gilles Tefaatau, visits. October 2004.

A young woman fixes her hair in
the communal kitchen in Vaiava.
April 2004.

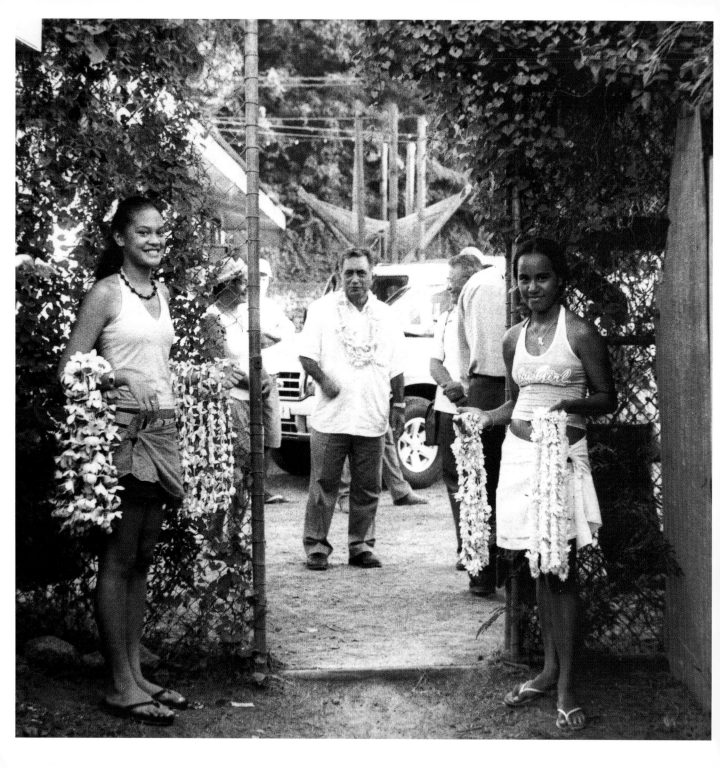

Oscar Temaru welcomed by two girls as he arrives in Hotuarea to celebrate the completion of the new communal shower-and-toilet building. December 2004.

While crowds wait for him, Temaru chats with neighborhood residents in Hotuarea just before the celebration.

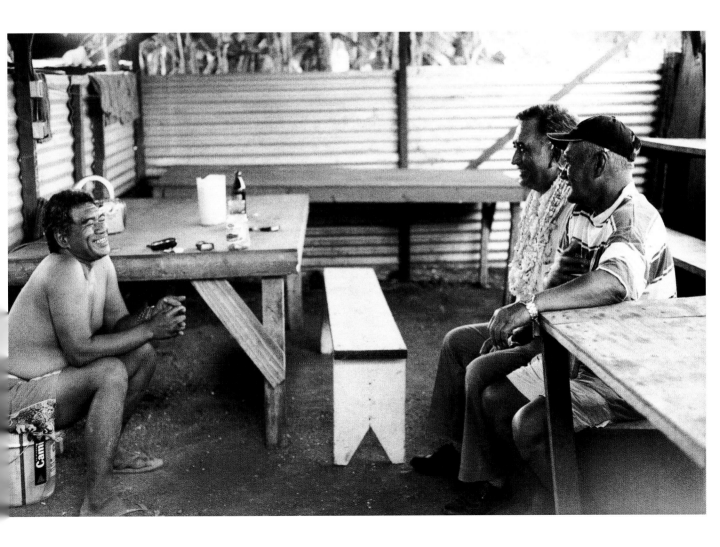

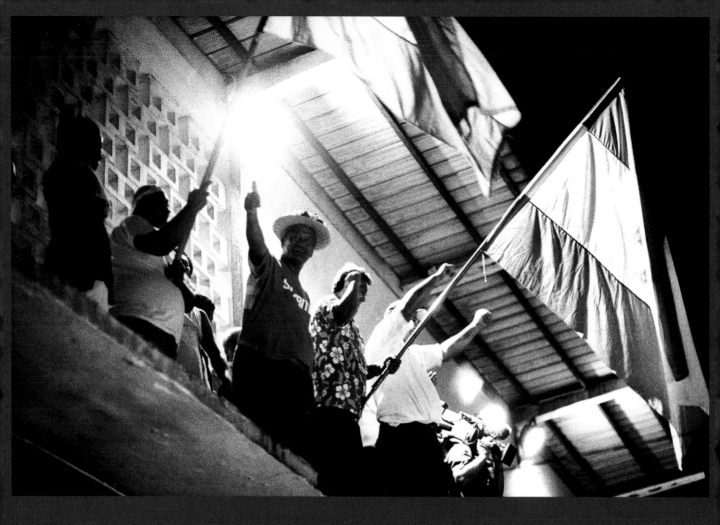

Oscar Manutahi Temaru, who was born in Fa'a'ā, was elected the town's mayor in 1983; three years later, he was elected to the Territorial Assembly. In May 2004, Temaru's political party joined with others in the Assembly to form a majority, and Temaru was elected president the following month. In October 2004, a political crisis developed, and Temaru's majority in the Assembly was defeated. Following massive street protests against the actions of the Assembly, new elections were held in early 2005, and Temaru once again became President of French Polynesia.

OPPOSITE
Temaru supporters celebrate
the new president's unexpected
victory in the territorial elections
and the beginning of *taui*, or
change. May 2004.

RIGHT
Following Temaru's loss of
power, new elections were
held the following year. A
Temaru supporter offers lei
of *tiare* flowers in celebration.
February 2005.

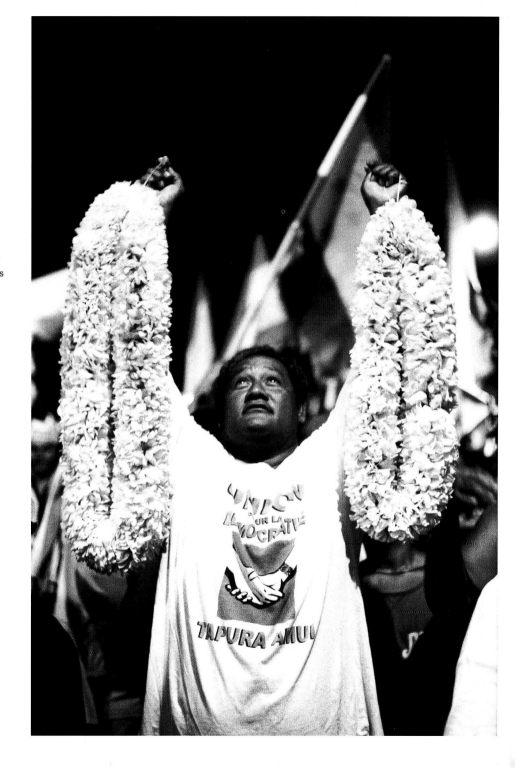

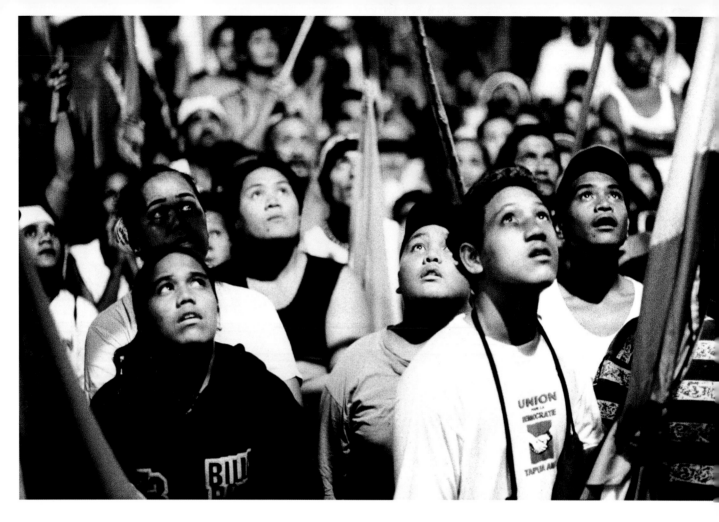

Oscar Temaru's supporters await
news of the results of the 2004
presidential election, then erupt
with emotion as Temaru's victory
is announced.

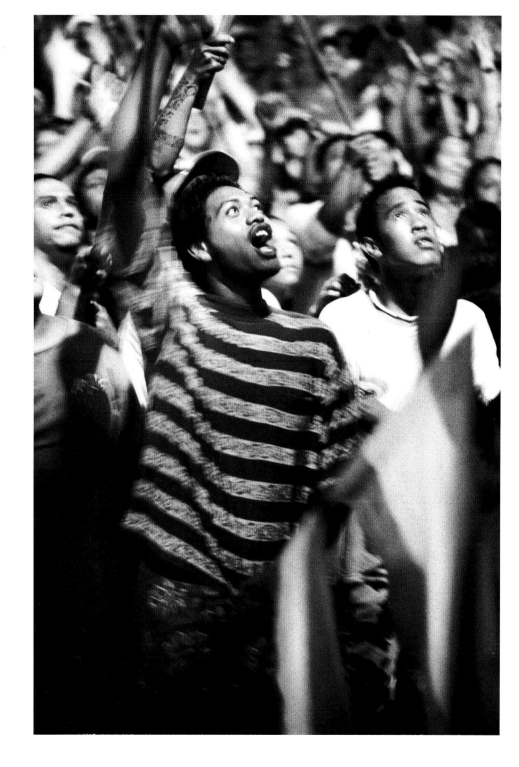

LOUISE PELTZER A STRANGE SHIP

ONE DAY, A STRANGE SHIP came to visit. Matari'i had
.the time to appear twice on the horizon after the *Providence* left, when Captain Bough-
ton decided to call at Matavai before going to where our cousins from Vaihi live.
Oh . . . the ship itself wasn't strange—it was beautiful and majestic like all foreign
ships—but the ship's crew, or rather, its passengers. It was the first time a *paratane*
ship with passengers had come to see us. It contained men, of course; but unlike the
crew, these *paratane* men were strange, even startling. Also, for the first time ever,
there were women.

Let me, in a few words, tell you the story of these people.

We knew something was going to happen. The omens are never wrong. The night
before had been atrocious because of violent storms and rain. I don't remember ever
having seen it so terrible. Each strike of lightning lit up the *fare* with a roar of thun-
der, revealing a family curled up and trembling in fear. What had we done? Why did
the *atua* display their anger this way? As if our misery wasn't intense enough, near
dawn the gods picked up the earth of Tahiti with fury and the ground shook. We
greeted the dawn with huge relief, and the first rays of sun were like caresses. The sky
was pure: Ra'a, the god of the wind, had tired from his exertions and calmed down.
There were no traces of his huge upset of the night before, and it was as if we had all
lived through a bad dream. But we could hear the faraway roar of the raging sea's
enormous waves smashing the reef and proving to us that we hadn't been dreaming.
Most of the *fare* had been damaged, so men and women got to work fixing them.

It was at this time of intense preoccupation that we heard yelling. It sounded like
an invitation to celebrate: *"Pahī, pahī . . ."* Children were the first to throng onto the
beach. It took us a while to distinguish the top of the mast of the strange ship that
sailed alongside the reef at a respectable distance. Distressed after a night of terror,
each person felt grateful to the gods, who appeared to ask for forgiveness by send-
ing us this ship and all the pleasures that went along with it. Some men hurried into
the valleys to gather fruits; others chased chickens and little pigs. The women gath-
ered flowers, rubbed themselves with *mono'i,* and competed to be the most beauti-
ful. The children copied them.

The ship didn't enter the bay until the middle of the day, so we had enough time
to prepare ourselves. Heavily loaded outriggers waited by the beach. Men anxiously
awaited the signal to leave. They couldn't take off too soon or they'd interfere with

the navigation of the *pahī*. Cries of joy accompanied the clanking of the chain and the thud of the anchor as it was lowered into the lagoon. The departure of the outriggers was flawless and, as usual, splendid. Children dove into the water to follow the canoes for a while, then returned to the beach and hollered impatiently. From that moment forward, nothing was ever the same. The canoes attached themselves to the boat's hull until early evening, then one by one, they let go and slowly returned to the beach with their loads intact.

We were astounded.

Our men were silent and shy. Our women—exasperated by the lack of reaction to their charms—cursed the strangers. I helped my father pull his outrigger onto the sand, my large eyes interrogating him in silence.

"Tomorrow," he said without conviction, "tomorrow we'll go back to the boat. Today, the strangers don't want to trade, nor do they want to come on land." I continued to stare at him, not comprehending his words, so he added with a mysterious air, "The strangers don't want to come down today. It is the day of the Lord!"

The next day, some outriggers went to the ship, but without enthusiasm. The joy of spontaneous welcome had evaporated. In the afternoon, some women, men, and children started to disembark. The *ariʻi*, King Pomare, went to welcome them, accompanied by Tu and Tetua, who were perched on the shoulders of a *teuteu*. I must admit that I was timid about approaching these strangers, who didn't look like the others we'd seen. Above all, I wanted to see the women, for we'd never seen foreign women before. Fearful, I stayed glued to my grandfather.

The women's faces were even whiter than those of their husbands, so white that they appeared translucent, and their heads were covered by hats that tied underneath their chins with a dazzling *revareva*. What was really shocking were the layers of dresses, one over the other. The layers concealed their bodies so much I wondered how the men could see their beauty. How could desire strike the men's hearts? The women's feet were like ours, but so small that they could be easily overlooked. Their feet were almost entirely covered in pink and blue ribbons and were so adorable. I looked down at my feet and became embarrassed by the shape of them. All of a sudden they appeared enormous to me. When I grow up, I want to cover my feet in ribbons of all colors.

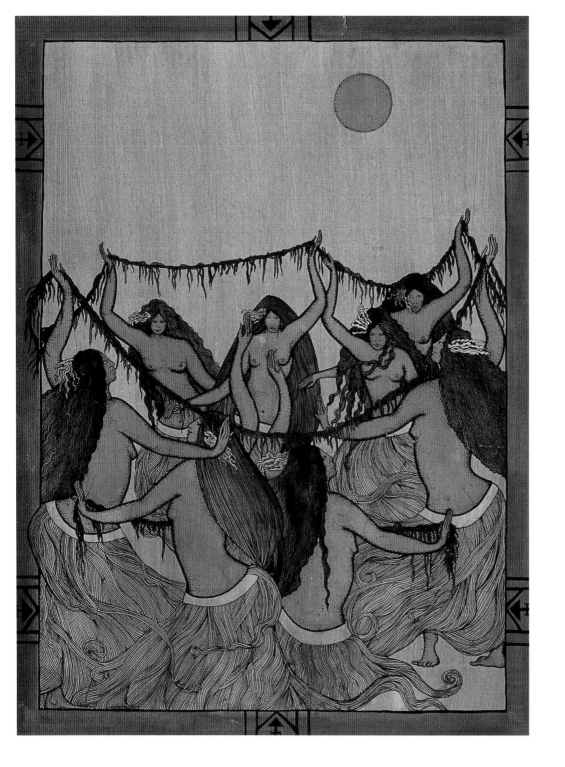

The *to'erau* wind rose up, cooled, and swept up the sails of these *vahine popa'ā*, who wavered and staggered. The men surged forward to hold on to them, then made them sit down before they flew away. I got up from a fallen coconut trunk, where I'd found a place to observe them, so that a foreign *vahine* could sit down. She sat very close to me and had a nice smell.

Friend, I know that these words on paper surprise you, but all this is true, and I haven't yet told you the most shocking! These women do not wear flowers in their hair or around their necks, nor around their wrists or at their waists . . . nowhere. And I looked everywhere! I am old enough to know that a woman should never show herself this way in front of men; in fact, it has been a while since I myself went out in public without flowers. What was I to do? I discreetly slipped away and picked all the flowers I could to form a bouquet, and then I offered it to the lady. My fear had dissipated. The strangeness of the situation had made me bold. The lady gently took the bouquet and gave me a timid smile. But alas! She kept the flowers in her hands. When she looked at me again, I pointed my finger at the flower I had in my hair so that she could see what I had done and follow my example. Lost cause: the flowers remained prisoners of the long, white hands with pearly nails.

Despite her odd clothing, I admired this lovely *vahine*. Just then, Peter the Swede arrived. He was one of the deserters of the *Daedalus*. I know him by sight, but like the rest of the *popa'ā*, he scares me. It takes time to get used to them. Peter and his companion, Cornelius, are good friends of the *ari'i*. They are treasured because they possess spears that spit fire and they know a lot that we don't. That day, Pomare summoned Peter to serve as interpreter.

The *Duff* was the foreign ship, and Wilson, its captain, gave a little speech to introduce his friends, whom he called missionaries. Then, one of the missionaries, the eldest and obviously the chief, stepped forward. He was quite large for a foreigner, but seemed small next to Pomare, who sat on the shoulders of the *teuteu*. The missionary was wearing black clothing, which enhanced the white of his shirt and scarf. His face was thin, but his features were pleasant. With a calm voice he announced the goal of his journey, already revealed by Wilson: he requested permission for him and his companions to live among us. He had come from the *paratane* country to announce the Word of God to the Tahitian people. He spoke in a loud voice to cover the noise of the wind and the sea; he was at ease, and we saw that he

OPPOSITE

Dancing Women

The *hivinau* is a fast dance performed in a circle. Popular in the traditional dance competitions, it originated in the eighteenth or nineteenth century, when Tahitians observed English sailors turning their boat winches while yelling "Heave ho!" (*hivinau* in Tahitian). BOBBY HOLCOMB

was used to speaking in public like our grand *tahu'a*. He often paused so that Peter could translate. He calmly and assuredly repeated the important parts of his speech several times, as if to avoid any confusion, and Peter obediently repeated to us, "I, Jefferson, missionary pastor from the London Missionary Society, come to the Tahitian people to announce the Word of the true God, Jehovah."

During the speech, the crowd got larger and a *pourau* rope was strung between two coconut trees to keep people back.

"God Jehovah is a god of love. My companions and I are men of peace. Under no circumstances will we participate in your battles. The few arms we have will only be used to protect the women and children. But soon, if you listen to the Word, you will live in the peace of the Messiah and have but one goal: to praise the Lord for His blessings. Tahitian friends, you are sons of God! We British men are your brothers!"

The eyes of the crowd flitted over Jefferson and Peter, then alighted on Pomare and Ha'amanimani, the Great Priest. Their faces were stoic as they listened attentively. Ha'amanimani already knew the missionaries and crew. From his outrigger, he had gone to meet the *Duff* when it sailed along the reef and found a place to anchor in Matavai Bay. Ha'amanimani had asked Captain Wilson to be his *taio*. It was a huge honor, but the captain ignored him. It was not until the next day, when Wilson learned who Ha'amanimani was—our *tahu'a nui,* one of the most important people in Tahiti—that he decided to rub noses with the high priest and call him *taio*. Once Jefferson finished his speech, he stepped back and rejoined his companions.

It was Pomare's turn to talk. He did so in his serious, loud voice. On a good day, his speech is a gift for those around him. We like games, feasts, and ceremonies, but all these displays of joy would not be the same without hearing, before, during, and after, the words of the *ari'i* that fire us up with the pleasure of being together.

Nothing is more exciting for us than a beautiful speech. It is a difficult art that follows strict rules taught in special schools. Only those who through birth or duty must uphold knowledge and authority can go to these schools. Bad luck falls on the careless, the clumsy, for the judges in the crowd are merciless. They would mock a speaker without regard for his title or his authority. A chief only has power if he maintains his gift of speech, and Pomare has this gift.

The appearance of these strangers who came from faraway islands to speak of

gods—was it not an homage to the Tahitian people, a recognition of their elevated spiritual consciousness? Pomare was proud that such a reputation managed to reach islands as far away as Paratane. It is true that Tahiti lives in the intimacy of the gods. But how could it be otherwise when it is so close to Ra'iātea, the sacred cradle of the gods? There is not one action, one gesture, one thought that is not in harmony with their desires! There are many *atua*. They are everywhere: good ones, severe ones, cruel ones, important ones to whom we submit body and spirit. There are also more modest gods, familial ones whom we honor. Each one has a role. Each event, each gesture, each thought is addressed to one of them; and above this multitude of gods reigns the great god, creator of all things: Ta'aroa.

Several times, Pomare thought he heard Peter speak of the *real* god, as if there could exist such a thing! Of course the foreigners had their own gods; it was only natural! What a scoundrel! It wasn't the first time that Peter had indulged in a fanciful translation. Could a god be anything other than real? Pomare held back the desire to burst out laughing. It wasn't the right moment to do so. He had to welcome the noble *paratane* priests with dignity.

Pomare's first words welcomed the foreigners. He asked them to consider him and his family as their friends and protectors. In a few rapid sentences, he accorded to all the very same wishes that the missionary pastor, Jefferson, had expressed. Yes, the foreigners could remain on Tahitian land as long as they wanted. It was true that they needed shelter to rest and house their belongings. Stretching out his arms, Pomare pointed toward the big *fare,* the largest in the *mata'eina'a.* Sometime before, it had been built for the ship captain who had come to collect *'uru* plants and who, despite his promise, hadn't returned. Pomare therefore offered it to the missionaries.

Like Jefferson, Pomare paused from time to time to allow Peter to translate. After speaking for a while, however, he became so impassioned that his sentences became longer and the time he allowed Peter to translate became shorter.

Jefferson had also humbly requested that a few acres of good land be put at the disposition of his companions and himself in order to plant a garden. It was hard for the foreigners to understand our generosity and our laws of hospitality. With a royal gesture that made the *teuteu* wobble, Pomare pointed to all the land of Matavai and everything on it, offering it to his new friends, his brothers: *fare,*

men, women, and children. The missionaries could even consider Pomare's own residence and all of its contents as theirs, but he didn't think it necessary to offer it. For him, it was understood.

After having seen to the needs of the missionaries, he started his speech on the *ari'i*. He raised his voice a notch and became more solemn. His arms began to gesture.

The crowd, which had been distracted until then, gave Pomare their attention despite the heat. Bodies pressed forward to devour the words of the chief. Peter sat down, his role in the ceremony over. The foreigners, composed and attentive, waited to see what was going to happen. Only the children of the missionaries, unaware of the grandeur of the occasion, played in the dust. With a slight movement of his feet, Pomare's servant widened his stance to stabilize his hold on the royal charge on his shoulders. From then on, no matter what happened, he'd be as solid as a rock.

Pomare introduced himself and his relatives and, with huge leaps, crossed generations, naming ancestors one after another and citing their names: all their names, including those they had acquired during their lives and those that signified a battle, a feat, a character trait, a title, a marriage. Each name brought an event in the people's history back to them. Pomare conscientiously went through the past. Not one of the roots of the genealogical tree could be forgotten. The specialists, the *haerepō*, would not have allowed such an omission.

From his great-grandmother Te'uraoteatua, Pomare went to the end of the *pa'umotu* branch, covering Tuheiari'i, Paniroro, Tapaiaha, Tangaroa. He patiently reached his distant ancestor Tumakinokino, who was from Fakarava, and the gods of his family. He then tackled the roots of the chiefs of Pare via his great-grandfather Ari'ipaea. Calmly, he cited the eighteen generations leading up to Tahipuanu'u and Ne'eutatuateanui. This effort of memory was considerable, and he paused before delving into Tetuahuria and the depths that eventually, generation after generation, took him to faraway Vehiatuaitemata'i, the chiefs of Taiarapu. Courageously, starting with his mother, Tetupaiaihauiri, he began to list the members of the side from Ra'iātea. He cited Rofai, the ten generations leading up to Tamatoa and Moeterauri. He spent a moment on the offspring of Porapora and Huahine, then came back to the main root in Ra'iātea, without which there would be no *ari'i* with divine rights. With a superhuman effort, he named the fifteen generations leading up to Uru and Hinatumuro'o, and generation after generation, he pressed on.

At this point, few spectators could keep up. A squatting elder punctuated the recitation of each generation with a slap on his thigh. The breathless crowd followed the *ari'i,* supporting him in his passionate endeavor. Step by step, Pomare continued on his dizzying descent. His rhythm slowed. Each new generation required phenomenal efforts of memory. Soon, he attained the fabulous depths where men become merged with the gods from whom chiefs descend.

As soon as Pomare ceased, a husky, spasmodic chant rose up from the chests of the men to signify their approval. The chief had been brilliant. In the falling dusk, this brutal chant worried the *popa'ā* women, who got up to move closer to their husbands.

It was Ha'amanimani's role to mark the solemnity of the occasion by calling on the gods, for he was their conduit. He did it in the typical manner that allows men to communicate with the gods, to seek counsel from them, and to tremble before them. In this way, mortals are allowed to conduct themselves as immortals.

If Pomare could have violated a *tapu* through publicly reciting his family genealogy, which is usually kept secret, there was no question that Ha'amanimani could have done the same. Taking into account various resources as well as the presence of the foreigners, he spoke only of the small gods of everyday life. The others were reserved for the ceremonies on the *marae.* As to the more important gods, the invocation was between him and the assembly of priests. Despite this reserve, his speech was long and his last incantations were pronounced in the black of night. The end of his speech was greeted with satisfaction by the chiefs and the entire assembly. The Tahitian gods agreed to welcome the new *paratane* god with kindness. Ha'amanimani warranted it.

Peter was napping. He was roughly awakened to announce the good news to the foreigners. So in this way, the Tahitian people, loyal to the traditions of the ancestors, demonstrated their respect for the sacred laws of hospitality and rejoiced that, once again, circumstances allowed them to share what they had received in abundance from the gods.

Translation from French by Kareva Mateata-Allain

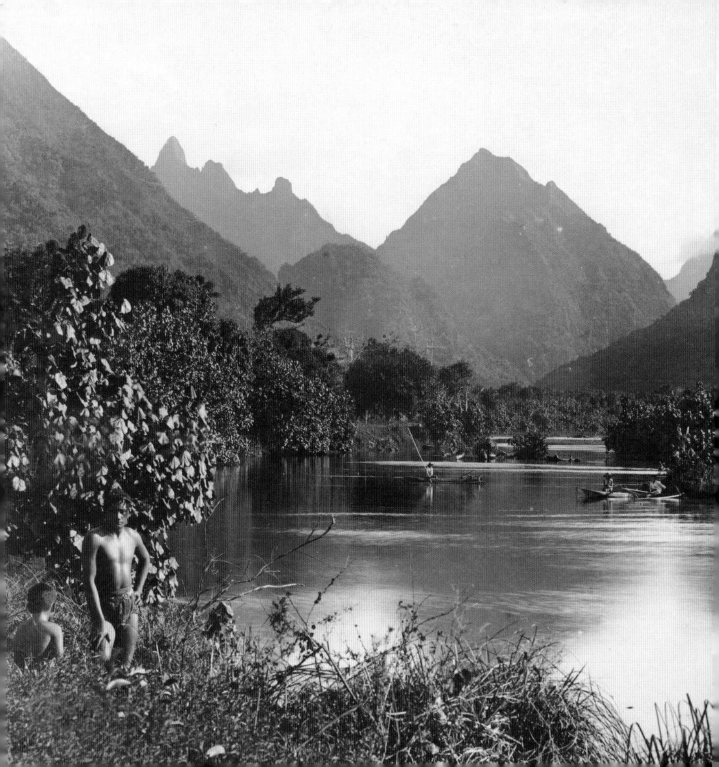

FLORA DEVATINE THREE POEMS

Hema and His Mother, Hina
The raised-back canoe, lashed with
coconut twine, illustrates ancient
building techniques. The bone
fishhook is also traditional.
BOBBY HOLCOMB

VOYAGE THROUGH WORDS AND NOTES

The music of children flows through my writing, joyous and light,
 moves in pirouettes, dances and marks the tempo.

It hangs on my thought, pulls it in lively motions, young and free like
 rock-and-roll, it makes little leaps
And chases itself in large arabesques in the cadence of *twist again!*

Story of a voyage leaving the water's surface and diving into
 multicolored blocks of multiformed coral in the shadowy depths
 of the sea,

Where fish turn and maneuver in an endless ballet of quick
 movements!
Maito, squirrelfish, *manini*, and blue fish,

Accompanied in the dance by impassive

Sea anemones of various colors, spiked sea urchins, *vana* and *ʻina*,
 carefully watching their prey,

With poisonous harpoons at the tips of their tentacles,
With articulated spines that perpetually sweep the watery space.

Musical voyage at the bottom of the water of memory of all that
 lives there
And exists to show us what its community can teach humanity!

Devatine

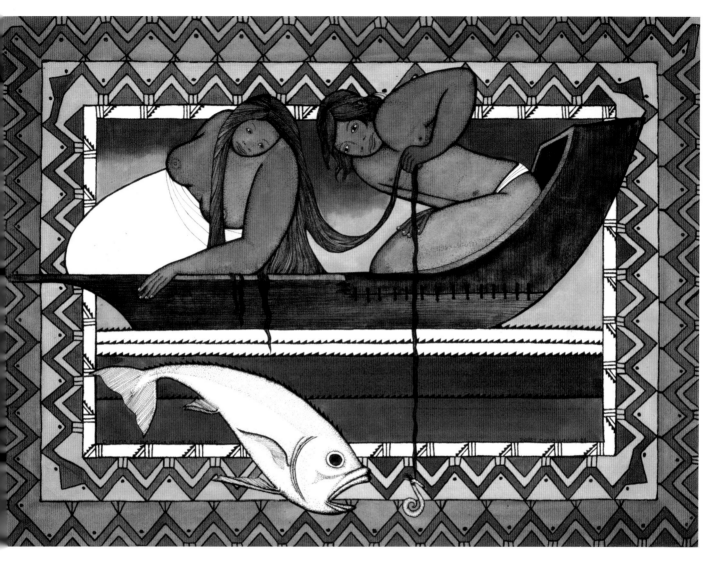

SLAUGHTER AND DEPRESSION

The giant palm tree in our garden
Fell yesterday morning

The giant palm tree, so imposing in size
Fell, yesterday morning it fell

The giant palm tree in our garden
Which reigned magnificently over the neighborhood
Welcoming everyone home

Collapsed in a huge crash
Trunk sprawling, fronds stripped
In the crowded space of our garden
In which the giant palm will never again stand
As a result of violent winds

Cut up, gnawed, it will rot in the garden
A sorry end for so beautiful a giant palm

Just before the palm fell,
We lopped the top off the great pine in our garden

Fearing high wind would topple it, damage rooftops,
Since it was over twenty meters high

Our garden's great pine that had
Balanced itself so nobly against powerful winds
Was shortened, plucked, stripped of its plumage

Such a lovely tree rising to the skies
Alongside its huge palm-tree neighbor
Made our house recognizable through the airplane window
Each time we returned home

A page turned a little too lightly
And the drought stalking us with firm step
Awaits the next season

Humans, we must admit, are thoughtless
And flippant in manner and actions

No regard, no regret for this disastrous end,
The savage lopping of these two
The majestic and tranquil palm, cut down, will never grow again
And the pine deserved more care

This is not to say that it's ingratitude that suffocates us
And we weren't looking to rid ourselves of them

The pine exudes white and red resin
From the wounds on the side facing the sun

I saw dark ridges on its ravaged shoulders
Struck by the spiked shoes of the woodcutters
I caressed its large and flat belly, illumined by the glitter of rain
Certain the pine will grow again, will recover its past magnificence

As for the palm tree, a stump remains
Still tall and strong and for a while
The strength and all the majesty and wisdom
From its full life and the many others nurtured under its shade

It is a reminder of respect to the memory of ancestors,
Of the departed father, of the departed mother,
And at the moment that I write, of the mother-in-law and
The father-in-law whose anniversaries of birth and death
Coincidentally were yesterday, within days
Of the anniversary of my father's death,
Reminders of other ways in which we should not forget them

In this way, the pine and the palm
Will be a little like the father, a little like the mother
Who went forth, releasing their life's work
Detached from time, losing themselves in the moon's phases

Cutting down the foundational, monumental trees
May liberate us from attachments to the ancient past,
To be our own individual, moving in our own rhythm, listening only
 to what pleases us

But climbing up the hill leading to the house
How great is the pain we feel, no longer seeing
The giant palm signaling me from afar
And its promise of cool shade beside the house
How great is the pain in no longer having that slender
Silhouette jutting high into the sky, greeting and wishing
Me, like Amadou, "Welcome home!"

In the cutting of these two great, most faithful friends
The garden has lost its soul
What is left has all merged together
Nothing distinguishes this from the other houses
The other gardens, the other inhabitants of the neighborhood

They are folded into the anonymous, encircling neighborhood

MEMORY

Memory returns to me, surprises me with the curve of a word, of an
 image, of a smell, of a route,

Noise of water, undertow of fear,
The calls of cocks, cries of birds,
Purrings of a motor circling the lagoon!

Memory rising without warning submerges me,

But then it soars high in the sky, like the hours of twilight; letting it
 fly, I internalize these reclaimed memories!

Memory knows that I track it in the dark hours of stormy days and
 rising tides,

Just as I know there was a time she demanded my attention, suffering,
 crying, narcissistically pulling me into her melancholy.

Memory of the lonely one who, at the end of the day, lays claim to
 what remains, finds it in the yellow and emerald-green
 interstices in the midst of grey-blue clouds tinted rose
Magical nocturnes.

Long, drizzled memory evolving: clouds in procession toward their
 watery fate!

Memory whistling, chirping, whispering while the night falls
But the coolness that descends from the heights of the land breaks the
 voice of the warm throats of the singers in the dew-laden grasses!

The memory of words long forgotten pierces in an instant the mind
 in its stupor before disappearing in the overwhelming silence
 of sleep.

And I struggle to put together the words that will bear witness to the
 voyage of the mind floating toward the imaginary good!

*Translations from French
by Jean Toyama*

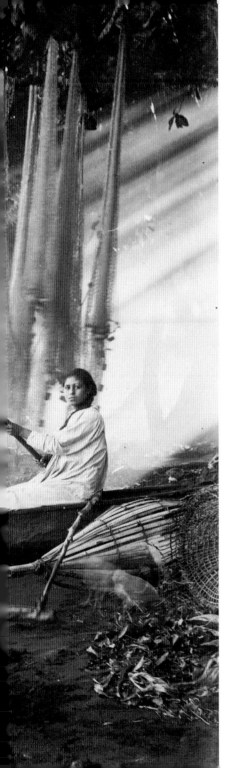

from

HYMNS TO MY ISLAND

LOUISE PELTZER

 RIDDLE

One day a gardener decided to graft
his guava tree onto an apple branch.

What do you think resulted
from this brilliant experiment?
A fruit that was half-fig, half-grape,
With neither taste nor scent.
The scientist became furious.

Left alone, the apple tree would have produced
A ripe red fruit: crunchy, juicy.
The guava—you know it well—
One eats it morning and night.
In other words: two delicious fruits.

Like you, I would like to know
The answer to this riddle.
But don't worry.
It's only a game.

TA'AROARI'I

On your grave, allow a friend to place
This modest poem of tangled flowers.
You see, this time I didn't cry.
These few tears are just a bit of dew.

Evening falls, the time you liked best
To dance to the sound of the drums and *vivo*.
Your joy, so grand, made your skirt fly
So that even God laughed.

There, so much happiness could only trouble
Those men who came from elsewhere, certain of their desires.
The joyous people, in turn, must suffer.
Isn't happiness the greatest sin?

In an era when the body was sinful,
When only the Word expressed thought,
What could dancing be if not a penance?
He might fall! He fell, just as they said he would.

Today, young Tahitians remember
That once a man elected to die
In order to save the dance that alone could nourish
Our generous souls and quench our spiritual thirst.

Those sad people from the past are now less sad,
Having themselves discovered the soul's language.
Their hearts murmur, "It is time to be free of blame—
Ta'aroari'i, you did not die for nothing!"

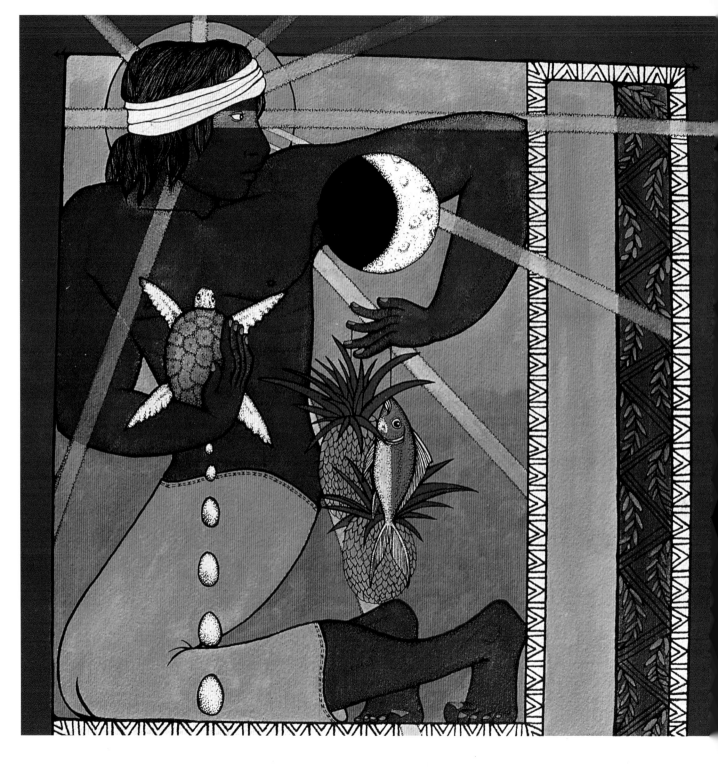

DIALOGUE

Who are you, man who says nothing,
Whom I meet each day on the road?

Gazing out at the lagoon, you taste morning's freshness
While I scramble about like a restless child.
Calmly, you prepare yourself for the day's work—always serene,
While I'm as jumpy as a puppet on strings.

I walk, run, and fly, hardly human anymore.
I'm rich, yet everything seems shabby to me.
At night, exhausted, I drink myself stupid.
I swear, once and for all, to put an end to it.

It's like I'm being churned in a breadmaker,
But I know I wasn't born this way.
Like you, I want to taste the morning air.
Won't you tell me the secret of your fortunate life?

Tahitian, I saw you begin to speak
While I was talking, I saw you make up your mind.
For two centuries we've been on parallel paths.
Tell me quickly, while I gather up the things I've stolen.

Too late! They're waiting for me. You'll have to tell me tomorrow . . .

*Translations from French
by Nola Accili*

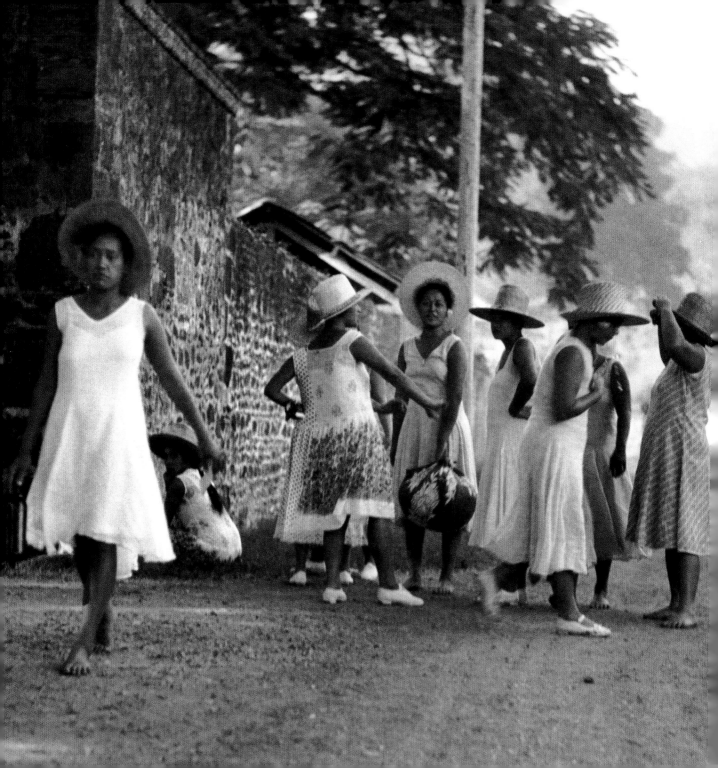

TAARIA WALKER

A LITTLE
SCHOLARSHIP
RECIPIENT
FROM
AUTI

IT WAS THE END OF 1939, and the schools had just closed for summer vacation. After Sunday evening prayers, the *mūto'i* read the announcements at the meeting house. The next morning, we were alarmed to find when we awoke that our mother was not at home. We rushed to the kitchen, where our father, loyal as always to his chores, was setting the table.

"Daddy, where is Maman?" our older sister demanded. "Have you already done the wake-up prayer?"

"Yes, I said the prayer while you were still asleep," he replied. "But your mother was awake all night. She was upset after hearing the announcements that Pare had received a scholarship to go to school in Tahiti."

"Is a scholarship bad? Will it harm us?" my sister asked.

"I'm not quite sure what a scholarship is, but your mother is very upset. She insists that Pare's choice to accept the scholarship is God's punishment for Maman's not respecting her parents' wishes when she married me."

The situation was getting even more confusing. The more the conversation continued, the more I trembled from fear. I lost my appetite and started bawling. Just then, Maman burst through the door, her hair disheveled, her *pāreu* crooked, her eyes bloodshot. She immediately confronted me.

"You are certainly the granddaughter of your great-grandmother. They were all pagans and now you are one of them, bringing bad luck. Your great-aunt Turaura is right: a child of lies attracts lightning from the sky. Stop that crying unless you want a slap across the face. Only children of the devil cry for nothing, since they are incapable of repenting."

Deeply touched by my tears, Papa picked me up, took me over to the *'ā'ano* to wash my face, and held out a hankie for me to blow my nose with. Sniffling, I asked him why Maman was yelling at me.

"Don't cry anymore," he said. "She is the one who is the devil! You must be strong enough to confront all the devils in the village and gather your energy for school. You know very well that I can't read; my only wish is to have children who are intelligent, like your mother, and as educated as Mme. Titi, the schoolteacher."

To be honest, my father spoke like a prophet—the way most Rurutu people did—although he didn't know how to read or write. My mother had, however, taught him to write "Tu," which was short for his first name, Tuari'i, so that he

could recognize his bags when he traveled. Because of his ignorance, he couldn't read the Bible and was never able to join the church. Maman taught him biblical verses by heart so that when he went to evening service he could sing the *tārava* he loved.

When we took him our slates scribbled with lines of writing and drawings, he would proudly do a village tour, showing our work to all his *fēti'i* so that they could see the light under which we lived.

That morning, he didn't parade in the streets like our mother to show his disapproval and despair. He went straight to the schoolteacher, Mme. Titi, who explained to him in detail the reason I was awarded the scholarship. From that day on, I became *tapu,* and Papa begged Maman to not worry anymore; he said he would take care of any expenses and would not allow anyone to be put out just so that I could go to school.

In all his evening and morning prayers, I heard him ask God for help and a long life so that he could live to see me finish my studies successfully.

Days went by, and Maman gathered our homemade crafts and all the goods from the garden, and Papa took the animals he had raised to the Chinese merchant. Mme. Titi had given the merchant a list of all that I needed for my boarding school in Tahiti.

What's more, the schoolteacher was so touched by the courage and goodwill of my father that she wrote to her brother in Tahiti who was married to my godmother's sister, asking them to be my guardians. They agreed, and everything seemed to be falling into place. Maman, often a worrier, took me to Teau the Seer to help dissolve the doubts and bad feelings that were eating away at her.

Teau was an astrologer and a cousin of my mother. He was the son of Emana, who became a pastor in Mangareva after evangelical school in New Guinea. When Pastor Emana died, all of his children, including Teau, went to live in Auti with their uncle Teri'itai, who was the chief of the village. Teri'itai married his brother's widow. It was in Auti that Maman took me to see Teau for this passionate consultation.

"My dear Teau," she asked, "give me an idea of what the future has in store for this head as hard as a rock." She pointed to me. "I would have preferred that her younger sister were chosen for this scholarship; she is so quiet and serious. In this one here, I have absolutely no trust. She only does what she feels like, and she's very good at

starting trouble and sowing terror when she's in a group of kids. I fear that once she gets to Tahiti, she'll slip away from her guardian and the boarding school. Her father is on cloud nine and refuses to listen to reason. Nothing will change his mind."

"Tell me her real name, the one that is on her birth certificate, plus her birthdate, the day she leaves for Tahiti, and the date of her baptism," the Seer ordered.

Maman scraped around in her memory and scratched her head. She shook me and demanded that I remind her of my birthday, and from that date she counted to my baptismal date, the first Sunday of the next month. When sure of her calculations, she gave the Seer all the information he needed.

On a scrap of paper, the Seer wrote my first name, separating the letters. He then wrote the dates and split up the numbers. Under each letter and number, he wrote other letters and numbers. He added the two numbers and wrote some letters beside the answer.

During the long hour that the Seer worked, Maman pulled my hair and yanked my ears each time I leaned over Teau's paper and tried to read what he was writing. After letting out a long sigh, the Seer raised his head and read all that the future had in store for me.

"The beginning is full of snags . . ."

"I told you, Teau, this filthy child catches trouble as it flies by," Maman asserted. "No sooner do I turn my back than she's off . . ." Maman peered at me, her eyes threatening. I could tell she wanted to pinch my cheeks.

"I do see a problem there," Teau agreed as he placed a finger on the scrap of paper. "But hang on before you get all upset, because the road ahead is still long . . . The end is very rewarding . . . I think that it's worth the trouble to encourage her and to support your husband in the realization of this decision."

At home, Maman, relieved, read my father my *trousseau* list. She had opened a huge box, which had arrived from the Chinese merchant, and wanted to make sure everything was in it.

Excited and curious, we were all glued to the sides of the box. Treasures came out of it: material to sew my dresses, as well as sheets, pillowcases, quilts, a plate, a bowl, a fork, spoons, a knife, soap, toothbrush, toothpaste, a glass. All that was just for me. But how was I to use it all? I had never eaten with a fork, or with a plate, and I knew even less about using a toothbrush. At Papa's request, Mme. Titi came to the house to show me how to act at the table. As a leftie, I had a hard time cutting my

taro with my right hand. My taro kept jumping out of the plate, which disturbed Maman. Mme. Titi noticed my parents' anxiety and reassured them.

"Don't panic! My brother René and Mama Moe in Papeʻete will teach Pare lots of good manners, and in the boarding school, a very nice monitor's main purpose is to educate the children who come from the islands. Pare is a very smart girl who is interested in everything. She'll learn very quickly."

The day of my departure, nearly the entire village invaded our house, bringing bags of starch, taro, bananas, fruits, *pēʻue* rugs, and even money. Grandmother, uncles, aunts, cousins, and even my great-grandmother, who used a cane, came by to massage me and bathe me in their tears, as well as counsel me that I must pray to God and Jesus Christ so They could help me and keep me safe.

When my great-aunt Turaura came up to me, I remembered what my mother said, and I couldn't restrain myself from demanding, "Mama Turaura, why do they say I am a child of lies?" She burst out laughing, and because of her loud voice, everyone heard the story.

"You little devil, you never miss a chance to get revenge. After the birth of your three older sisters, my nephew—your father—couldn't stop telling me when your mother was pregnant with you how afraid he was of having a fourth daughter. He always said that if it was a girl, that he'd lose the heart to go look for food. If it was a boy, he'd bring all the fish in the ocean and all the *fēʻī* from the mountains and place them at my feet. When you were born, I sent my son Temo into the mountains to look for him and tell him that he had just had a son and was to load up horses with provisions and send them to my house. The day of your baptismal, everyone was afraid of what would happen. At the church, when the pastor declared your name and gender, I saw your father's reaction. But he was so good and forgiving that later he was beaming, and when leaving the church, he tapped me on the shoulder and assured me that he would always consider you his son anyway and spoil you even more than the others. Today, you're making up for everything. That is the lie, and I think it's a good thing!"

My father signed on as a cook for the *Tumuhau,* the sailing ship of the Rurutu people, so that he could accompany me to Tahiti for free. My scholarship included my trip. There were at least a dozen horses charged with pandanus sacks, bananas, *fēʻī,*

huge bags of *poi,* and *pēʻue* rugs in rolls too huge to be put in sacks. My trunk and my mattress were also on the ship.

After a few weeks—during which we stopped in Tupuaʻi and Rimatara—Papeʻete appeared before me at the harbor: a magnificent city with immense houses and cars.

My guardian parents received us warmly on the quay. The mother cried as she kissed me. She spoke to Papa about the sister of hers who had died—my god-mother, Paremata, to whom I owe my name Pare. She was happy to have me in honor of Paremata. We filled a pickup truck with all our stuff and headed off to Tipaerui, where my guardians lived.

After putting aside part of the provisions for the house, my guardians and my papa left for town to sell the rest of the sacks of starch, the *pēʻue* rugs, the coffee, and everything else we brought from Rurutu.

Some days later, in the morning, my guardian introduced me to M. Gillot, the director of the school. He made me read a page out of a book and declared that I'd be in Mlle. Stella Williams's fourth-year class because of my age. After a short meet-ing with my guardian, who was given all the information about what I needed for school, we went home. On the way, we bought an ice-cream cone from a Chinese vendor on a bicycle.

Wearing my big pandanus hat and holding my basket, I was prepared to face the unknown world of civilization. The first day, the boarding-school supervisor led all the new students to class. After that, we were on our own.

My teacher, Stella Williams, was a young woman with curly blonde hair and blue eyes. She spoke so quickly that I couldn't understand what she was saying. She took me by the hand and made me sit at a desk. She took off my hat and placed it at my feet, next to my basket. After repeating a sentence to me several times, I understood that she wanted to know my name. That, I knew by heart. I got up, crossed my arms like Mme. Titi had taught me, and recited, "My name is Taaria Teiaore. I was born on Rurutu in the village of Auti on the eleventh of October 1930. My father's name is—"

She interrupted me and pressed down on my head to make me sit. She silenced the entire class, which had burst out laughing, their hands pressed against their mouths as if they were little mice. I found them peculiar, as well as my teacher, who barely moved her lips as she spoke. My classmates made faces and whispered,

"Rurutu 'amu poi," which means "Rurutu are *poi* eaters." My savage Rurutu instincts boiled inside me, and in the depths of my heart, I screamed to Jesus to calm me down before I twisted the necks of these ill-behaved people.

This went on for two days, until I was transferred to another class and was introduced to Mlle. Simone Raoul, who must have been warned of my behavior. She welcomed me with a huge smile and showed me my desk, which was next to that of a small girl.

The children in this class were more normal and didn't pay any attention to me. They were busy copying Toto's bicycle, drawn on the board. I had never seen a bicycle on Rurutu, and in the short moments I had glimpsed the ones the Chinese ice-cream man and some of the teachers had, I couldn't remember if they had two wheels or three. How many did Toto's have? I took my slate and copied my neighbor's work, and she tattled on me right away. The teacher marched over, bluntly erased my work, and ordered me never to copy, saying it was dishonest.

I took an instant dislike to my classmate, and for several days, I was paralyzed with disappointment and regret for having left my island, my friends in Auti, my sisters and brothers, my teacher Titi, and my parents. Meanwhile, my papa was able to sell all his goods. He left a lot of money with my guardians to help them take care of me, then prepared to return to Rurutu. He came to the boarding school to say goodbye. He looked so handsome, dressed in new clothes and happy to see me well taken care of. In my head, I told myself not to disappoint him, and during my long prayers that night, I yelled at Christ for His deafness and awful indifference to me.

A third teacher then received me into her class. Her name was Mme. Moetu Herault. In a few short months I had changed classes three times, always going backwards. Mme. Moetu's class was the lowest, full of young children. I couldn't go any lower. They'd have to send me back to my island after this. The work consisted of building houses with blocks. I was the only nine-year-old among those Lilliputians, who were six or seven, and I felt like a grandmother. I helped the little ones build their houses and watched over them. At the board, I read about Toto, Titi, Lili, and so forth, and I drew a good picture of a bicycle to register it in my memory for the rest of my life.

At the request of M. Gillot, the director, many of my fellow boarders and I were taken under the supervisor's wing. We were also monitored by some older boarders,

who made sure we did our homework during study hour. They spoke to us in correct French and wouldn't let us speak pidgin. M. Gillot had the firm conviction that not speaking French was a major handicap for the children of the islands: he felt that no Polynesian child could advance without a perfect grasp of the French language. We were absolutely forbidden to speak Tahitian and were threatened with punishment if we did. In my case, which was always out of the ordinary, I spoke neither French nor Tahitian, and since no one spoke Rurutu, I ran no risk of being punished. But I decided to speak only in French, for if I let a Rurutu word accidentally slip out, my classmates made fun of me ruthlessly.

Some months before the end of my first school year, M. Gillot again put me in the fourth-year class, and Mlle. Stella expressed her admiration of the changes in my behavior and my speech. I no longer seemed like a deaf-mute, and promptly answered all her questions, almost at the same level as the other students.

The following years sped by as if on roller skates. Each time I returned to Rurutu during the long vacations, Mme. Titi had me stay at her house. That way I was able to improve my French and refine my behavior, while taking part in all the traditional ceremonies of my island.

The captains and passengers of the ship appreciated my father's work so much that he was guaranteed a job, and each time I had to travel, he was able to escort me between Rurutu and Tahiti.

But in 1942, I received a letter from my mother telling me that my father was gravely ill, bedridden, and unable to come get me during the long vacation in either July or December. He had signed on to the *Manureva* as a sailor so that he could come and wait for me in Tahiti. Just before entering the Tupua'i Lagoon, the ship was thrust upon a reef and was stuck there all night. The bad weather and strong seas made things worse, and under the stress, the boat split in two. All the passengers jumped into the sea and swam toward land. Having gotten to the reef, my father stood up just as a huge sheet of metal slammed against him in fury. He was pitched violently against a rock, hitting it with his stomach. Despite tremendous pain, he continued swimming as best he could, crossing the immense Tupua'i Lagoon, and then he washed up onto the beach. Some Rurutu people who were on the *Tumuhau,* which arrived sometime later, took him back to Rurutu. His condi-

tion was hopeless; he had not left his bed since the accident and was tormented by agonizing abdominal pains.

My guardians were happy to house me during the entire July vacation. They never tired of trying to raise my spirits. One of my guardians, a police officer, spent his days off dictating passages to me with the help of a little dictionary.

In November of that year, I received my certificate of study. The month before, I had just turned twelve. The latest news about my father was not reassuring, so I decided to leave Tahiti and return to Rurutu at the end of school. However, I would have to leave before my guardians came to get me, since they would have forbidden me to return home by myself.

As soon as the exams were over, it was time for the traditional tour of the island. Some of the boarders went home early because their ships were leaving; I decided to do the same. Thanks to the supervisor being gone and everyone dancing and chanting *"Vive les vacances!"* I was able to run to town and find the *Tumuhau* anchored in its habitual spot in front of Chez Tāporo. I raced back to school, grabbed my mattress, and hauled it onto the ship. During its call at port, *Tumuhau* served as a sleeping area for people from the Australs who didn't have anywhere to stay in Tahiti. There, I found some *māmā*s from Tupua'i whom I knew from past trips. They were devastated to learn about my dying father, for they remembered his kindness on board the ship. They took my mattress and found a spot for it. I ran back to the school, fearful and thinking every officer I saw was my guardian. I grabbed my trunk and walked innocently out of the schoolyard. Without stopping, I walked to Sigogne Beach. Exhausted, I lay on a bench by the roadside to catch my breath. Then I got up again and kept going sometimes carrying my trunk, sometimes dragging it on the grass. I finally arrived at the *Tumuhau*. The *māmā*s grabbed my trunk and hauled it onto the ship. I then took up residence on the ship under the care of the *māmā tupua'i.* About a week later, I was overwhelmed with joy when Rurutu people started to fill the ship and I found myself among my own. I kept praying to soon be far away from Tahiti.

Back in Rurutu, I found my father was skeletal and hardly possessed the strength to caress my face and congratulate me on passing my exams for the certificate of study. He wanted to cry but had no more tears. I kept repeating to him, "I did it,

I got my first diploma. Papa, I came without telling anyone so that I could give you the good news and prove to you that your perseverance, your patience, and your courage were not in vain." His hand, resting on my head, limply fell on the mattress, and he closed his eyes. My mother and my uncles made me let him rest; his fatigue was so intense that he could hardly utter a word.

"We have tried everything but with no luck, and he can't swallow without having awful spasms," said my mother. Then she explained that there was one last resort, passed down from my father's mother.

"What last recourse? Have you talked to the nurse? The priests? And what about the healers?" I asked.

"We have tried everything and consulted even Teau the Seer, who spent nights by your father's bedside. Your grandmother finally appealed to the grand sorcerer, Matamoni de Avera. According to this dubious character, your father has been possessed by an evil spirit and must be boiled in order to exorcise it from his body."

Some people believed that if a sick person relapsed or his condition worsened despite all attempts to heal him, he might be possessed by the devil. A pastor would then pray frequently for him over several days. If the patient's condition didn't change, the next step was to consult seers and sorcerers, who identified possible spell casters. The alleged spell casters were then sought out and threatened with death unless they admitted their crimes. If the spell caster was already dead, then Rurutu people incinerated his skeleton.

Incineration always happened at night, in order to escape detection by the police. The tomb was opened, the coffin was dug up and broken into, and bags of holothuria and sea urchins were emptied into it. Dry flowers and coconut leaves were piled on the body, and it was set on fire. Sometimes, an entire night was spent tending to a powerful fire to ensure the bones were reduced to ashes. Bones that were hard to burn were put in a sack and transported to a secure, well-hidden place to finish the incineration. Every trace of violating the tomb was carefully erased, and the gravediggers later made their way down to the beach, where they burned their clothes before diving into the water to purify themselves.

If the patient's condition still didn't improve, the sorcerer then ordered that the infirm be boiled to cast out the spirit inhabiting his body. Several cauldrons of water and wild basil were put to boil, then poured into an outrigger canoe. With

the help of several heavily muscled men, the sick person was held under the boiling water for a specific length of time. A struggle always ensued. If the sick person didn't die after being immersed, he was considered healed. This type of treatment produced more deaths than recoveries: covered in third-degree burns, most victims died from pain and infection.

Horrified by my mother's words, I started screaming. My sisters and brothers and I cried and begged all the adults invading our house to stop this diabolic act from happening.

But the next day, the dreaded ceremony was to take place.

Matamoni the Sorcerer arrived early and, with the help of my grandmother, led the ceremony, which consisted of boiling several vats of water and wild basil. Not far from the house, awaiting the boiling water, was a big outrigger, propped up on rocks. As soon as the water spurted bubbles, it was poured into the outrigger. White-hot rocks were also put in the water. Three of our uncles carried our father in their arms, but were interrupted in their walk toward the canoe by our youngest sister, who wrapped her arms around our father's stomach and hung from him, weighing down the three men. Together we children hung on to our uncles' necks, and one of the men tripped, dipping our youngest sister's feet into the boiling water. The entire gathering was stupefied by our sister's screams and immediately insisted on calling off the ceremony. The chief and the pastor were quickly summoned. Upon arriving, they threatened to punish this criminal activity with imprisonment. My father, placed on the ground after my sister's foot had been scalded, had just missed being cooked in water. My mother now had two injured people to care for, as well as a deep hatred of my grandmother, whom she blamed for our bad luck.

Right before New Year's Day, Papa died, leaving Maman alone with eight children.

When it was time for me to return to school, Maman sold *pēʻue* rugs and *tīfaifai* quilts so that she could replace some things of mine that had worn out. The day of my departure, she gave me a basket full of shell necklaces to sell in Papeʻete for pocket money. All my *fētiʻi* came to say goodbye and offer presents and good advice.

The *Tumuhau* arrived, and we left for Tupuaʻi, where we were to have a five-day layover. The day after we arrived was a Sunday, and all the Rurutu, devout Christians, filled the churches. While we prayed, we could see, through the windows,

violent gusts of wind bending coconut trees. Just before the end of the service, a messenger arrived and announced that the *Tumuhau*—anchored in the lagoon by Mata'ura Village—had snapped its ropes and was stuck in the sand on Ta'ahuaia Beach, three kilometers away, right across from the Catholic church. The stampede of Rurutu at the back of the church put an end to the service. We found that the schooner was indeed embedded in the sand. It sat very still, despite the waves whipping around it.

The Tupua'i people scurried around to find families who would put us up for an indefinite period; there were at least a hundred people on the *Tumuhau,* including the crew. At that time, Rurutu were known to drag along their children, cats, and dogs on sea voyages for no apparent reason other than to spin tales of them being cradled by the ocean.

Every day between the ebb and flow of the waves, the Rurutu tried to dislodge the boat using a coconut tree as a lever. The next morning, the boat would be back in its original position, and they would start all over again.

Luckily, Tupua'i is an island surrounded by an immense lagoon with an endless supply of fish and seafood. The Tupua'i people fished for the Rurutu who did not leave their boat. Though they established a permanent rotation, months went by without the Rurutu making progress. Women and children gathered shells on the islets. They cut pandanus and wove *pē'ue* rugs so they didn't get bored. Even I filled my trunk with necklaces made of shells that I gathered, pierced, cleaned, and threaded. At that time, shells were quite sought after by tourists, and there were never enough at the Tahiti markets.

Six months later, in June, the *Tumuhau* finally decided to move, and the Rurutu, exerting themselves, didn't give it time to sink back into the sand. As soon as she was afloat, the *Tumuhau* was tugged to Mata'ura and then anchored with double ropes.

After two days of the crew's checking the boat for seaworthiness, we received the signal that we were leaving for Tahiti. A good wind helped us slide atop the waves, and the island of Tupua'i had long disappeared before we heard loud creaking sounds coming from the cargo hold. Sailors informed the captain that the boat was filling with water and that all the trunks, cases, and wood at the bottom were floating and slamming against the sides, producing a horrific racket. We quickly threw things into the sea: water tanks, drums, chicken cages, pigs, and all the animals that

were on board. The sailors pumped water, and others in the hold passed buckets of water from hand to hand. All the men and women frantically emptied the containers they had and cast their trunks and affairs overboard. When the captain was informed that the water was still rising, he decided to return to Rurutu. Prayers rose up, children shook with fear, and those emptying water gasped for breath. The captain did not leave the helm; the sails, swollen with wind, seemed to fly over the waves. All this drama took place in the dark of night.

At dawn, we detected a black line on the horizon: Rurutu. The captain ordered one of the whaling boats to be lowered into the water. Four sailors got in and disappeared behind the waves. When the sun fully rose, Rurutu was visible and we could distinctly see the mountains. With the same relentless rhythm, the passengers continued to empty the boat, and before noon the whaling boat came back accompanied by eight others equipped with coils of rope. The men roped the boat from all sides, ready to save passengers in case she sank.

The good wind had not abandoned us, and the boat drew near Moera'i Pass just before evening. The entire population swarmed the beach and helped tie down the *Tumuhau*. The passengers piled into the whaling boats, and the schooner was pulled and hoisted onto the reef.

This catastrophic journey made my mother lose all courage to send me to school. I had lost everything—my trunk, mattress, shells—I was six months behind on my studies, and I didn't have my father to save the day.

As usual, Mme. Titi showed up at just the right time, extremely touched by the intensity of our bad luck. Once more, she begged my mother to not lose hope, saying Maman had to think about us children. Mme. Titi wrote me a long letter to take to the school director, and she saw to replenishing my *trousseau*. Her brother René lived in Pape'ete and had asked to adopt me as his own daughter and see to my needs. My mother had no choice. She decided to accept Mme. Titi's proposition and thanked her for her divine charity. What's more, the teacher's family in Moera'i were ready to help.

As luck would have it, the schooner *Gisborne* put down its anchor at Rurutu. Its crew and passengers were amazed to see the *Tumuhau* stuck on the reef at Moera'i. No one in Polynesia had even known about the boat's seven-month disappearance. The Rurutu people had thought the *Tumuhau* had long since arrived in Tahiti and

then sailed on to the other islands in its circuit. Mme. Titi took advantage of the *Gisborne*'s presence to ask the ship's captain, M. Columbel, for free passage for me so that I could return to school. He agreed right away, which convinced my mother to accept everything she was offered, and I left on good terms with her.

In Tahiti, my guardians greeted me with the same warmth and enthusiasm, but Mama Moe cried after reading Mme. Titi's letter and learning about my father's death. Both my guardians forgave my running away to Rurutu. They had been devastated after my disappearance from the boarding school. When some Rurutu had told them they had seen me leave on the *Tumuhau,* my male guardian dropped the charges of negligence he had brought against the boarding school. I admitted to being the only one responsible. Because I was able to see my father before he died, I didn't regret anything.

The day after my arrival, one of my guardians took me to see M. Gillot. After reading Mme. Titi's letter, the director placed his hand on my head and informed us that the school had been closed and wouldn't open until the end of September due to an epidemic that had struck all of Tahiti. I wasn't behind after all. I returned to the boarding school the night before school resumed on the first of October. From that year, 1943, until 1951, I did not return to Rurutu. My guardians became my adoptive parents, but, unfortunately, not for long. When my adoptive father visited Rurutu in 1946, he died there, and my adoptive mother decided to move to Rurutu. I therefore stayed with my paternal grandmother, who was living in Pape'ete at that time.

This grandmother took me in even though she was already raising three of my cousins. I lived with her in the garage of the Vivish family, close to the town hall of Pape'ete. Grandmother was very poor, and we would all help out by washing dishes for the Chinese in Fare 'Ute. Before going home each evening, we would go to a hangar behind Cinéma Tony and fill our baskets with shells, which we would thread at night. A can of Nestlé's Milk filled with shells cost us twenty *francs,* and the next morning we'd sell each necklace for five.

During the next vacation, I decided to take a job as a maid for Mme. Nordmann, a sweet old lady whose two grandchildren from Makatea lived with her. I became the children's babysitter and loved my work. Mme. Nordmann insisted that I live with her. In the evenings, I did the shopping, cooking, and housework, and cared

for the little ones. We lived above the Maeva Bar, where I got a job for an hour each morning cleaning the toilets, whose nauseating stench permeated the entire building. I didn't turn down any work, no matter how menial, because I needed the money to buy clothes and school supplies. I wanted so much to go home with a degree in hand, as repayment for all the goodness bestowed on me.

During other vacations, I worked for Mme. Brault in Orovini as a housekeeper and nurse's aid. Every afternoon around four o'clock, I would prepare the table for tea, and M. Flosse would come by and bring cakes. I also took care of many sick, elderly people, to whom I am indebted for having pulled me out of difficult situations in life.

After receiving my *brevet élémentaire,* I put in a request to the hospital at Pape'ete, where I had been working for three years, to be transferred. At last, I came home as a nurse to Rurutu.

Translation from French by Kareva Mateata-Allain

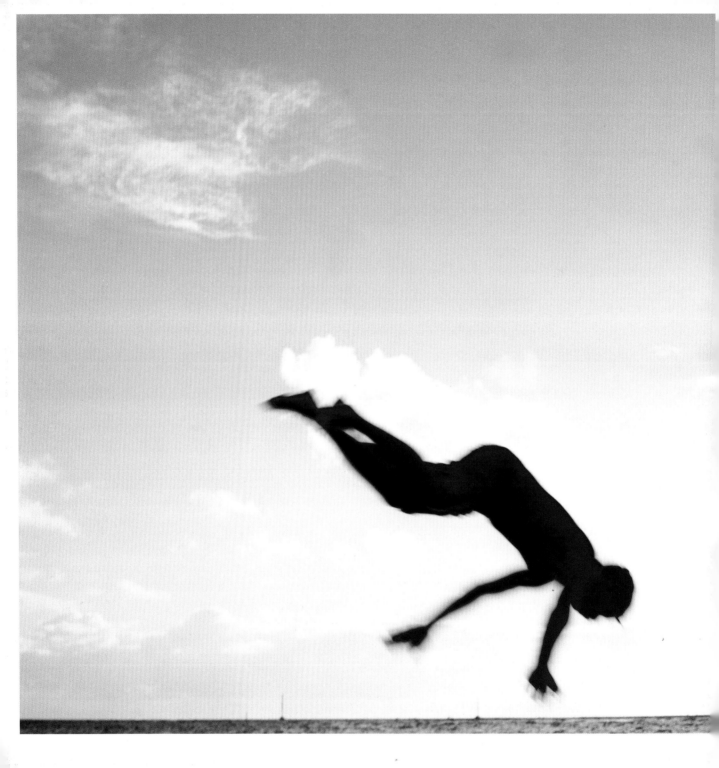

MARIE-HÉLÈNE VILLIERME TANGATA

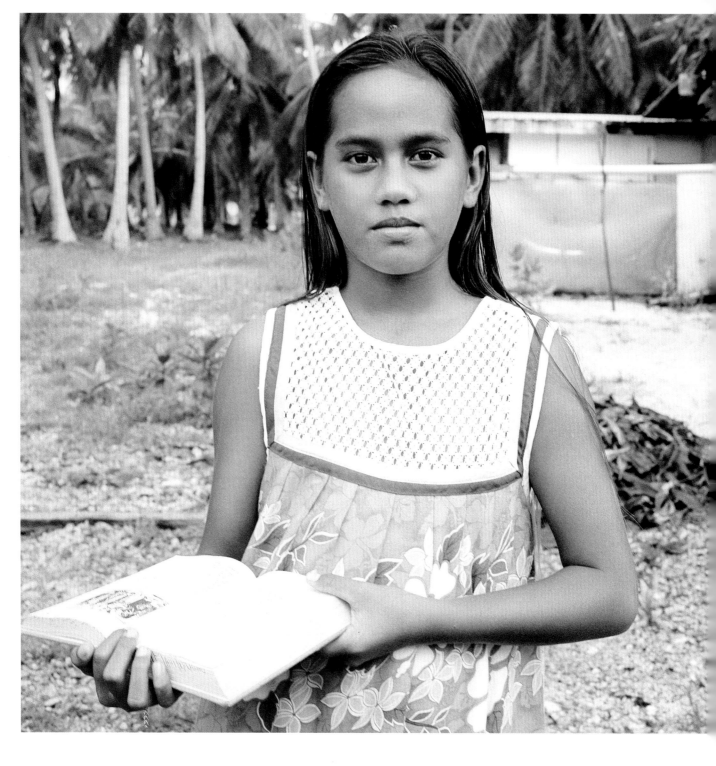

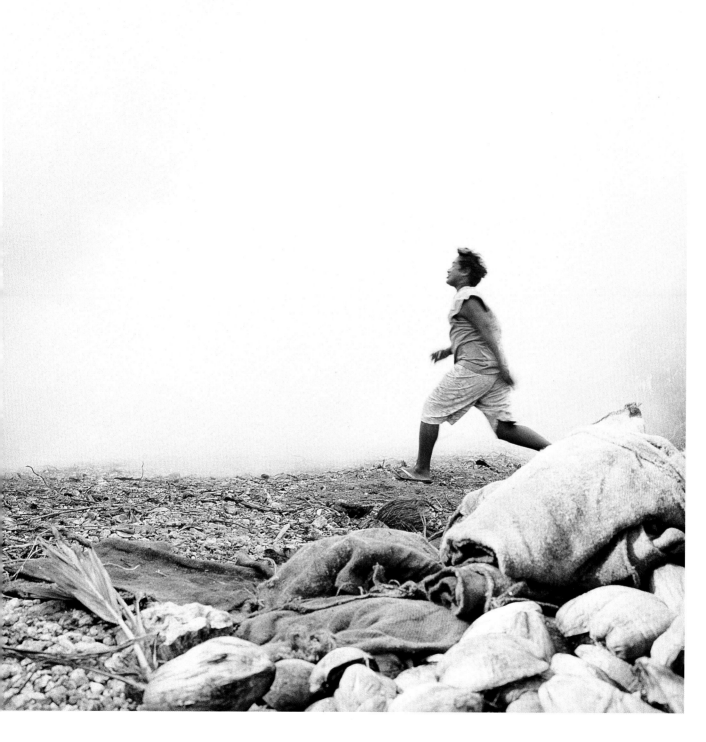

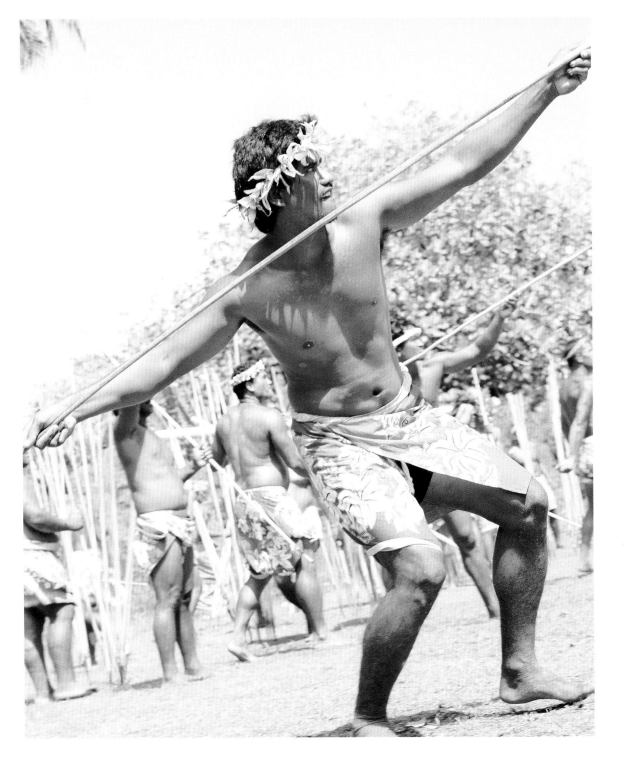

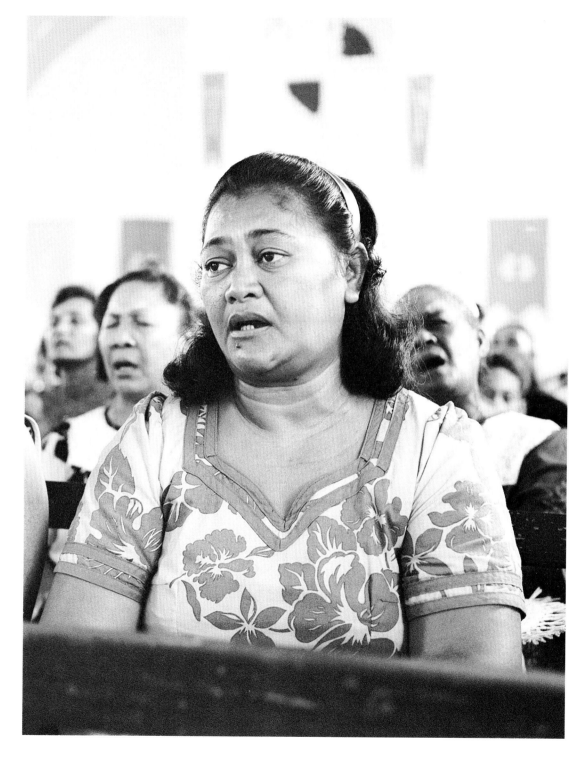

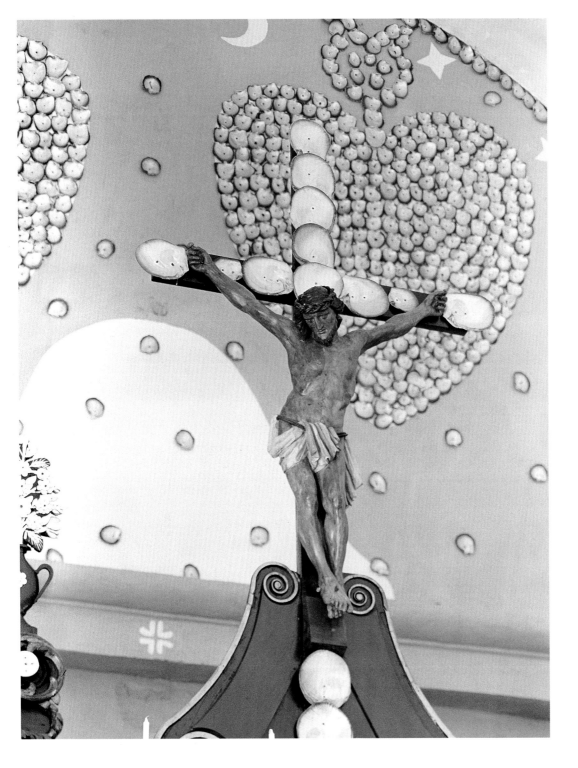

TANGATA: The photographs in this series were taken in the Tuamotu and Gambier Islands and are from Marie-Hélène Villierme's latest book, *Tangata: A Polynesian Community* (Éditions le Motu, 2005). The Tuamotu archipelago comprises over seventy-five islands and atolls arrayed across nearly a thousand miles of ocean; the Gambier archipelago comprises a small number of high islands surrounded by a single enormous reef. Except for Makatea, a coral island that has white cliffs three hundred feet high and has been heavily mined for phosphate, most of the Tuamotus are small and poised barely above sea level. The elemental forces of ocean waves, intense sunlight, and sudden typhoons are always present. Here, tightly knit communities share skills and resources to survive. On those special occasions when an entire community comes together—for example, to compete in games, to celebrate, or to worship—relationships among individuals and families are reinforced.

PAGE 52: Water games, Rangiroa, 2004.

PAGE 54: Young girl during an Easter procession, Tatakoto, 2004.

PAGE 55: Games in the smoke of a limestone oven, Napuka, 2004.

PAGE 56: Javelin thrower, Fakarava, 2003.

PAGE 57: Praises, Anaa, 2003.

PAGE 58: St. Michael's Cathedral, Rikitea, 1999.

PAGE 59: Calvary, Tatakoto, 2004.

OPPOSITE: Preparation of a limestone oven, Napuka, 2004.

PAGE 62: Preparation of a limestone oven, Napuka, 2004.

PAGE 63: Games in the smoke of a limestone oven, Napuka, 2004.

PAGE 64: Champion javelin thrower, Fakarava, 2003.

PAGE 65: Old lady of Makemo, Fakarava, 2003.

PAGE 66: Three old ladies on the square of the cathedral, Rikitea, 1999.

PAGE 67: Gathering day of *pahua* (clams), Tatakoto, 2004.

PAGE 68: Sailors on a schooner, Toau, 2005.

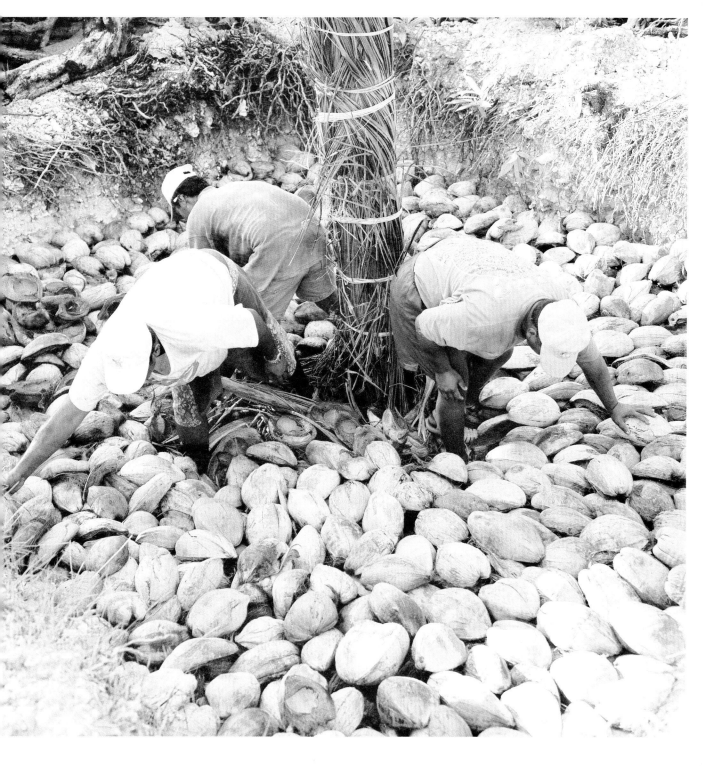

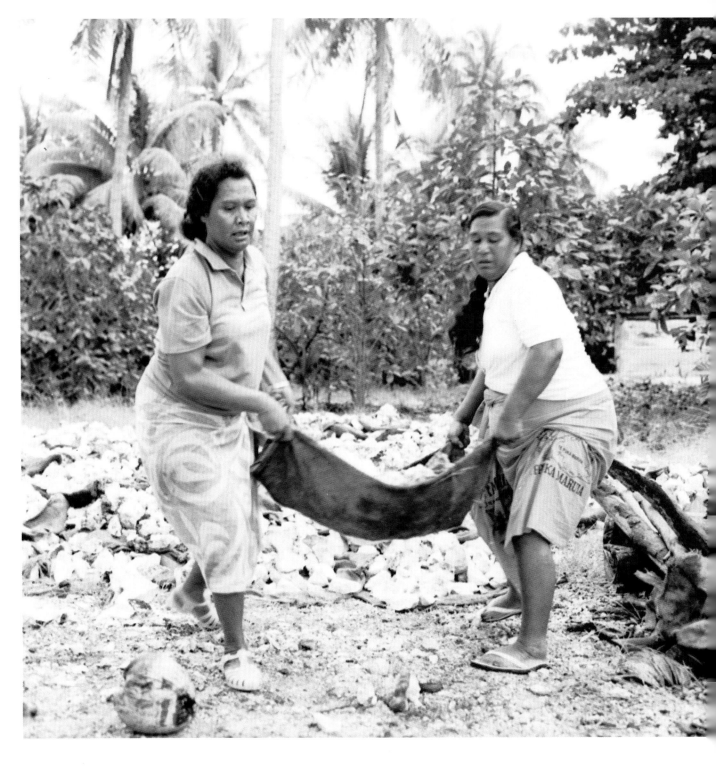

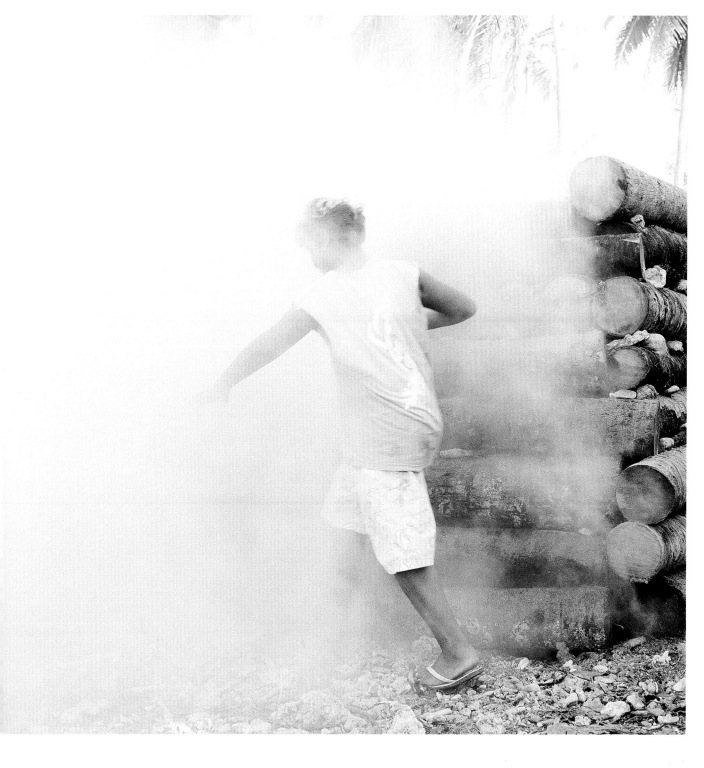

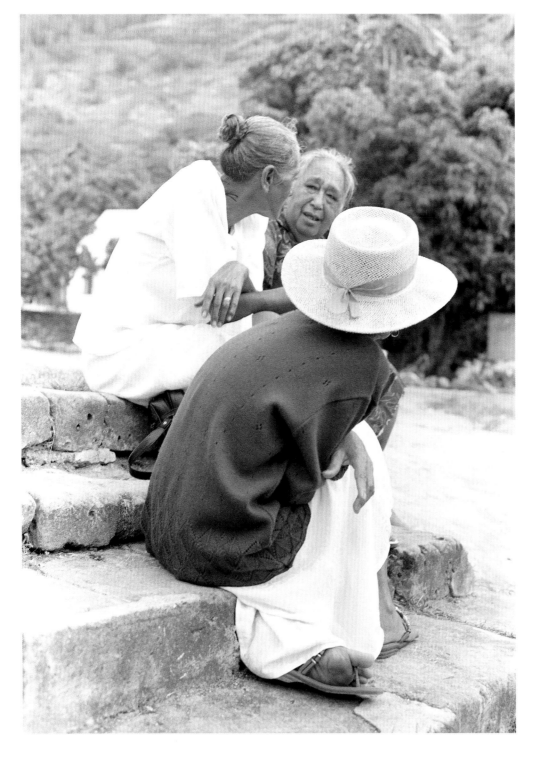

Tangata is a Polynesian word used throughout the Pacific with variations in pronunciation and meaning, defined generally as "a human being, person, or individual." The equivalent in Tahitian, for example, is written *ta'ata*; in Hawaiian, *kanaka*; in Samoan and Tongan, *tagata*. In some of these languages, however, there is a clash of multiple intentions, since the word can also refer to the community of humankind as a whole—just as in English, *man* can also mean "mankind"—and/or to the ethnicity of a distinctive island group.

The relationship of the individual to community has been of particular interest to photographer Marie-Hélène Villierme. Her first large-format book, *Visages de Polynésie/Faces of Polynesia* (1996), is comprised primarily of portraits of individuals. Her new challenge, called "Rites and Communities," is a vast audio-visual project documenting the sense of community fundamental to Polynesia. In a recent interview, she noted that soon after beginning the project, she became aware of how difficult the undertaking would be. Even after narrowing the project to the peoples of French Polynesia, she was faced with an astonishing diversity of social, religious, linguistic, and other cultural differences. Further, she realized that many communities in the far flung islands did not know one another and seldom met and interacted, and therefore the very notion of Polynesian community was multifarious. Moreover, there were people who told her that "traditional" community simply no longer existed in the Islands because of the introduction of modern technologies, such as television, which had undermined communal practices and values.

Undeterred, Villierme embarked on the project. The first of the volumes in the series, *Tangata: A Polynesian Community*, contains photographs of the communities on the sparsely populated Tuamotu and Gambier Islands. Many of these islands are home to fewer than 500 people. For example, Napuka, where she documented the communal restoration of a limestone oven, is home to fewer than 300. The importance of the book, she said, may be its affirmation that practices of a communal life still exist in the Islands and that these practices remain important and should not be forgotten.

RAI A MAI THE SOURCE

an interview with Henri Hiro

The following interview, conducted by Rai a Mai (Michou Chaze) for Nouvelles de Tahiti *(News of Tahiti), was published on 12 March 1990, one day after the death of Henri Hiro. Later that year, it was republished by Tupuna Productions in a memorial volume of Hiro's poetry,* Pehepehe i ta'u nūna'a / Message poétique.

Rai a Mai You've expressed your ideas in a variety of ways: through politics, through the evangelical church, as head of the Maison des Jeunes et de la Culture [Youth Club and Arts Center], by wearing a *pāreu,* and most certainly through your poetry.

Henri Hiro That's the way it turned out, but I didn't plan it that way. Everything's been a result of the fact that I've always loved the Tahitian language; after all, it's my mother tongue. When I wrote the poem *'Oihanu e* [God of Culture], it was because writing the poem was the most direct way to express what I was feeling. The poem just came to me as it is—all at once.

'Oihanu e is about creating a continuity between our traditional civilization and the way we live today. I would like today's culture to look back to its roots, to its source, which is Polynesian culture. From this encounter between the past and the present, something new will be born.

The poem *Aitau* [Devour Ravaged Time] is a companion to *'Oihanu e.* It too expresses, to some extent, the desire to return to the source of our culture, no matter what it takes, to create a new way of being: a renaissance for a new humanity.

I want to add that the races here now—and this is a very important point—can be part of this renewal, based on a Polynesian foundation, which will evolve naturally in its own way. For me, the foundation for this evolution must be the Polynesian culture. So what I'm saying is that you who are French, you who are Chinese, and you who are Tahitian—each one of us must possess the same respect for this Polynesian cultural foundation. All of us must look to these beginnings as the source from which to build a new society. Everyone having mutual and equal respect, everyone wanting to preserve the integrity of the culture—that's the starting point.

The moment we allow ourselves to disparage this principle, it will be impossible to succeed.

RM You are the forerunner of the cultural renewal movement. Do you think that it has borne any fruit?

HH One thing is certain: Polynesian people are standing up and looking around at what's happening to them.

RM And what do they see?

HH The disappearance of what is distinctly Polynesian—and this has frightened them. They are terrified because they see that the path we are on will only bring more and more loss. That's why they recognize that their only chance to prevent such a future is to return to their roots, and renew their cultural foundation. Today, I think that Polynesians are looking at themselves and asking, "What's happening to us? We are in the process of being completely annihilated!"

RM What do you think is going to happen? What's the next step?

HH For this renewal to continue, Polynesians must write. However, that's actually the second step. They've already taken the first step by building and living in Poly-nesian-style homes. Having done this, they now must write and express themselves. It doesn't matter what language they use, whether it's *reo māʻohi,* French, or English. The important thing is that they write, that they *do it!* And I think that in a short while we will have Tahitian authors—authors free of insecurities and able to express who we are!

RM It is surprising that so many people are choosing poetry as their preferred form of expression. Look at you, for instance, as well as Turo a Raapoto, Chantal Raiheni, Charles Manutahi, and Angelo Neuffer. They've all chosen poetry. Why?

HH I think that it's because the Tahitian language itself is so poetic. As soon as you begin to express yourself in this language, you enter a dimension that is not ordinary, that is not the dimension of everyday language. It is above you, and as you use the language, you are lifted little by little until you find in your expression a poetry that is the dwelling place of all Polynesians. From the moment we begin to rediscover ourselves—as we speak, think, and live this language—it is, to put it simply, poetry. Does this happen only with us? I don't know.

Even when you are writing in French and a few Tahitian words creep in, these words can't help but add poetry to the text. How it happens isn't important. What's important is that Polynesians are using their language. And that they are embracing their language through the written word.

The churches taught our children to write, but then only allowed the children to express themselves orally. As a result, writing disappeared. It was important for writing to be passed on from one generation to the next. The evangelical church and others accomplished the work of making Tahitian a written language—and what difficult work it was! Now, they have passed the baton on to us.

RM The future through writing! And this will be the future of our country?

HH I don't dare make prophecies. Politics has become so blurry; money-making has begun to corrupt the moral fiber of our society . . . I prefer to remain on the sidelines, where I don't predict anything anymore.

RM You were brought up in a religious school, then you studied in France. When you returned home, you told me, you had doubts about your faith. Have you changed since then?

HH Oh, yes, I've changed! It wasn't that I no longer believed in God. I simply wanted to put everything aside in order to devote myself completely to my family— the children and their mother, that's all. I was fed up—and am still fed up—with politics and the government. That part of my life is over, and in that way I've changed! I believe in God and am now a full member of the evangelical church.

RM The Christian religion is not a *mā'ohi* religion, but hasn't it somehow become "indigenous"? Today, it's an integral part of our culture. When it first arrived, it crushed our culture, but at the same time, it helped it to preserve and perpetuate our language.

HH That's just the problem: we don't know what "indigenous" means in regard to religion. And that's exactly the deeper question that Turo and I are exploring. He goes as far as saying, *Ta'aroa is God!* A little hard to accept, isn't it? But what other name can Polynesians give God if not Ta'aroa? And you can imagine the implications of making the two identical—how the past would have to be reinterpreted . . . It's my impression that something very important occurred between 1779 and 1900 that caused the extinction of the tenets of Polynesian culture. And if we knew what it was, it would explain the rapid evangelization of our country.

Why then not go back to God, to Jehovah, as a step in reexamining our Polynesian culture? We know that so many things correspond in biblical and Polynesian

roots, like the story of Creation or the Flood. Let's not rob God of His creativity! Why not embrace the name Ta'aroa and retrace the biblical narrative in that light?

RM Doesn't it seem that even before the arrival of the Europeans, a revolt occurred at the heart of Polynesian religion?

HH Belief had declined. 'Oro had imposed himself as the new god, after the fashion of Ta'aroa. Ta'aroa and 'Oro were in opposition, which explains why human sacrifices came about. Ta'aroa is much more compassionate than 'Oro; with 'Oro, you have war.

RM The creator god and the angel Lucifer.

HH Yes, with 'Oro there really was war! And at that moment, evangelization arrived, and it wasn't easy for the missionaries: they were all by themselves.

RM Let's return to where we began our conversation: your determination to uncover the foundation for a Polynesian renaissance. The theme of your poem "Aitau" is the need to "devour ravaged time."

HH I wrote that poem in one fell swoop. The "ravaged era of the past" is what keeps us separated from our deeper past and our present Polynesian culture. It's what we must devour, digest, and overcome in order to reconnect again. We must be able to eat up this epoch in order to be able to create a new society united with our true beginnings. That's what's important. There are many ways to understand and overcome this ravaged epoch; it's up to each one of us to find his own way.

RM You're back home after a long and fascinating journey, which is so typical of you. In the past, you agitated for a political battle by creating Ia Mana te Nuna'a [Power to the People] at the same time you wanted to work through institutions like the evangelical church.

HH Let's say that in the beginning I had a thirst to know God. This was the real starting point for my quest to find knowledge. I attended the theological school of Montpellier in France.

When you go far away, you see in a new light the things that have been closest to you. Isn't that so? For me, it was my culture, my country, my people, my own situa-

tion, the activities of the church and its contribution. In short, the big questions. It was my time of soul searching, a very propitious time, since we were emerging from May 1968 [the period of student rioting in Paris].

So, I returned to the church with disturbing questions weighing on my mind. And the first collision between the church and myself was, of course, my protests against nuclear testing [the French exploded nuclear devices in French Polynesia from 1966 to 1996]. The church immediately forced me to leave by giving me an ultimatum.

So I found myself at the Maison de la Culture, an organization connected to both the state and the territory. That's when we created the political party called Ia Mana te Nuna'a. In the beginning, it was a socialist party in that it promoted social justice and the evolution of political institutions. At that time, the idea of creating an independence movement had not come up.

We worked a lot at the Maison de la Culture to rehabilitate Polynesian culture, to give it its proper importance, emphasizing language, dance, chants, and theatrical expression. After that, nothing went right for me. I quit and returned to Huahine.

That period was a step toward preparing me for something else. This "something else" was the renewed valuing of the totality of Polynesian life—a model for living that has a wholeness and is not just a patchwork of disconnected fragments.

A life that is Polynesian in its totality includes everything: home, nutrition, clothes, economy, conduct, chants, dances, music. The whole thing. We are talking about the revival of a way of life that was abandoned but has always remained in the Polynesian consciousness. It was nearly suffocated, but it can be revived.

Here are some of the traditional values of Polynesian culture manifested in the home, the economy, and the culture. First, the home: it should be simple and always open. There's a lot to say about this. When something is abandoned, it's because there were prejudices against it: a devaluation. Polynesians devalued their traditional open living spaces in favor of houses enclosed by walls, in which one suffocates, where there is no air. I must say this. Things have become so polarized. People think there are only two values: "forward progress" and "backwardness." Everything that is "backwardness" is Polynesian, and everything that's "forward progress" is European; "forward" is good, and "backward" is a descent into the dark ages. This is a trap that causes us to reject everything that is really our own. At the current moment, we are on a path that will lead to our abandoning everything we have.

Following this path means going toward what is European, toward being Western-ized, toward everything that is theirs.

RM And the schism gets wider the further you go. Two worlds living more and more in opposition to each other, until eventually there is a complete rupture.

HH But I refuse to think in opposites; even opposite colors are called "comple-mentary" and produce harmony. These two cultures must come together.

I think that now we can no longer speak of independence in terms of breaking away, but as sovereignty over decision making, according to the identity and uniqueness of individuals.

RM It's also your desire to create a Polynesian economic system.

HH Absolutely! The basics are here. It's not a dream. I'm not making this up. Coconut trees produce for seventy years. We still eat 'uru from trees planted by our ancestors. The fish are here. We can have a self-sufficient economy.

RM A Polynesian restoration.

HH That's it. They razed the coconut groves to make way for housing develop-ments. But self-sufficiency is possible given the bounty of nature. And following upon self-sufficiency, there are also prospects for exports . . .

RM This economic plan is quite different from the economy others propose: one based on tourism, luxury resorts!

HH We have the impression that that is our destiny: to become the servants of tourists. That's our image of the future.

RM In your economic plan, you give Polynesians their dignity and grant their capacity to be masters of their environment and economy. Those are the conditions of independence.

HH As soon as this plan is put into place, complete and not piecemeal, you can't avoid talking about independence. If, from the beginning, these fundamental ele-ments of independence are adopted by each family unit, you can't but hope that all the people will adopt this thinking.

RM And what about the present economy?

HH It's an economy of money that chases money. As everyone knows, it's a false economy. Everything is false to the extent that there are financial forces encouraging a level of consumption greater than the bounty of the country itself. This imported largess is founded essentially on the policies of the government administration and on the CEP [Centre d'Expérimentation du Pacifique, the French nuclear-testing program in the Pacific].

First of all, the phosphate mining in Makatea has begun to erode social values, draining the life forces of the island, and once the ore is exhausted, the island will experience a painful decline.

Second, the filming of *Mutiny on the Bounty* brought with it a wave of easy money, which in the long run has had a negative effect.

Third, General de Gaulle arrived in 1960 and made a speech announcing to us his "personal determination" to open Polynesia to "civilization." He said that this opening couldn't be accomplished without building an airport. I don't think that he mentioned, however, that after the airport would come the CEP; later we learned that Fangataufa and Mururoa had been handed over to France for nuclear-testing installations. After that came the military, more easy money, massive immigration, and so forth.

Nuclear testing contaminated everything. We found that out without help from the media: for example, we saw the *nanue* fish dead around the island of Rurutu. Our extended family was totally shattered. The concept of *fēti'i*—finished. The education of our children, according to Polynesian discipline, disrupted. Our life was in turmoil!

RM Regarding the move toward independence, one can speak about how the attitude of the church has evolved. The church has done phenomenal work, and its commitments are evident now.

HH The future of our church is Polynesian. To go against independence is to go against the Gospel.

RM The evolution of the church's position and its current commitments seem to be the result of your work—along with that of Turo a Raapoto—to gain new respect

for the Tahitian language. This work has now been taken up by others and is causing a reevaluation of Polynesian history.

HH It is a phenomenal evolution in attitude—and a permanent one. In the end, it was a good thing that I left the church. I entered OTAC [l'Office Territorial d'Action Culturelle, formerly Maison des Jeunes et de la Culture] and continued to say the same things. And the church finally understood.

RM You adopted symbolic gestures at this time.

HH A symbolic gesture expresses a break, a shock, and it's understood as a provocation. Thus, it was necessary to choose significant gestures: the wearing of a *pāreu*, for example. That's a story in itself! *[Laughter]* I was a joke! . . . Everyone's joke! . . . The poet! The dreamer! The intellectual! The bumpkin! *[Laughter]* Because of the *pāreu*, I lived through a period of ridicule. Some people confronted me directly, but since I wore it on all occasions and everywhere, it shocked people and then became ordinary. And then, more and more people started to wear it. The *pāreu* reconciled Polynesians with what was always profoundly a part of them. It reconciled them with themselves.

RM Now we are entering a period of reconciliation. You occupy a position of extraordinary status because you defy being labeled—for instance, in terms of politics or institutions.

HH There's something about politics that bothers me: the partisanship. No one wants to listen, to lend an ear, to stretch out a hand, to speak to anyone who is in the other party. I will never accept being put in a position that prevents me from talking to whomever I choose.

RM We spoke about your poems *'Oihanu e* and *Aitau* and their messages.
I think that we could end with a message that is no less beautiful: that of *Hō Mai Na* [The Gift].

HH *Hō mai na* means giving everything, the way a mother gives everything she possesses to her son. The mother gives, and when she has given everything possible, the son can go on from there. He will always have his mother near him; his mother

connects him to the source of everything: his roots, his blood, his ancestral lineage . . . The child is made whole because of these connections and can proceed. The mother is the symbol of the direct link, the parental link; the land is the mother. That genealogical linkage is the umbilical cord, the *pū fenua,* the placenta.

Au Revoir, Henri

Henri Hiro has become an institution. Polynesians recognize the Māʻohi in him. He won the battle. But the story of Henri Hiro did not end in Huahine. His story has not ended! His ideas and projects changed things for the Polynesian people. The first beneficiaries are his family, his wife, and his children.

"If I succeed in making my wife and my children happy, I am certain that I could make my people happy—the Māʻohi," he once said.

Good-bye, Henri Hiro. It seems that we must say good-bye to you. But you remain with us. Your voice and your laughter will always resonate in the valley of Arei in Huahine, and echo from mountain to mountain. And in the same way that the low winds at the base of the valley rise, your voice will spread over the whole of Māʻohi Polynesia.

Translation from French by Jean Toyama

THREE POEMS

HENRI HIRO

AITAU

Ia ù i tīfenefene noa
I te muriavai o te tau ra,
E te aroaro pinaìnaì ta ù i hāroà
Nā roto mai i te peho horo tārere,
Mai te aroaro ânāvai ra
Ia fā aè te fetià Taùrua.
Fāriu atu nei taù aro,
Faaata iho ra Òrohenā
Hahape atu ra taù tarià
I te faarooraa e :
Aitau ! E àitau ! A àitau !
Paù iho ra, paù aè ra,
Paùû haere noa atu ra taù tāura
I te uiui a te mau uì e :
Aitau no te aha
Aitau i te aha

Paìuma atu nei au
I te àuru o te tau,
Mama iho ra nā âpoo mataì e hā,
Hitià, Tooà-o-te-rā,
Apatoà, Apatoèrau,
Hahape atu ra taù tarià
I te faarooraa e :
Aitau ! E àitau ! A àitau !
Ôtuì iho ra, ôtuì aè ra,
Ôtuìtuì-haere-noa atu ra taù
 tāura
I te uiui a te mau uì e :
Aitau no te aha
Aitau i te aha
Nāue atu nei au
I roto i te ana tau
Toro maa iho ra te aa o e tumu,

DEVOUR RAVAGED TIME

Coiled in upon myself
I'm seated at an opening in Time.
I hear an echo rebounding from a deep valley
like the murmur of a river
when the morning star rises.
I turn and the living shadow of Mount 'Orohena appears.
With the spirit-mind clear and my ears unstopped
I receive this message:
Eat time
It is up to you to take it into yourself
You must devour the long, wasted past.
And my Spirit here, there, in all places at once
is shattered by the incomprehension of coming generations:
Devour time . . . For what?
What good is it to devour time?

I climb to the summit of the ages.
The caves of the four winds open
East-West
South-North
With the spirit-mind clear and my ears unstopped
I receive this message:
Eat time
You yourself must ingest the long passage of ravaged time.
And my Spirit here, there, in all places at once
is shaken to the core by the questioning of coming generations:
Devour time . . . For what?
What good is it to devour time?

I plunge into time's flowing current
Its trunk divides into two parts
One rises towards the temple of the sky,
the other burrows into my native soul.

Hiro

With the spirit-mind clear and my ears unstopped
I receive this message:
Eat time
It's up to you to devour it
You must consume the long period of ravaged time.
And my Spirit abiding here, there, in all places at once
contemplates the questions of coming generations:
Devour time . . . For what?
What good is it to eat time?

My Spirit rediscovers the fundamental reality of the ancestors.
They've stopped speaking the words that were to inspire,
the instructions to be memorized:
Be fruitful!
Be fruitful, be fruitful!
You, the new generation!
You must bring forth yet another generation!
But it must be a generation born
from the deep essence of Polynesia.

My Spirit cries out to the innumerable gods
in the infinite sky
but they are no longer present at our ceremonies.
They have withdrawn
forsaken by generation after generation:
Be fruitful!
Be fruitful, be fruitful!
You, the new generation!
You must bring forth yet another generation!
But it must be a generation born
from the profound essence of Polynesia.

Coiled in upon myself
I'm seated at an opening in Time.
And I murmur to myself:

Toro maa i Taputapuātea ra e,
Toro maa i Taputapuātea pū
 fenua,
Hahape atu ra taù tarià
I te faarooraa e :
Aitau ! E àitau ! A àitau !
Taraire iho ra, taraire aè ra,
Taraire haere noa atu ra taù tāura
I te ui a te mau uì e :
Aitau no e aha
Aitau i te aha

Heheu aè ra taù tāura
I te mau papa tupuna ra.
Aore rā a rātou parau
Tei faaurua i te mau tutuu ra.
E tō, e tō, e tō, e te uì hou e,
Ia tō ā òe i te uì hou,
Ei uì hou no te iho tumu māòhi rā

Tāpapa atu nei taù tāura
I te raì tua tini o te mau atua ra,
Aore rā rātou i te mau ôroà ra,
Ua hihipo anaè i te tāiva a te
 hinarere.
E tō, e tō, e tō e te uì hou e,
Ia tō ā òe i te uì hou,
Ei uì hou no te iho tumu māòhi rā

Ia ù i tīfenefene noa
I te muriavai o te tau ra,
Tahutu noa atu nei au ia ù iho.
Ua rau te tau
To ù tiaìraa i to ù fenua,
Ua mātaetae te hinaaro

O te hinarere i te iho tumu.
Ua rau te tau
To ù pārahiraa i te hiti o to ù nei
 fenua,
Ua horo pūpara noa te manaò
O te hinarere i te ātea ê.
Ua rau te tau
To ù hopararaa i to ù nei fenua,
Ua tīravarava noa te tiàturiraa
O te hinarere i nià i te peu vavi.
Ua rau te tau
To ù tiàvaruraa
I te manava i papa i to ù nei fenua,
Ua òere haere noa
Te hinarere i to ù nei fenua.
Aitau rā, àitau rā, àitau rā i to ù
 nei fenua!

For too long
I've distanced myself from my homeland,
and the need for deeply rooted identity
has disappeared from among the recent generations.

It's been far too long since I sat
at my homeland's side.
The previous generation carelessly tossed
their ways of thinking into the deserts of elsewhere.
For far too long
I've forsaken my country.
The conviction of the new generation
feeds itself on vanity.
It's been far too long since
I reached down into myself
to find the roots of my people,
just as the new generation
wanders about, lost in its own homeland.
Devour the time, devour the lost time.
Consume the ravaged waste
so that the deep past can unite with the future.

Translation from French by Jean Toyama and Frank Stewart

SORROW

O love! Love!
When the sorrow comes, it pierces me to the core.
Love cuts deep like a sharpened spear.
Where can we place our trust?
To whom can we call out for help?
Today, love has been sullied by money.
Love was Creation's way to bring humanity together
but today, love's home is empty, a place where only sorrow dwells.
Can I ever resign myself to live without true nourishment?
I will continue on the road I've taken
I will continue to proclaim to everyone
that love is our past, the present, and forever.

Translation from French by Frank Stewart

MIHI

Te here nei e
Te here nei e
E puta hoto ra ia àati.
E òoi mai te òfe.
E mōtuu mai te teàai.
E tiàturi atu rā i hea
E taù atu rā ia vai
Te here ua tāraufau,
Ua tāraufau i te rau àuro.
I te nohoraa o te aroha
I hono i te iho taata,
Te mihi ua faatumu.
O ta ù aè ia ìnaì?
O ta ù aè ia ahi māa?
E horo ā vau i ta ù nei horo,
E poro ā vau i ta ù nei poro,
Te here tei te matamehaì,
Te here tei te tumu,
Te here tei te faahopeà.

UNTITLED

Immaculate and inseparable adorning, my *pāreu*,
Soft, maternal, and protective warmth of my dreams,
Haven of peace, soft restful breeze for my body,
Dwelling, root of my appearance,
Basaltic foundation of my being,
Poet, continually soothing my soul,
House, mother of my sustaining land,
The inherent limits of my country are at your breast,
Through you, I am Māori,
What I am, I owe you,
Witness of times past and to come.
O Māori house!
There, the Polynesian men rediscover in you
Such warmth . . .

Without speaking, already you are an orator,
Without singing, already you are a *tārava,*
Without dressing, you are the *pāreu* made fast,
Without thinking of eating, you are the *ahimā'a,*
Without tasting, you furnish sustenance,
With nothing . . . already you are . . . already me.
From far away already,
Eloquent, your voice reaches me
"Do come home!"
Through you, I am Māori,
What I am, I owe you.
Witness of times past and to come.
O Māori house!
There, the Polynesian men rediscover in you
Such warmth . . .

Multiple houses,
For sleeping, for eating
For cooking and receiving

Houses with their appropriate aspects:
Pōteʻe, haupape,
Hauparu, taupeʻe.
Wood from the land,
Roofs from the land
Walls,
And floors,
All for sleeping,
All for eating
Witness of times past and to come.

On your *pēʻue* friend,
Your sleep is rest,
The fly can brush against you,
And the spider weave his veil under your nose,
O Māori house!
There, the Polynesian men rediscover in you
Such warmth . . .

Also Māori, we return to the house,
Which alone can preserve our secular heritage;
Being warmly tender can lavish Māori love on us,
Being the master, it is our pride,
Being free, our dignity,
Let's face up to it,
One is for the other,
One towards the other,
Thus will we have retied the cord of ancestral *mana*.
No more shame,
No longer the bowed head,
The outstretched hand,
All for sleeping,
For eating
We continue.

Translator unknown

THREE POEMS

PATRICK ARAIA AMARU

TE HIRO'A E TE IHO TUMU

Ia fati te are no te moeroa
I te teahatai no te orara'a
Ia tuma te mata'i no te mo'e
I te teoteo e te ite
Ia topa te mau unàunà pa'a
Ia vai tahaà no te tino
Ia vai tahaà te varua
E aha pài te mea toe mai?
E aha pài te mea toe mai?

Te hiroà e te iho tumu ia
Tei hono ti'a ia tatou
Te hiro'a e te iho tumu
No roto mai i te pu fenua
Te pu fenua no te aià,
To tatou nei metua vahine

Ia fati te are
Ia farara te mata'i
A moe na te hiro'a,
A moe na te iho tumu!

CULTURE AND IDENTITY

When the waves of the long sleep
break on the shores of life,
when the wind of oblivion erases
pride and knowledge,
when appearances vanish,
once the body is naked,
once the spirit is bare,
then, what is left?
Tell me, what is left?

The culture and the original identity
which bind us together,
the culture and original identity
coming from the afterbirth,
the afterbirth of our country,
our mother

When the waves crash and break,
when the wind comes racing down.
think about your culture,
think about your identity.

Amaru

THE HOLY RITUAL

Now is the moment when the corpses ascend.
The spirits of the dead depart for a new temple.
Heaven is crying tears of sadness
for these begging souls
who scream their distress
before the wandering moon.

Here carelessness dies for suffering to spread
and on the altar of agony,
love and compassion are growing weary.
Cynicism must be vanquished to soothe the anger
of this god as jealous as all exclusive gods are.

May this magic ritual open a way for their despair.
May the one who holds the power
offer them a shelter.
May the tormented spirits
finally find the deserved peace.

TE RAHU

Ua tau te tau i mahu ai te mau tino
I imi ai te mau varua I te taura'a
 hau
Roimata aroha no te ra'i
I teie mau varua mihi
tei 'oto heva nei
I te marama 'ite ra

I ô nei e mahea ai te nevaneva
Ia tu mahorahora te mauiui
E i te fata o tei mainaina
Te manunu nei te here aroha
A mo'e te tahitohito
No te tamaru i te horiri o teie
 atua fe'i'i
mai te mau atua otahi ato'a

Ia vetea te rahu o teie mau peu
I te e'a no to ratou hepohepo
E o tei fatu mana ra
A ho atu ia te ahi o te pare
Ia 'ite te painu varua mamae
I te ava ti'a hau

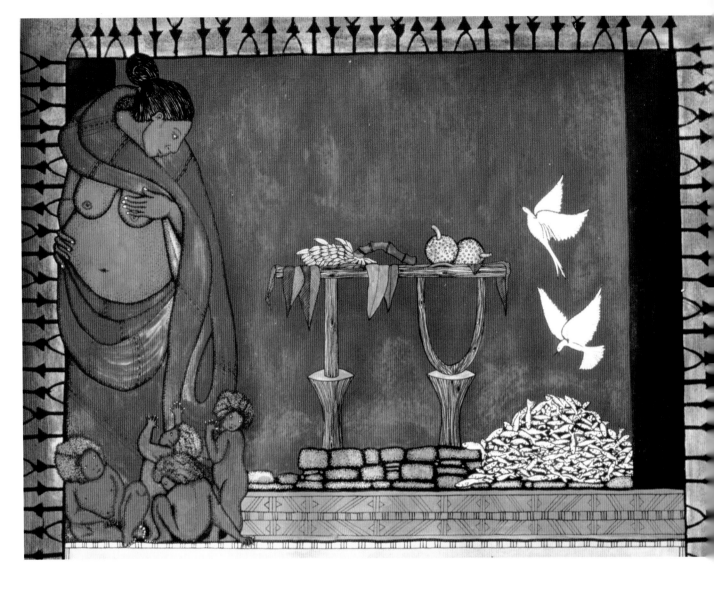

Offerings on an Altar
BOBBY HOLCOMB

THE AWAKENING OF THE COUNTRY

Waves of forgotten words
are yelling to the rocks
of my ignorance.
The voice of the god TANE
echoes
to the third heaven
of my conscience.
How delicious is the shiver of my country!
The sacred cord of knowledge appears
above the darkness
of my eyes.
The shadow of ROO ATUA
takes flight
towards the Banian tree
of my MARAE
How delicious is the shiver of my country!
The sun went down.
The sorrow raged.
I fell on my knees
and the night started to cry.

A VIVO rang in my ears.
A smiling face appeared to me.
It is the celebration,
the ancestors' celebration.

HEIVA

Te vahatete nai te are
no te parau moe
I te toʻa tai
no toʻu po uri
Te tavevovevo nei te reo
O TANE atua
I te raʻi toru
No toʻu manava
Aue ia horiri navenave no toʻu âia!
Te hiti nei te maro tapu
No te vanaa
I niʻa i te mohimohi
O toʻu nei mata.
Te marere nei te ata
A ROO ATUA
I te tumu ora
No toʻu nei MARAE
Aue ia horiri navanave no toʻu âia
Topa atu ra te ra
Pato atu ra te oto
Topa turi atu ra vau: oto atura
 te pô

E taʻi VIVO tei toʻu taria
Mata ataata tei hiti iaʻu
E heiva teie
No te mau tupuna

Translations from Tahitian by
Anne-Marie Coéroli-Green

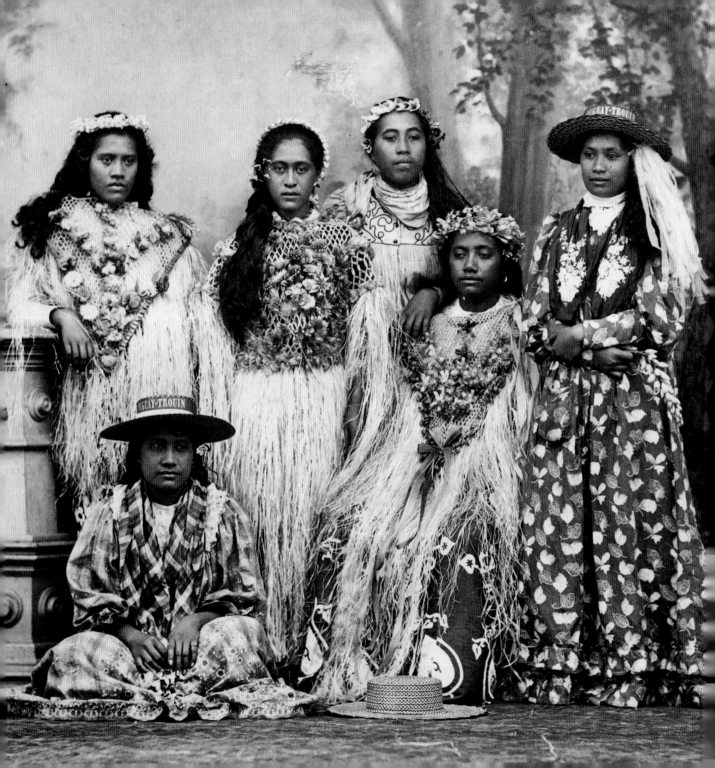

from

VAI:
RIVER
RAI A MAI## IN A
CLOUDLESS
SKY

Havai

Sitting on the woven mat, Havai looks out at the sea. Her eyes follow the waves that roll and shudder under the wind. Twilight has come, and close behind, the black shore of night is approaching, but Havai doesn't light the lamps.

The fading twilight feels good to her. It feels good with them all around her. They are all present, murmuring, whispering, and smiling at her. Outside, Ahurai, goddess of the wind, caresses the beaches with her breath. A fleeting taste of autumn is in the air. Golden *'autera'a* leaves have tumbled onto the grass.

As twilight darkens, a light dew arrives, nighttime aromas filter through the air, ride the breeze into the wide-open house: *pītate, moto'ī,* and *miri.* Beautiful, joyous perfumes; scents that are red and warm; aromas that grow exultant, more and more intoxicating as the night settles in.

Meanwhile, they are all there. They murmur and whisper.

Standing by the window is her grandfather, Tehapai. Her mother, Tuarua, is sitting in the rocking chair. Her husband, Tahiti, is beside her.

Havai loves the coolness of tropical winter, but tonight the cold seems more extreme. Shivering, she tightens the colorful *tīfaifai* around her.

It is time to go.

A cricket is singing in some corner of the house. His chirp is strong in the coming night.

The cat is purring, coiled up on the pillow beside her. Havai reaches out and caresses the softness. The dog is on the terrace behind the house. He gazes up at the mountain, at the first glittering stars of evening. His ears move in the wind. He sniffs the air. Suddenly, he jumps up and barks. His cry rips the night. But it is no more than a rat slinking through a gap in the brush.

Havai watches the night approach, slowly covering the world and dimming the gold of twilight until it finally reaches where she sits. She watches as the night enters her body: her bare feet, her thin legs, her hands swollen with veins, her white hair, her face, her eyes that feel the breath of night. Soon she is no longer a person, no longer anything at all. A shadow among shadows.

Django

The road curves, becomes a dirt lane, and at the end is a blue, colonial-style house. In this house, only the first floor is inhabited; the upper floor is haunted. Grand-

père and Grand-mère live with their granddaughter on this patch of wild property that extends to the mountain crest.

Grand-mère is the granddaughter of the last great chiefess Tefana i Ahurai, who was married to the first Protestant minister of the district. But not even she still lives on ancestral lands, which are very beautiful but infested with *piafau tupa,* land crabs from the suburbs.

And so we live here, with Grand-père, whom we call Django because he once played with Django Reinhardt in France. At sunrise, Django wakes me up with his guitar music. After bread with butter and coffee, we leave on horseback. We frolic through the dust of the mountain roads, say hello to Sen-Ya-Ut, the little moonbeam who gives me *chouchoutes chinois,* and then we cross the river seven times before arriving at the summit, from where we can see the island Eimeo.

Later we go back home, our bags filled with *corossols,* Chinese tamarinds, African apples, and *caramboles* that will fill Grand-mère's *'ūmete.* Grand-mère cooks on the huge wood stove. While she is busy, I go into forbidden places. The red carrot tree. I only want to taste them—only taste one. Suddenly, fire is in my mouth. *Water! Sugar! Bread! Anything to stop the burning!* The red carrots tasted like fire.

Another forbidden place I prefer is the cattail tree, which gives me asthma. To help me breathe normally again, hot poultices are placed on my chest.

Then Maman comes from Pape'ete on a bike to see us. She brings wax crayons that melt in the sun, and paints that we use to create rainbows on newspaper on rainy days. At night I sleep in Django and Grand-mère's room. While they are still up, I am a little afraid by myself. Between the lace curtains of the window, the night is blue, the coconut trees are blue, the grass is blue, everything is blue.

Sometimes in the evening, Grand-mère is all alone. She is at the window. She is watching the night, staring at the dirt road that disappears between the coconut trees before reaching the main road. Django isn't home. He has gone to drink champagne.

Champagne. Tahitians become Gypsies, and Tefana becomes Paris. And Grand-mère, forgotten, looks out from behind her lace curtains, fanning herself to relieve her asthma.

It is almost dawn. Django scratches his guitar as the first rays of sun touch my eyes, heavy with sleep.

Today is the day for washing the Jeep in the river. One turn of the crank on the front end, and it's off we go! Django wants me to sit on his shoulders while he

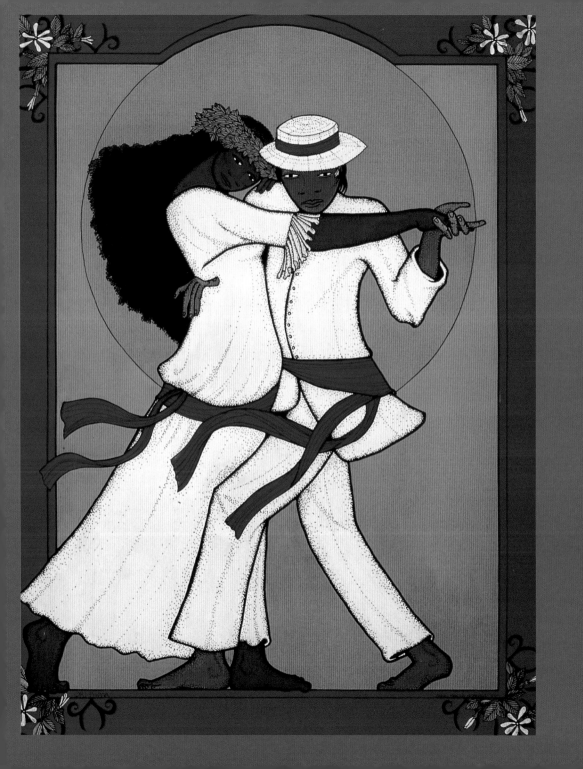

drives. I am terrified, especially because the mountain is so steep that, when we go downhill, I am almost touching the sky with my head. I am so scared that I press my eyes against Django's neck.

When we return, Grand-mère has prepared *corossol au vin.* I want to drink wine! Like everyone else! Grand-mère, daughter of Puni and Mai, raised by French nuns in the Couvent des Oiseaux, doesn't want to give me any. Django takes a glass, puts a little sugar in it, adds a little red wine and then some water . . . and *voilà!*

Then one night, there are some friends in the blue, colonial-style house. They drink champagne. They sing. Django plays, and his eyes are moist. His grand-daughter is staring at him. She wants to marry him when she gets older. She is happy when he dances with her.

The little girl gets up and walks outside in the night.

"Django! I hear footsteps! No, it's not horses. It's soldiers, lots of soldiers, marching."

Puni and Mai's daughter left in the blue night. The champagne carried Django into his delirium. The blue house was demolished. In its place, concrete walls, solid and eternal, were built. The soldiers of the Battaillon d'Infanterie de Marine of Fa'a'a marched into the yard.

China Blue

China. They called you China. You sang. And in the blue night, you left without understanding.

While creating the world, Rahotu made the first tree in order to immortalize his love for Mihia i te tai, goddess of the sea. The tree's flower opens at night, like a sun. In the fading sunrise, it falls and quickly disappears into the yellow humidity of the sand. And some people doubt that the flower exists at all.

Golden skin, like honey from the Marquesas, surrounded your *maman*'s slanted eyes.

You are born. You eat fish still wriggling, salty, and damp from seawater. And at night, dragon eyes and moon cakes.

Your *maman* works at the print shop. In the place that was the ancient palace of the queen, she is given a litre of milk every day for you, for your illness. *Why, Maman? What illness? Ink sickness . . . I don't know . . . They say it's not good for us to work over there. You have to drink milk.*

Vai: River in a Cloudless Sky

You don't like cow's milk. You prefer coconut milk with fish.

You live in the country, not far from the road that leads to the orange orchard. You bathe in the deep basins of the river that border the road. Next to you, your mother is washing clothes. At night, you catch the sleeping shrimp by surprise. You slide into the water without a ripple, without words, so as not to scare them. In the still water, you avoid making concentric circles with your legs. You thrust a *pāreu* under the shrimp. *Hop!* There they are, waking up in the bucket. But even more sport is had by hunting them in lamplight and catching them one by one with a small harpoon.

Climbing back up from the river, avoid *tūpāpa'u* places, where the spirits stay. Pretend you don't feel someone leaning over your shoulder. Plug up your ears and don't listen to the woman floating in the air who is crying, hiding her face from you. And avoid the cave of the two *tiki,* one made of coral, the other of stone. They live upstream, and people say that on some nights, the coral *tiki* goes back to the sea, bathes, and then slowly walks up the dirt road to return to the cave. You can see its wet footprints. If you hear groaning when you are near the cave, it means the stone *tiki* is alone. Calmly abandon your fishing and go back home. Don't run. Don't show your companion the hairs rising on your arms. Instead say, "I'm cold."

One day, a man as ferocious as the crazy King Tamatoa V comes to Tahiti. He says that we must build an airport. For one year, night and day, trucks haul rocks out of the river. They wake babies and their families. And the spirits run away.

The man with the big nose speaks of force and power, of defense, and of the bomb. He comes with other men from his country to see the bomb explode over the Pacific Islands at night. And the men, these chiefs of war, stare at the sky with their backs to the land, gazing at the beauty in the ecstasy of violence.

Hurry! China! Hurry! You must run to the river and rinse your eyes. *Water! Water!* But the fire is everywhere. Whatever is timber is sparks and flames. The landscape is red with the greatest fire since the big bang, since the origin of the verb *to be.*

At school, the rain blows across the yard in gusts. It lifts up white veils and dampens skirts. *E ua huru'ē roa, parau a'era 'o pāpā, e tūpita 'i'a tei pa'a'ina a'enei. It's a really strange rain,* said Father. *Another bomb has been set off.*

"China! Do not speak Tahitian! You will write one hundred times 'I will not speak Tahitian.'"

Yesterday, the Chinese store had beautiful silk kites made with rose and yellow paper glued on fine bamboo stems. So light, they would rise very high as soon as

you let them go. You just had to release a little bit of the string at a time, then tug it towards you, release again . . . and *voilà!* The kite is already high above the coconut trees, and with another tug on the string, it is rubbing the watercolor clouds that move so quickly. It races with the clouds in their crazy flight against the deep blue. Sit down on the sand and watch it soar until it is but a tiny point and is gone. A child somewhere will find it clutching a tree. Will it be intact? More likely the branches will have broken and torn it. If the tears are neat and clean, the child will try to glue it back together carefully. Otherwise, the child will simply throw it away.

Making it dance, Kitty reels the kite in. Sitting beside him on the sand, you build little round houses with only one door, like igloos. And between the coral trees, you dig a trench that goes all the way to the sea.

Bye, beach! Bye to the kite-flying party! Go down the beach, to the mouth of the river! Find Kitty!

Kitty with lagoon-blue eyes. He is watching you. You are so pretty, so fragile. It's as if, in the night, your girlish round cheeks have become like a woman's. When he talks to you, you don't reply. Your embarrassment is palpable, untranslatable. You don't understand. Is this what it means to become a woman?

You feel a deep fatigue. You're not able to go to junior high school anymore. Maman helps you lie down beside the water. In the shade of the ironwood tree and its Christmas perfume, Kitty tells you about the partying, surfing, mountain hiking, and fishing you'll do with him once you feel better.

The doctor wants to put you in the hospital. Kitty holds your hand, golden against the colonial bedroom of lace and white cotton. "Look at my hands. They are so thin that I can only see veins. The nurse told me I have leukemia. Do you know what this illness is? They say there's no cure. Do you know, do you?"

Kitty doesn't know how to answer. He's not sure. He is afraid to be wrong. He takes you in his arms and passes a hand through your long, black hair and puts his lips on your forehead, your eyelids, your cheeks, your lips . . .

China falls asleep.

Kitty gently positions the white pillow beneath her head. Outside in the blue night, the rain is falling once more.

Again that damned bomb . . .

Translation from French by Kareva Mateata-Allain

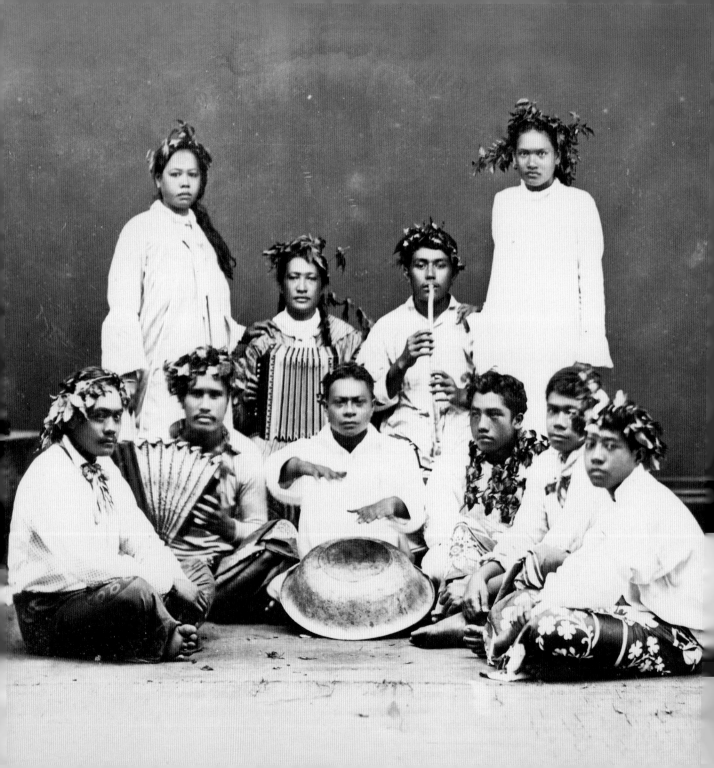

BRUNO SAURA MAKER OF DREAMS

IN 1976 BOBBY HOLCOMB settled in the village of Maeva, which was the seat of ancient Māʻohi royalty when Huahine was still called Mataʻirea. For the first time in his life, he really settled down, at last finding himself in a world he'd always dreamed of, or the world of his dreams. Here, as in the legends, people take the time to live, to talk, to sing, to drink, to dance; and they love, above all, large public gatherings, particularly those of a religious nature. Bobby's religious feelings brought him close to these people. Enchanted by Polynesian culture, he was not afraid of the ancient idols of the Māori religion but rather found them noble and dignified. Like the work of Gauguin and others, his paintings were haunted by the shadows of the night, but he chose to cast them in the light of day.

A great lover of mythology, he found his own place in local history and legends, beside the ancient Māʻohi of Tahiti, Huahine, and Raʻiātea who had immigrated, in bygone days, to Hawaiʻi, located far to the north of Maeva and at the summit of the Polynesian triangle. The ancestors of the people of this country were his ancestors, he was one of them, and he acquired their language and returned to them his knowledge.

Bobby read avidly, not just for pleasure or from habit, but to discover and pass on the techniques of lost crafts, the use of certain materials, and the ancient pastimes. The theme of traditional *māʻohi* games—archery, kite flying, floating rafts of wood and leaves—enriches his paintings, as do the motifs of dance costumes and musical instruments. Theory and practice being inseparable, he joined and soon became teacher of the folkloric dance group of Maeva. In the village of Fare, he taught high-school students to make *ʻaumoa* similar to noughts-and-crosses and other games from the past. In the schools of Tahiti and elsewhere, he produced plays adapted from legends, his favorite being *Pipirima*. In 1978, he collaborated with the poet Henri Hiro on an adaptation of a legend from Huahine: *Ariʻipaea Vahine*. The actors, drawn from the Māʻohi cultural renaissance movement, joined together to form a *pupu ʻarioi*, reviving the pleasures and experiences of this society of players and servants of the god ʻOro.

His new friends were touched by his extreme generosity. He gave his paintings away and freely offered his services to assist movements or associations formed to protect nature. Always willing to lend his time and talents, happy to learn by creating, he also loved to teach. A number of his songs were written for children and carry messages in the form of mnemotechnic phrases (simple repetitive catch

OPPOSITE

Self-Portrait

BOBBY HOLCOMB

Maker of Dreams

107

phrases), making it easy for children to remember them. It came as no surprise when he was honored by the country as its Man of the Year in 1988. Indeed, children loved him, the younger generation admired him, and Polynesian society recognized him as a leader.

Yes, Bobby was loved in Tahiti, always smiling, simply dressed, crowned with flowers, intelligent in speech, manipulating the French language with elegance and Tahitian with goodwill. So much did he resemble the people of this country that he was looked upon as a cousin or parent who had been overseas for a long time, but had come home to take his place in the great Polynesian family.

Though Bobby earned his living more by his art than by singing, he was better known to the public for his voice, warm and resonant, spreading across the air-waves of both radio and television. His work as a painter, on the other hand, was recognized by relatively few.

If his eclecticism was demonstrated by his choice of musical compositions and variety of interpretations, his paintings showed more unity. His works followed and resembled one another but without repeating themselves. It is difficult to find one that is aesthetically displeasing, though many of them benefit from being explained so that their depth may be fully appreciated.

With the cooperation of the owners of the paintings—and in order to satisfy his public—Bobby had two exhibitions. Bearing the name ʻAparima (Mime of the hands), they were held ten years apart, the first at the City Hall of Papeʻete and the second at the Reva Reva Gallery, also in Papeʻete. He sold his paintings to meet his daily needs, the main one being his grocery bill at the Chinese store. In April 1991, two months after his death, his paintings were displayed in a retrospective exhibition at the Museum of Tahiti and the Islands. Evy Hirshon, with the help of Manouche Lehartel, initiated the project. Never in his life had Bobby been able to gather together more than thirty paintings for an exhibition.

Let us imagine that we are with Bobby in his studio on the other side of the lagoon from his old red house. It is a tranquil spot here beside the reef. In his quaint little chalet of wooden shingles studded with small coloured windows, he finds inspiration not only in the early hours of the morning but also the hours until mid-afternoon. The heat does not bother him. The white light from the beach gives truth to his colours.

Now and then, Bobby painted on wood and plywood with house paints, but he

preferred paper and acrylics. His materials were in harmony with his themes. There is a feeling of nature in his paintings, of a certain *māʻohi* primitiveness. Bobby never went to art school and thus never learnt perspective or how to use oil paints or even how to stretch a canvas.

Does he really paint? It could be said that he draws graphic forms with colour: the contours of his subjects, the precision of their tattoos, the details of their hair all have a bold graphic quality.

Warm tones dominate; in fact, they were the only ones he used at the beginning, in keeping with his affinity for classical art with strong Egyptian influences. He also wanted to use the natural colours of Hawaiian or Tahitian costumes: blacks, reds, yellows, whites, browns, and oranges.

If the passing years enriched his palette and made him bolder in his choice of colours, they also confirmed his mastery of the design of his paintings. His balance became perfect. He acquired and elaborated on the technique of taking a motif from the ancient *tapa* designs he used within a painting and making it serve as a frame. Often it was a detail from plant life, or perhaps a geometric figure, like triangles repeated and reversed.

In drawing his subjects, Bobby preferred to depict forms rather than movement. In this respect, his subjects appear suspended in time. If they are not stationary, they are dancing or falling, or the wind is ruffling their hair. They seem to be in slow motion, as if to give him time to grasp their attitudes.

Bobby sometimes took the liberty of distorting his subjects: huge feet with long toes projecting beyond the frame; women's bodies round, too generously plump, and loosely draped in lengths of cloth. He emphasized such distortions with a scattering of tiny dots around these parts of the body.

Most of his works depict scenes from the *mā'ohi* past, though he sometimes painted Tahitians in modern-day dress: white trousers and shirts for the men; *purotu* (pretty girl's) or *māmā rū'au* (grandmother's) dresses for the women— or else street clothes or dress clothes. At the request of the publishing company Haere Po No Tahiti, he even painted a logo representing a tattooed Mā'ohi tapping the keyboard of a computer. But for the most part, his figures are drawn from *mā'ohi* mythology. The men are brown, tattooed, dressed in *maro* (loincloths) of red or white, strong-limbed, and broad-chested, their hair often pulled up in a chignon. The women, usually round and plump, are also opulently coiffured, their long tresses covering—or revealing—their charms. Sometimes their hair dances with the sea or flows into the form of traditional costumes.

Though Bobby loved children, he rarely painted them, and he never painted old people. Nearly all his figures are in the prime of life.

Totem animals abound, particularly those of the lagoon and the sea: turtles, sharks, whales, and fish of all kinds. There are also birds—*vini, 'ū'upa, 'ōtu'u*— and, above all, lizards.

Moʻo are in evidence in Gauguin's works and abundant in Bobby's paintings because they have an important place in Oceanic art and imagery. They are often represented in sculpture and tattooing, so much so that in several Polynesian languages, *moʻo* is used for both "lizard" and "tattoo."

Apart from this cultural interest, Bobby had a personal liking and even a kind of respect for this strange creature, a neighbour or cousin to the scaly fish. Almost a bird, it lives half-suspended in the air; and it is quite an "artist" too: able to look at the world upside down.

Bobby painted people. He painted animals. He did not overlook the stars, the moon in its different phases, the sun, the clouds, drops of rain falling like turtles' eggs, bolts of lightning, the wind that makes banners fly, and rainbows, which herald peace or victory.

The luxuriance of plant life, the radiance of the shore, the innumerable shades of the lagoon are purposely absent. It took some time, in fact, before he could bring himself to paint the ocean blue. Before that, it was red or orange, reflecting the colour he had given the sky. Bobby never liked swimming. The sea only interested him because it supported such activities as surfing, canoe racing, the ancient migrations—or was the setting for certain legends. Even in the painting *Pēperu,* which depicts the voyage of a double-hulled canoe, the sea is merely suggested, neither painted nor drawn.

His subjects are historical or mythological, and sometimes their costumes, their attitudes absorbed his attention to the point of neglecting nature, except as a means of enhancing the value of his subjects. Flowers are rarely depicted growing; more often they are woven in crowns for dancing or are present as objects of beauty or as offerings to the gods. Never a valley, rather its elements: the mango tree, the *fara* (pandanus), the coconut, the *tumu ʻati* (breadfruit), the fern, the ylang-ylang.

Sometimes cultivated fruits appear, such as bunches of bananas, and often pineapples, whose golden colour and rebellious thatch attracted him. Bobby rarely painted a still life, except the magnificent pineapple placed in a wooden bowl disputed over by the human figures carved on each side.

When a mountain is featured in a painting, it is merely a form without detail, a silhouette, as that of Huahine's Mouʻa Tapu, signifying all the mountains of Polynesia.

Saura

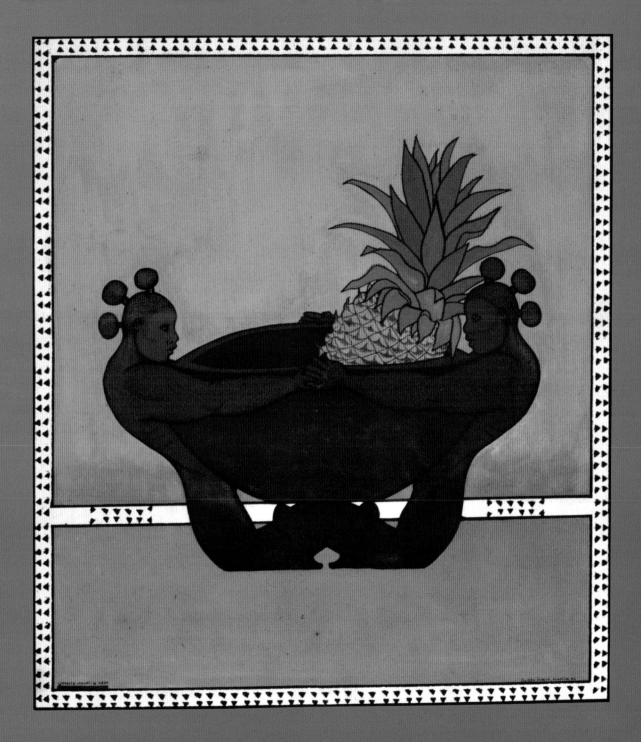

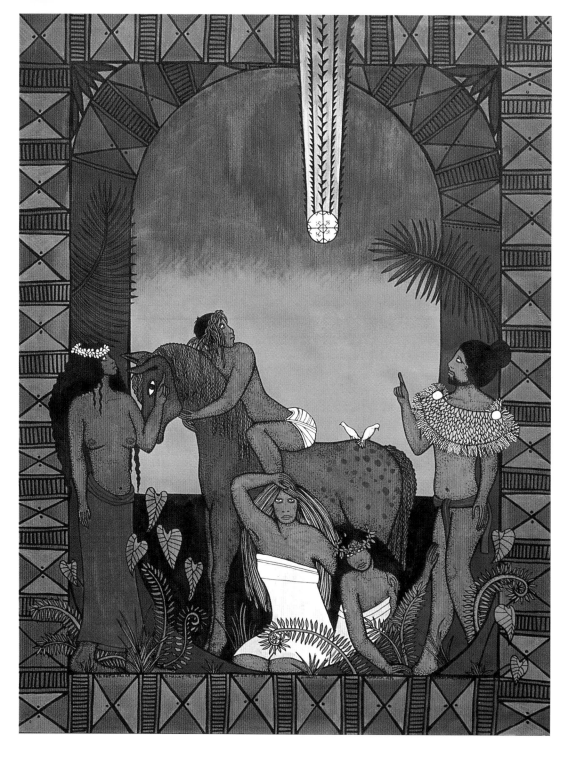

In the village of Maeva, Bobby painted trees, people, and the *marae:* ancient piles of stones erected and blessed by the Māʻohi. His house and garden served as a setting for a personal collection of the objects he revered and crowned with flowers, following the example of the men and women to whom he gave life in his own paintings.

He was fascinated by the ancestral Polynesian religion and intrigued by stories of kings and their subjects and by fairy tales. In this way, he was the ugly duckling transformed into the little prince, the eternal child always filled with wonder—a dreamer and, through his art, a maker of dreams.

For this reason, he painted angels, those endearing creatures peaceful and asexual, which he borrowed from Catholic imagery and then immediately tropicalized. Daring the cultural and pictorial synthesis of the ancient *māʻohi* times and the Christian tradition of today, Bobby presented an angel appearing to the goddess Hina, whom he re-baptised as St. Hina. He also painted an angel with wings of *tapa,* and through his magic, a Māʻohi child bears the name of the son of David. Even the return of Halley's Comet in 1986, believed by some to portend the end of the world, inspired a painting that evokes the nativity scene.

Nevertheless, Bobby was not a religious painter: he did not put his art at the service of religion, but rather put religion at the service of art. He neither professed a doctrine nor followed one. What attracted him to myths and traditions was their capacity to inspire images. In another time and place, he might have applied the same talent and enthusiasm to illustrating Grimm's fairy tales or Aesop's fables.

However, Bobby's place and time were the islands of Tahiti in the 1980s, a period of cultural renaissance, a return to the source, to which he contributed so much. In the now increasingly materialistic Tahitian society, people have been struggling to come to terms with a new value system imposed by foreigners. Bobby, by contrast, showed, through his lifestyle of simplicity, that it was possible to live in a different way. He preferred to live on the outer islands, painting and communicating his visions of the gods.

His paintings are a call to honour the past.

JOHN LIND BOBBY

I FIRST MET BOBBY HOLCOMB in March 1984 on the tropical island of Huahine, 120 miles northwest of Tahiti. Mutual friends in Australia had told me we'd get along. That turned out to be an understatement.

Everyone in Huahine knew Bobby. So when I arrived at the tiny port of Fare in the early hours, I was told, "He'll be here soon. He always comes to Fare in the mornings." Sure enough, he appeared on his bicycle only four hours later.

He was an exotic sight. He wore a woven crown of ferns atop his golden braids. A shopping bag of woven pandanus leaves hung from the bicycle's handlebars. A pair of shorts and a T-shirt completed his attire. His feet were bare, and his body was decorated with Polynesian tattoos. Later I learnt that his golden dreadlocks did not identify him as a Rastaman. They were instead fashioned after the hair of the Chimbu Highlanders of Papua, New Guinea. So what greeted me on our first encounter was a traditional hairstyle forty thousand years old. I wondered why faddy hair salons even bother.

Bobby welcomed me without hesitation, and within the hour I was seated in the sparse kitchen of his modest home. It was a red hut beside a lagoon in the fishing village of Maeva. As he rolled a cigarette of Dutch Bison tobacco, I observed his features. They eluded identification. He was undeniably handsome, but in a gentle way. There was even a classical, timeless beauty about him. Was he an Aztec? A Persian? A Minoan?

Bobby was actually a Hawaiian American cocktail. His father was half black and half North American Indian. His mother was half Portuguese and half Polynesian. He was born on 25 September 1947, in the rubble of post-war Honolulu—Pearl Harbor to be exact.

His mum had been a bargirl. He'd never known his dad.

Hunger was his childhood companion. To console himself, he had devoured Communion wafers at Roman Catholic services and tap-danced in the streets. One day he found an abandoned bicycle without any tyres. He jumped on it and headed out of Honolulu to just anywhere that was different. He knew, in time, he'd travel with a vengeance.

As I wandered around his home in Maeva, I noticed his broad reverence. Beside his personal shrine stood a collection of wooden and stone *tiki,* and a statuette of the Virgin Mary stood near his bed.

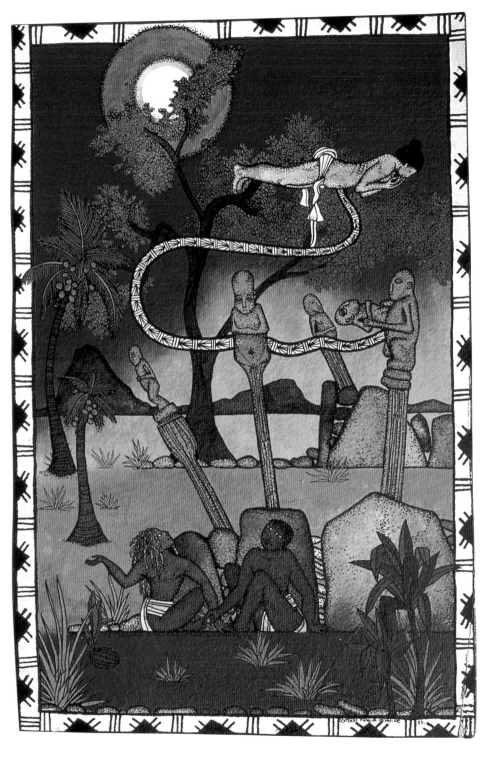

But the incongruous figure that dominated his home appeared in a colossal colour photograph, magnificently framed, of a fatherly man with a dignified face and silver hair. How come he had pride of place?

This was Duke Kahanamoku, two-time Olympic swimming champion and patron saint of surfers all over the world. This was Bobby's role model: Hawai'i's ambassador of goodwill to all nations. Duke represented the father Bobby perhaps wished he had had. He certainly represented Bobby's idea of "goodwill to all nations."

As painter, composer, singer, teacher, and *bon vivant,* Bobby was an inspiring example of a free spirit. As the Islands were in the midst of an ugly trend towards French colonial urbanization, his lifestyle was almost countercultural in its simplicity. And through music clips, he tried to encourage environmental awareness in Tahiti's polluted capital of Pape'ete, known locally as "the dustbin."

Bobby Holcomb the musician was particularly admired by the Tahitian young-sters for his warm, rich voice, his simple lyrics, and his cheeky *joie de vivre.* But his impact was more deeply felt on the cultural level. Bobby had learnt Tahitian, applied it to modern music, and wooed audiences back to their roots. Joining forces with other musicians, such as the Big Boys from Ra'iātea, he ignored the hotel circuit, preferring to travel great distances to perform for the islanders in community centres, youth clubs, hospitals, and sports fields. He revolutionized Tahitian music, becoming known as the father of reggae *à la sauce Tahitienne.* His music combined a little jazz, a little rhythm-and-blues, a little rock-and-roll. And he campaigned for a nuclear-free environment. He was definitely against *La Bombe.*

In 1988 the youth of Tahiti voted him Personality of the Year for his contribution to the community. But Bobby would always retreat from the noisy adulation of Tahiti to his tranquil home in Maeva. Here he would teach the local children their cultural heritage, and in the privacy of his modest home he would paint. Music was just a hobby. His paintings were more introspective and perhaps more profound. His mythical paintings reopened windows to a slumbering netherworld of ancestral spirits, warriors, and lovers. In fact, Bobby was possibly closer than most present-day Tahitians to the characters of Polynesian mythology.

He also was an avid reader, a great raconteur, and a mine of information about almost every culture. In short, he was great company. He was one of the rare breed whose impoverished backgrounds did not lead to bitterness and whose intense

self-education did not obscure the possibility of magic. His optimism and his recognition of mysticism were the culmination of profound human experience. His conclusion was that we humans are more good than bad.

He would say, "The 'baboons' among the human race have to be counteracted by artists. The world needs artists to perceive and express the dimensions beyond the 'nine-to-five'. . . and it's not some demonstration in the street that's going to bring peace. It's going to be our human dignity, how we actually live our lives and how we integrate art into our behaviour."

In this respect, Bobby's philosophy reflected the beliefs of an ancient Tahitian sect: the 'Arioi, who worshipped 'Oro, the Polynesian god of religion, mysticism, music, dance, art, and eroticism. Bobby and 'Oro parted company over war, which 'Oro also represented, though Bobby could be described as a warrior for the preservation of Polynesian culture.

Into the wee hours Bobby and I would philosophise. When tolerable *vin ordinaire* had been drained, we would graduate to gut-rot flagons. Mosquitoes kept us alert. Bobby's mind never seemed to lose focus. He expressed a holistic knowledge of the world, woven from his travels and cultural experiences. Through Bobby's tales, I would relive the heady days of Haight-Ashbury, when he and his best friend, Simon Henderson, "stormed heaven" together. Or under the South Pacific stars, I would be with them in Paris, where they had been regular guests at Salvador Dali's residence.

There, the maestro Dali would cheekily throw together the bohemians of The Living Theatre or the cast of *Hair* with the tottering remains of minor monarchies. There, Bobby would call himself Bastard Prince of Abyssinia and demand thrones and ocelots from room service (and get them).

As land crabs scurried in the moonlight, I would fly to Luxor, the mosques of Constantinople, and the mountains of Afghanistan on the wings of Bobby's vivid reflections. And as if words were not enough, Bobby would crawl across the floor, prostrating and crossing himself amidst panicking cockroaches, to demonstrate what happened at an annual Gypsy festival he had witnessed in Granada, Spain.

As the silver light danced with the lagoon's mysterious shadows, Bobby explained how he finally turned away from his restless travels among alien cultures to seek his own home, to touch base with the quarter-Polynesian in his blood. Thanks to the generosity of a young Swiss heiress, Kimi, he voyaged by luxury liner to the Polynesian Islands in 1976 and found his home on Huahine, an ancient religious stronghold.

When Bobby spoke about the different peoples of the world, it was without judgment. I knew I was in the company of someone who had been to the gates of Heaven and Hell and had returned without malice. His voice was gentle. His laughter was contagious. His child-like wonderment was inspiring.

He lived day by day, surviving on the strength of his personality and his creativity. He enjoyed the generosity of friends who tolerated his artistic temperament because they knew he was special. It was as if he were keeping alive the sacred child within us all. His paintings of Polynesian mythology were a way of preserving a cultural purity, a sacred innocence.

With his close friend in Huahine, Dorothy Levy, Bobby tended the ancient Polynesian *marae* of Maeva. *Marae* are open-air temples with basalt altars dedicated to the Polynesian gods. Bobby and Dorothy often assisted Yosi Sinoto, who is from the Bishop Museum in Honolulu and has devoted his life to resurrecting Maeva's past and restoring the ancient *marae*. Bobby became a custodian of Maeva's *marae*, dutifully annointing the stones with fragrant *mono'i* oil and draping them with floral garlands, offerings to the gods.

Ritual was an important part of Bobby's life. He expressed this in his paintings, in his work as a performing artist, in his attention to detail, and in his timetable. He would rise at 4:30 A.M. to work on his paintings until daybreak. This was his time of communion with himself and with the gods, who, disguised as geckos, would observe his progress from above. With his ritual over, he was free to deal with the mundane.

During all this, however, he had neglected his health, as if refusing to live on the physical plane. In December 1990, he learnt he had cancer. Those of us who flew in from overseas to be with him in his remaining days did so without hesitation. It was as if we had been quietly summoned to be part of his final ritual.

Within two months he was dead, at age forty-three.

Tahiti mourned his death. Island radio stations changed their programmes to devote a day to his music. French television in Tahiti made his death item number one on the evening news, ahead of the Gulf War.

Bobby's funeral on Huahine was held in the traditional Tahitian style. It was modest compared with what would have occurred on Tahiti.

As he lay in state in the community hall in Maeva, the big, fat *māmā*s (subjects he had painted with affection and respect) sang for him in their white cotton dresses

Archaeologist Yosihiko Sinoto (right) with Chantal Richerd, a teacher from Huahine. Famous for his pioneering research and brilliant discoveries throughout Polynesia, Sinoto is well-known and loved in Tahiti.
CLAIRE LEIMBACH

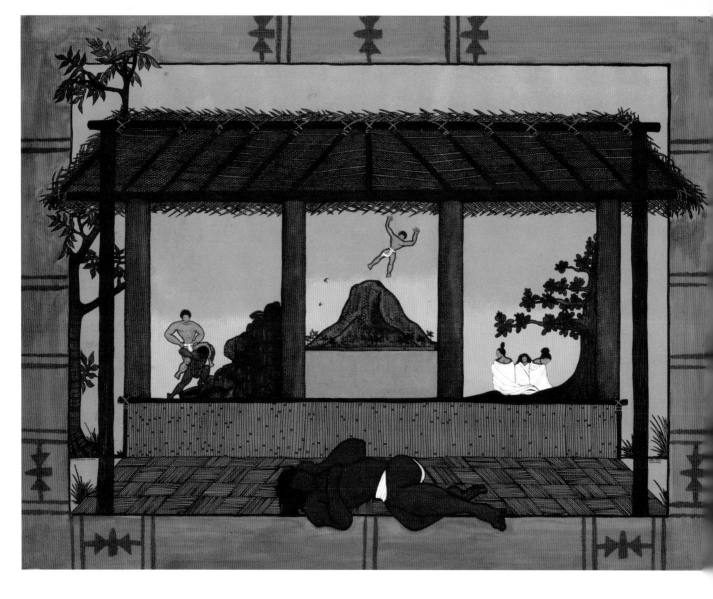

Fara's Dream

This painting is based on a dream of being carried to the
hill of Mata'irea in Maeva, seat of the island's royalty.
In the background, a man takes flight from the top of
the sacred mountain Mou'a Tapu. BOBBY HOLCOMB

and straw hats. Wide-eyed children gathered at the windows, framed as if in his paintings, while cockerels and dogs assisted the priest in his address.

Bobby's coffin was draped with a yellow cloth and surrounded by a protective border of ‘autī leaves, used in sacred rituals to ward off evil spirits. Beneath his head, a crimson cloth served as a pillow. At his feet were his favourite clothes and his woven pandanus basket. Paka lōlō was placed in his wooden tobacco bowl with the sacred turtle carved into the lid. His ‘ukulele and jar of brushes and pencils were not forgotten. Dried Hawaiian flowers were sprinkled in his hair, and a crown of ferns and scarlet hibiscus blossoms was placed on his chest.

Bobby was buried at the base of Huahine's sacred mountain: Mou‘a Tapu.

As I flew out of Huahine at sunset, I looked down at the amber waters of the great interior lagoon of Fauna Nui. I glimpsed Bobby's village of Maeva, situated in the sacred crescent of marae known in ancient times as "the great burial place." I mused that it was befitting that he should be buried there, as his tale might well have been written long ago. The island of Huahine might well have summoned him back from the lands across the water so that in time Bobby himself would become part of this sacred mountain.

from

CÉLESTINE HITIURA VAITE BREADFRUIT

and

FRANGIPANI

MUSSELS

It's twenty past one in the morning and Materena is sitting at the kitchen table.

She can't sleep.

At six o'clock she's going to get the bread at the bakery and then she's going to make the coffee. Materena yawns. She's tired, but she can't sleep and there's no point lying in bed with the eyes open.

She could go scrub the bathroom for an hour only she's too tired to scrub but not tired enough to sleep a deep sleep—the kind of sleep when you think of nothing. Materena sighs a long, heavy sigh.

She's worried. Today at eleven o'clock, she's going to court, and God knows what can happen to you when you go to court. Eh, you can go to prison. Many of her cousins have been to court and proceeded straight into the *gendarme*'s van. Direction: Nu'utania Prison. Her cousin Mori, for instance. He borrowed a canoe, and the owner of the canoe sued him, and Mori spent two days in prison.

Materena is going to court because the *gendarme* caught her on private property. Here's the story.

Behind the airport, there's some land next to the sea. That land behind the airport used to belong to the Mahi tribe, but an ancestor exchanged it for a few litres of red wine. The exchange was carried out under private seal, so nobody knows the name of the *popa'ā* who got the land for cheap. It's not for certain that he was a *popa'ā*, but back then (when the Mahi people lost the land behind the airport) the *popa'ā* people did a lot of exchanging with the Polynesian people—under private seal.

Materena loves that place behind the airport. She's been there six times. There's *'aito* trees for shade, there's white sand, and there's the calm sea that is safe for the kids to swim in. Above all, there are lots of mussels, and Materena loves mussels. Mussels fried with garlic and onions or raw mussels with a pinch of lime juice.

Whenever she feels like eating mussels, Materena packs bread, limes, cordial, cans of corned beef, bucket, can opener, and a knife and heads off with her kids to that special place. It takes them about twenty minutes to walk from the house. When they get to the landing strip, Materena makes sure the traffic light is green and there's no planes in the sky. Then she gives the children the run signal, and they always race across the landing strip. Materena stays behind the kids and yells, Hurry kids!

As soon as they get to that place, the kids go for a swim (they're not allowed to go past the rock where the warm, shallow water ends and turns into dark-blue water) and Materena gets busy digging mussels. She sits in the knee-deep water and digs her fingers into the sand. She always gets a mussel, but she only takes enough to fill up the bucket.

And it happens that Materena feels the presence of the people who used to dig mussels there, the people way before her time: her ancestors and their friends. They're sitting in a circle, and they talk and they laugh, all the while digging mussels.

Since discovering it, Materena had hoped to be digging mussels at that special place for years to come.

But a *gendarme* paid her a visit in his police car.

Moana spotted the police car first. He hid behind his sister and shrieked, "Mamie, the *gendarme!*" And Leilani covered her flat chest with her hands, as she wasn't wearing a T-shirt.

Materena stopped digging and hurried to the shore, where the *gendarme* was waiting for her.

"*'Ia ora na.*" Materena smiled at the *gendarme*.

The *gendarme* just looked at her.

"*Bonjour, monsieur.*" Materena thought that maybe the *gendarme* didn't appreciate the other greeting.

Again, the *gendarme* just looked at her, so Materena looked at him. There and then she figured out that the *gendarme* was in a bad mood. His eyes were angry; maybe he'd had a fight with his woman.

"What are you doing here?" he asked in a bad mood.

"My kids, they swim." Materena showed the *gendarme* her kids. "And I look for a couple of mussels."

The *gendarme* was more interested in what was inside the bucket Materena was still holding, than in her kids swimming. "Are you aware this is private property?"

"Private property?" Materena asked, as if she didn't know what the *gendarme* was going on about.

The *gendarme* took a black booklet out of his pocket.

"Name?" The *gendarme* clicked his black pen.

"Materena Loana Imelda Mahi."

"Address?"

"Fa'a'ā, PK 5, 5, behind the petrol station."

The *gendarme* furiously wrote the information down. "Occupation?"

"I'm a professional cleaner." Materena's voice was louder.

The *gendarme* looked at Materena and wrote CLEANER. "Marital status?"

Materena grimaced. She wasn't sure what answer to give the *gendarme*. She wasn't married right that moment but would be definitely in the next six months minimum. Perhaps even earlier, the way Pito kept giving her hints. He called her "wife" twice this week, and yesterday there was an article in the *Journal* about a politician's daughter's marriage and how it cost over two million *francs,* and Pito said, "All that money . . . It's not like we get married to show off."

"Marital status?" The *gendarme* sounded impatient. *"Monsieur,"* Materena replied, "I'm not married today, but I'm getting—"

The *gendarme* interrupted. "Either you're married or you're not. Marital status?"

"I'm not married."

"Are you a single mother?" The *gendarme* glanced at the children, who were still in the water.

"Non!" Materena didn't know why she had to shout. *"Non,"* she repeated in a lower voice. "I'm still with the father of my children."

"So, you're in a de facto relationship," the *gendarme* said.

"Yes, *monsieur.*"

"Couldn't you just tell me this earlier?" The *gendarme* looked annoyed. "I haven't got all day to play guessing games."

He scribbled DE FACTO and then ordered Materena to vacate the property—immediately.

"And this is private property," he said as he was leaving. "Do you know what 'private property' means?"

"You can't go on the property." Materena hesitated.

"It is against the law to trespass on private property," he said. "Just you remember this. Vacate the property immediately."

He tipped his hat and left.

As soon as the *gendarme*'s blue car was out of sight, the children got out of the water and raced to their mother. Materena explained the sad situation to them and immediately began to pack.

"That *gendarme!*" Tamatoa shouted. "Who does he think he is! If Papi was here—"

"You don't tell the *gendarmes* what to do," Materena said. "They tell you what to do. If you tell them what to do, you get a court summons in return." And very seriously, she added, "The *gendarmes* are the law."

"But, we weren't doing anything against the law," Leilani said. "The sea doesn't belong to one person. It belongs to everybody."

"God owns the sea." Moana waved to the sea.

"We walked on the private property before we got to the sea," Materena explained.

"But," Leilani continued to argue, "when the *gendarme* came, we weren't on the private property."

Materena, already on edge, snapped. "Leilani, it's not the moment to show off, OK? We're going home."

That evening Materena told Pito what had happened behind the airport.

"Why did you give your name to the *gendarme?*" Pito was angry. "You never give your name to the *gendarmes*. You make up a name. And why did you give your address?"

In Pito's opinion, and he was speaking from personal experience, if you don't give your name to the *gendarme,* the *gendarme* can't do anything. He can try to find you, but nobody is going to give him information because Tahitians—they don't talk to the *gendarmes*. They only talk to the *mūto'i.*

"And what are you doing crossing the landing strip anyway?"

"We only cross when the light is green," Materena said.

"Eh, sometimes the traffic lights don't work properly."

Materena also told Loana what had happened behind the airport.

"What are you doing digging mussels there?" Loana was angry too. "I told you the mussels there are poisoned, cursed, and no good to eat."

Once, Loana ate the mussels from the airport, and she nearly had to have an emergency operation.

"That *gendarme,*" Loana continued, "I'm sure his woman gave him trouble in the morning and he had to take out his bad mood on you. Eh, maybe his woman left him for a younger man—a Tahitian."

Three days after the encounter with that bad-mood *gendarme,* Materena received a court summons.

She showed it to Pito.

"Ah, it's nothing," he said.

But Materena was in shock. "I can go to prison for this?"

"Nobody goes to prison over a bucket of mussels." Pito laughed and carried on reading his *Akim* comic.

She showed the court summons to Loana.

"Don't you worry about it, girl," she said.

"I can go to prison for this?"

"Let them try a little. They don't know my name. We're going to see Maeva, and she's going to fix the situation pronto."

Maeva was definitely the woman to see—she knew about the law. Maeva is a distant cousin of Loana—from her mother's side. Maeva is a secretary of the boss of this big company, but she should have been a lawyer. She took the government to court a few months ago over Crown land in Rangiroa, and she won the case. The story was in the newspaper. There was a picture of Maeva, barefoot and carrying her pandanus bag on the front page with the thirty witnesses she got to speak at the tribunal of Rangiroa. One by one, these witnesses told the judge—who had flown from Tahiti for the case—a story about their land.

Loana and Materena went to see Maeva at her office. Maeva listened to the story as she typed a letter. She was very busy that day.

"This is what I think," she said, typing her fast typing still. "There was a private property sign and Materena ignored it."

Loana was about to explain that Materena ignored the private property sign because the land used to belong to the Mahi family but an ancestor sold it for a few litres of red wine, but Maeva held up her hand—meaning, I haven't finished.

"I know about the litres of wine," she said. "We all lost land over litres of wine and the land we lost over litres of wine is not the issue here. The issue here is that there was a private property sign and Materena ignored it. Is the sign really visible?"

"Well, it's nailed to a tree," Materena replied.

"How high?"

Materena wasn't sure what Maeva was asking her.

"Is the sign nailed at eye level?"

"*Non,* it's higher."

"Do you have to lift your head to read the sign?"

"Ah, *oui.*"

"Do you always lift your head when you see a tree?"

"*Oui,* to see if there's anything ripe in that tree."

"We're talking about an *'aito* tree here, yes?"

"Yes."

"And there's nothing ripe in an *'aito* tree."

"Well, the *'aito* doesn't have fruit." Materena was getting more and more confused.

"So, when a tree doesn't have fruit, you don't look up, correct?"

"True."

Loana made an interruption. "Why are we talking about trees?"

"We're talking about trees because the sign, which is the core of this story, is nailed to a tree." Maeva looked at Materena. "Describe the sign to me."

"Well . . . there's a blackboard and the writing is in white."

"How big is the board?"

Materena showed Maeva with her hands.

"OK," Maeva said. "It's not a big sign. And the letters, are they in capital letters?"

"*Non,* normal."

"Is the sign only written in French?"

"*Oui.*"

Maeva nodded. "Did you see the sign the first time you went there?"

"*Non.*"

"How come?"

"You can't see that sign if you don't look for it."

"Why is it that you can't see the sign?"

"It's a bit hidden by the branches."

"Did the *gendarme* ever point out the sign to you?"

"*Non.*"

Maeva stopped typing and swung her office chair to face Materena and Loana.

"OK. You go take a photograph of that sign. Make sure you can't see the whole sign in the photograph. Don't you two cut the branches to make that sign more visible."

"That's all we do?" Loana asked.

"Yes."

Loana had thought her cousin was going to tell them to argue about a particular article in the law that said that when the land is sold over a few litres of red wine, the original owners of the land still have the right to the land in some way. "That's really all we do?" she asked again.

"Can I go to prison for this?" Materena asked.

Maeva did her serious business look. "Girl, if you go to prison, your story is going to be on the television. Nobody can be accused of trespassing on private property when the private property sign is not visible."

So, Materena and Loana went to take a photograph of the not-visible sign.

They also went to the courthouse three days before to familiarise themselves with the environment: Loana's idea. They sat at the back and watched and listened. There was a young man who stole a TV—he got convicted. There was a young man who stole a car —he got convicted. There was another young man who stole a hi-fi system—he got convicted. The judge spoke harshly to these young men, like he was *fiu* of dealing with thieves. There were mamas and grandmamas crying all over the place. One man (the one who stole the car) yelled out, "I'm innocent!" And the judge said, "Get a job—and pity your mother for a change."

"You can't compare yourself to them," Loana reassured Materena once they were outside the courthouse. They're hoodlums and you're a hard-working mother. You're going to get dressed nice; you have to look respectable. Those hoodlums, they didn't even comb their hair."

Loana advised Materena to take the kids to the tribunal because apparently the judge always feels sorry for you when you've got kids, but Materena refused. The kids, they're going to school.

The kids don't know about the court summons.

Materena's boss doesn't know about the court summons.

And Pito can't take a day off because he's had so many days off (due to hang-overs) that he may lose his job.

Materena and Loana are in the truck on their way to Pape'ete. It's nine thirty, there's plenty of time, but Materena wants to be in the tribunal way before eleven o'clock, because it's best to be in the tribunal early. Then you don't keep the judge waiting.

Materena is wearing a dress and her hair is plaited in two plaits. There's no rouge on her cheeks, and there's no flower behind her ear. There's just the dress and the bleached white flat shoes. And the pandanus bag.

The rock-and-roll music in the truck is annoying her. It's too loud. But you don't tell the driver what music he can play in his truck.

"You've got the photos?" Loana asks in Materena's ear.

"Yes."

"You're sure?"

"Yes, Mamie."

But Loana wants to see the photographs with her own eyes, so Materena gets the photo holder out of her bag. There's thirty-six photos of the tree and the *Private Property Trespassers Will Be Prosecuted* sign that you can't really see. They used a whole roll of film. Loana flicks through the photos. She's satisfied now. She puts the photos back in the holder. Materena puts the holder back in her bag.

"Don't you get nervous," Loana puts her comforting hand on Materena's shoulder. "Stay calm."

"Yes."

"Because when you get nervous, you say a whole lot of nonsense."

Materena, looking out the window, nods.

"Like how you've gone to that place six times," Loana goes on. "I told you not to go there. Ah, *hia, hia,* the children, we think once they're grownups, we don't have to worry about them, but the worrying never stops."

Materena keeps looking out the window.

"Stay calm," Loana says.

"I'm calm."

"Don't be afraid of the judge. He's just a person. Just imagine him on the toilet. He's somebody, but he's not God. Ah, if I had the money, I would have hired a lawyer to defend you. A lawyer has to be better than you defending yourself. A lawyer knows the tricks and the rules. All you've got are photos."

"I can defend myself." Materena strives to sound confident.

"Don't cry at the tribunal," Loana says.

"I'm not going to cry."

"When we cry, it's like we're guilty. The judge doesn't like it when we cry in front of him. He prefers it when we stay calm."

"Yes." Materena wishes her mother would keep quiet. She's concentrating here.

"Don't forget that when you speak to the judge, you have to call him 'Your Highness.'"

"Yes, I know."

What is the boss going to say when she finds out about the conviction.

"And don't talk to Your Highness the way you talk normally. We don't say 'eh' to Your Highness."

"Yes."

Pito, he can't even cook rice.

"Look at the judge in the eyes."

"Yes." Materena's voice is now a sad murmur.

And my poor kids, eh. No way I'm going to prison.

"Do you think you're a pilot?" the judge asks.

Materena is standing before him, her head held up high but not too high for the judge to misunderstand respect for arrogance. She's surprised about the question. She thought the first question Your Highness was going to ask her would be, "Did you see the private property sign?" She would then have said, "No, Your Highness, because the sign is not very visible and I've got proof, I've got photos."

Does she think she's a pilot? Of course not! Why would she think that she's a pilot? Is Your Highness trying to trick her?

"*Non,* Your Highness," Materena hesitates. "I don't think I'm a pilot."

"Er, it's Your Honour," the judge says. "Imagine, you and the children are on the landing strip and a plane has to land."

The judge looks into Materena's eyes. "Are you imagining?"

Materena wants to tell Your Highness (Honour) that they only cross the landing strip when the light is green and the light is still green by the time they reach the other side. Also, she always checks the sky for planes; she knows that sometimes planes have to do an emergency landing and the pilot doesn't have time to contact the traffic controllers. It's a risk to cross the landing strip, Materena realises, but it's safer to cross the landing strip than it is to cross the road.

She can't imagine herself and the kids on the landing strip and a plane has to land. But she's not going to argue with Your Highness.

"Yes," she says. "I'm imagining."

There's a moment of silence.

"Anything can happen," Your Highness goes on. "The pilot might try to divert the plane and in doing so crash the plane, killing hundreds of people . . . or he might choose to run you and your children over. Are you imagining?"

Ah yes, Materena is imagining now and she's not feeling good.

"And I do not count the fact," Your Highness says, "that you are endangering yourself and your children by swimming at the airport. Underwater electrical cables for example."

Materena gives Your Highness a shocked look. "Underwater electrical cables? It doesn't say on the private property sign that there's underwater electrical cables."

"So, you *knew* about the private property sign." The judge looks a bit angry now.

Materena too, she's angry. She's not thinking about her defence. She's only thinking about how her kids and herself could have been electrocuted.

"Monsieur," she says, "I know all about electrical cables. My brother, he was an electrician once. I know you don't mess around with electrical cables. You can die when you mess around with electrical cables. Now, *monsieur,* that sign doesn't say anything about the electrical cables."

Materena is forgetting to call the judge Your Highness or Your Honour. "*You* imagine a little, eh? My kids, they're swimming and they get electrocuted because nobody told me about the electrical cables. Imagine how I'm going to feel. I'm going to feel like I killed them. I'm never ever going near that place again. And, *monsieur,* that private property sign better be fixed . . . I'm glad the *gendarme* sent me a court summons."

Ah, yes, she's blessing that man now. She's taking back all the bad talk she and Loana did about him—how his woman left him for a younger man because he's a cranky old bastard—etc.

And then Materena starts crying. She tries to fight the crying, but the revelation about these underwater electrical cables—it's too much of a shock.

"I'm happy we didn't get electrocuted." Materena is now wiping her eyes with the palm of her hand. "Give me one hundred thousand *francs,* give me a million *francs,* I'm never ever going to that place behind the airport."

Case dismissed.

A Child's Dream

MICHEL KO

THE ENCYCLOPEDIA

The bathroom is scrubbed every day in Materena's house because Materena can't stand her bathroom being dirty. Soap scum makes her cranky and so does hair in the bathroom drain, toothpaste smeared on the tap, grime around the tap rings. Well anyway, Materena scrubs her bathroom every day.

She's scrubbing, scrubbing really hard and wishing her twelve-year-old daughter, also scrubbing, would stop talking, but when your daughter helps you with the housework, you don't criticise. You just smile and nod, you answer her questions, or you say nothing because you don't know what to say.

"Mamie?" Leilani taps her mother's hand. "Did you hear me?" She's waiting for her mother to explain why it doesn't snow in Tahiti, and once again, Materena will have to say that she doesn't know.

This is happening more and more these days. Let's just say that Materena can't keep up with Leilani's hard questions. Who started the French Revolution? What's the medical term for the neck? There's a limit to what Materena knows. People can't know everything.

'Auē! Materena was much more comfortable with her daughter's questions when they were simple. Who invented the broom? (A woman.) Is it true that eating charcoal makes the teeth white? (Absolutely not; brushing your teeth every day with toothpaste makes them white.) Who invented the rake? (A woman.) What time does the first star appear? (The first star appears at quarter past six.) Who invented the wheelbarrow? (A woman.) Is God a woman or a man? (God is everything that is beautiful.)

Leilani used to say how clever her mother was, but Leilani doesn't say this anymore. So, why doesn't it snow in Tahiti? How would Materena know this? "Girl," she says with a sigh. "I don't know why it doesn't snow in Tahiti."

"Ah . . . I knew you wouldn't."

"Why did you ask me then—if you knew I didn't know?" asks Materena, a bit cranky.

"I just hoped you knew."

"Well stop hoping. Ask me about the ancestors, the old days, cleaning tricks, budgeting, who's who in the family album and at the cemetery, plants, Tahitian words of wisdom, traditions. Don't ask me why it doesn't snow in Tahiti. Ask your teacher."

"I do, but Madame always says, 'That's not what this lesson is about, Leilani.'"

Leilani drops her scrubbing brush and stomps out of the bathroom complaining that she doesn't know anybody who can answer questions, and that all she gets is "Be quiet, Leilani."

'Auē! Materena feels so guilty now. Here, she's going to give her daughter a kiss . . . and some coins to get herself an ice block at the Chinese store. My poor girl, Materena thinks. She's always stuck at home with me.

Materena finds Leilani reading yesterday's newspapers at the kitchen table—elbows on the table. "Girl?" Materena isn't going to say anything about the elbows on the table—how it's rude and everything. "You want to get yourself an ice block at the Chinese store?"

"*Non,* I'm fine."

"You're sure, *chérie?*" Materena kisses the top of Leilani's head.

"I'm just having a rest. I'll come and help you again in a minute, OK?"

"*Non,* just relax."

"*Non,* I want to help you," Leilani insists.

"All right then . . . But don't worry if you can't help me; you help me enough as it is." And with this, Materena escapes to her bathroom and locks the door. Ah, what peace. Materena can sure use a few minutes of silence.

A few minutes later. "Mamie?" It's Leilani knocking at the door.

"*Oui.*" Materena chuckles, thinking, Already?

"There's someone at the door."

"Who is it?" Materena opens the bathroom door, scrubbing brush in hand.

"It's a woman with a briefcase."

"Eh, *hia.*" Materena is annoyed. That woman at the door is here to sell her something like perfumes or to talk about religion, and Materena is in the mood for neither. "Tell that woman I'm not here."

"Mamie, just go and say good afternoon to her. I feel so sorry for her." Leilani explains that she's been watching, from behind the curtains, the woman door-knocking in the neighbourhood. Two relatives closed their door on her, one relative opened the door and waved the woman away, and one relative walked out without a word and proceeded to water her plants.

"What are you doing spying on the relatives?" Materena cackles. "It's to give you ideas for your memoirs?"

"I was just looking," protests Leilani. "Mamie, the woman is waiting for you."

"She asked to speak to me?"

"*Non.* She asked, 'Is your mother home?'"

"And what did you say?"

"I said, '*Oui,* my mother is home. She's scrubbing the bathroom.'"

"Couldn't you say I was asleep?" Materena puts her scrubbing brush down and rearranges her chignon and her *pāreu.* "People should know that we're Catholics around here and that we've got no money," she says, walking to the door. "You only have to look at the houses."

"Good afternoon," Materena says, greeting the Frenchwoman, who can't be more than twenty years old and who looks a bit like a Gypsy with her floral dress, sandals, and loose hair.

"Oh, good afternoon, Madame," the young woman says with a rather strange yet beautiful accent.

"Are you from France, girl?" Materena asks.

"*Oui,* from Marseilles," the young woman says with a smile.

"Ah, Marseilles." Materena nods knowingly.

"Have you been to Marseilles?" the young woman asks Materena eagerly.

"Girl, I've never been out of Tahiti in my whole life." Materena laughs.

"Where's Marseilles?" asks Leilani.

"It is in the south of France . . . I could show you on a map if you like."

Before Materena has the chance to tell the young woman not to worry about it and to go on with her mission, Leilani gives her consent. Yes, she'd like to see where Marseilles is on the map of France. In a flash, an encyclopedia comes out of the woman's briefcase as she explains that she always has one with her to show people what the set looks like. And it's just by chance that she has volume 6, E–F, with her.

"You sell encyclopedias?" Materena asks.

In one breath the young woman confirms that she is selling encyclopedias and says there's a promotion: a twenty-percent reduction. She goes on about how much she loves encyclopedias, she's had an encyclopedia set since she was eight years old, she's on holiday in Tahiti—one of the most beautiful countries in the world—she arrived two days ago.

Ouf, that's a lot to spill in one go, Materena thinks. But how nice to say that Tahiti is one of the most beautiful countries in the world. "Come inside the house," Materena says. "Let's sit at the kitchen table." The young woman doesn't need to be asked

twice. With one giant step, she's in the house before Materena can ask her (politely) to take her shoes off. It isn't a Tahitian custom to take your shoes off before walking into a house, but it's nice when you do because then you don't bring dirt in. Well anyway, it's too late for Materena to tell that woman about shoes and everything. But for Leilani it isn't. "You can't come in the house with your shoes on," she says, her eyes widening in stupefaction. "You're going to put dirt on Mamie's carpet."

The young woman's face turns red with embarrassment, and she hurries back outside. She takes her shoes off and neatly places them next to the row of thongs by the door. "I'm very sorry," she says. "I've just arrived, you see. I'm not aware of this country's customs as yet." Walking in, she adds, "Oh, it's so lovely here."

"It's comfortable, girl." Materena smiles, relieved that her house is very clean today. Her house is always clean, but today it shines. Everything has been dusted, and there are no cobwebs on the ceiling and no fluff on the carpet.

"Oh!" the woman exclaims, stopping right in front of the pot plant placed in the middle of the living room. "Is this a real plant?" she asks, stroking the leaves. Before Materena can say, "Of course it's a real plant!" the woman inquires if it is a Tahitian custom to place a pot plant in the middle of the living room.

"Well," Materena replies, "*oui* and *non*. In Tahiti, we believe that a pot plant—"

"It's to hide the missing carpet square here," Leilani informs the visitor. And right before her mother's horrified eyes, she lifts the pot so that the visitor can see for herself. Leilani explains that everybody does this in Tahiti. They use pot plants to hide missing carpet squares, holes in walls, anything.

"I see," the woman nods. "It's a very intelligent way of doing things." She walks to the wall to admire a quilt pinned up. "*Magnifique!* Whoever made that quilt is talented. This quilt is truly a piece of art." She goes on about the intensity of the bright flowers, the intricate patterns, the balance of the design, the use of geometry.

"My mother made that quilt when I got married," Materena says, caressing it tenderly.

"Mamie is going to be wrapped in that quilt in her coffin," Leilani adds.

Materena gives her daughter a quick annoyed look: You don't tell strangers stories that only concern the family! The woman looks at Materena. "Is this a custom in Tahiti?"

"An old custom, girl. Not many people are wrapped in quilts when they're dead these days, but I want to be wrapped in one my mother made just for me because,

you know, once you're linked with your mother through the umbilical cord, you're linked for eternity."

"These are such beautiful words, Madame . . . I'm so honoured to meet you."

Materena cackles, thinking that this girl has got to be the best salesperson she's ever met. The girl is now looking at the framed photographs below the quilt, and Materena doesn't mind. If photographs are on the wall, it means it's fine for people to look at them; you don't need permission. You only need permission to look through a photo album.

"This is my beautiful oldest son, Tamatoa, at his confirmation," Materena tells the interested visitor. "He's playing football right now with his father and uncle. And this is my youngest son, Moana, at his confirmation. He's also playing football with his father and uncle at the moment. This is my mother when she was young, this is me when I was young, and this is my husband when he was young. This is my husband and me when we got married six months ago . . . with our beautiful children."

"Is it the custom to marry late in Tahiti?"

"Oh, *oui* and *non*," replies Materena. "In Tahiti we believe that it's unwise to marry before—"

"Men don't like to get married in Tahiti. They always give excuses, and they're lazy."

Again, Materena gives her bigmouthed daughter a discreet look to be quiet.

"And is that you?" the woman asks Leilani, pointing to a framed newspaper clipping.

"*Oui,* that's my girl," Materena says, sighing with pride. "It was after a running competition. She came in fiftieth, but there were thousands of competitors."

"One hundred and twenty, Mamie."

"And this is a school award Leilani got when she was ten years old," Materena says, ignoring Leilani's last comment. "For a story she wrote."

"Do you like to write?" asks the woman, smiling at Leilani.

"Oh, *oui,* she loves to write!" Materena exclaims. "She's always writing, that one. She writes, she reads, she's very intelligent. All my children are intelligent, and to think that I'm just a professional cleaner."

"Oh, you're a cleaner!"

"A professional cleaner," Materena corrects.

"I admire professional cleaners!" the woman exclaims. "My mother is a professional cleaner. I believe professional cleaners ought to be decorated!" Materena looks at the young woman with narrowed eyes. What's this? she thinks. Is it to make me buy an encyclopedia set?

"I admire professional cleaners too," says Leilani. "It's so hard to clean. Last time I helped Mamie clean Madame Colette's house, I was so tired. I had to sleep in the truck on the way home."

"You didn't help me," Materena hastens to add. She doesn't want the encyclopedia woman to start thinking things. "When you told me you wanted to be a cleaner, I had to show you how hard cleaning is." Materena explains to the Frenchwoman that it is definitely not her plan for her daughter to become a cleaner. In fact, she's always pushed her daughter to see beyond cleaning and get a job that has nothing to do with a broom and a scrubbing brush.

"You are a clever woman," the encyclopedia woman says. "May I show you the encyclopedia?"

"Sure. What's your name by the way, girl?"

"Chantal."

"Ah, what a beautiful name you have, Chantal. OK then, Chantal, you and Leilani make yourself comfortable at the table. I'm going to make us lemonade."

"And what is your name, Madame?" Chantal asks, with a genuine smile.

"Materena."

"You have a beautiful name too, and," Chantal adds, turning to Leilani, "your name is lovely as well."

Leilani informs the visitor that she was named after a Hawaiian ancestor, but not Leilani Lexter, whose husband (Tinirau Mahi) would soon regret having married her because she liked partying too much. "I was named after Leilani Bodie," Leilani says. "She was very serious. She was a medicine woman."

"Oh . . . well, you might become a medicine woman too," says Chantal.

"I don't think so. I don't like sick people."

"We never know!" Chantal exclaims as she sits at the kitchen table.

"May I ask you a few questions?" Materena, cutting the lemons for the lemonade, hears Leilani ask. In no hurry at all, Chantal invites Leilani to ask her as many questions as she wants. Materena cackles. Chantal, you have no idea what you've just got yourself into, she thinks.

"Why doesn't it snow in Tahiti?" Chantal repeats Leilani's question. "That is a very intelligent question, and the answer is that Tahiti is too close to the equator." She asks for some paper and a pen, which Leilani hurries to get, and the next minute, Leilani is getting a free geography lesson.

Then Leilani would like to know what the medical term for the neck is.

"Easy," the Frenchwoman says. She quickly draws a human body, and the next minute, Leilani is getting a free biology lesson.

And who started the French Revolution?

Easy . . .

And do fish sleep?

"Of course." Chantal smiles. "But because fish don't have eyelids, they can't close their eyes. But fish do sleep."

On and on and on, Chantal shares her knowledge with a delighted Leilani—the knowledge she insists she got from years of reading encyclopedias and other books of interest.

The salt in the sea is the same as the salt people put on food. Its chemical name is sodium chloride. Plants make much of their food from water, carbon dioxide, and sunlight. This process, called photosynthesis, produces oxygen.

When we're sick, our body temperature goes up above normal, which is thirty-seven degrees. This rise in temperature is called a fever and is triggered by the germs that cause the illness. They release chemicals that act on the part of the brain whose job is to control temperature. This, in turn, produces other chemicals that make us feel cold.

The human body has more than six hundred muscles, which together make up more than forty percent of the body's weight.

Sixty percent of the body consists of water.

Hiccups are caused when our diaphragm—the wall of muscle between the abdomen and the chest—goes into a spasm.

Fingernails grow four times as fast as toenails.

By the time Materena is signing her name at the bottom of the form binding her to thirty-six payments for the encyclopedias, Chantal looks very drained.

She has earned her commission, that's for sure.

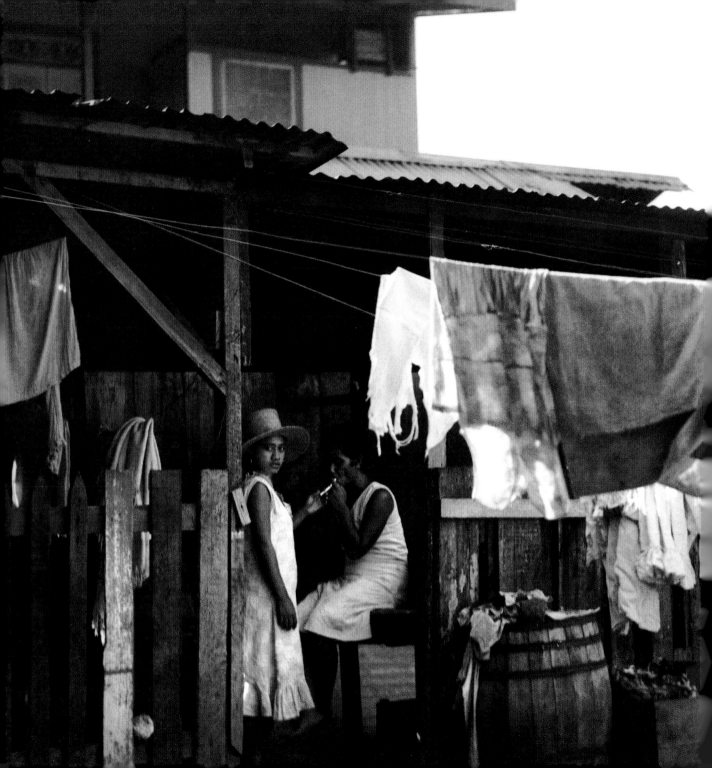

from M U T I S M S

T I T A U A P E U

AN ENTIRE FAMILY poses for a photo. In the background is a steamship. They are all ready for departure, refreshed, smiling, or grimacing, perhaps due to the blinding light of a tropical land. They are on the quay at Noumea in New Caledonia. This photo is now thirty years old . . . The father is tall, imposing, bronzed. He has charm and a beautiful smile. Above all, he is shy of the camera.

The mother, much shorter, is also smiling. Her hair is mid-length, her eyes like black olives, her skin light colored. There is something in her look: the emptiness we see in the eyes of people who don't expect anything from life.

The children are standing directly in front of the couple.

The eldest is smiling. He has a tooth missing and must be about nine years old. The middle one is obviously pouting. She is to the right of her little sister, who has a snarled grin and squinting eyes. Then there is me, the baby, who is gazing sadly at the woman. A normal chubby baby . . . nothing more. Around them are friends they will probably never see again. The photo still exists. It still lets off a lot of light —a raw light, blinding. It's a family portrait, but it's not exactly warm. It somehow froze the painfulness of leaving.

Everyone had a beautiful smile, yet they all looked fake. The pain is still apparent . . .

I think all departures cause a rift inside. We tear ourselves away from one place, one land, in an attempt to re-root ourselves somewhere oceans away. But what unexpected thing lies on the other side?

Anguish, excitement, relief, and fear must have overtaken each of them, one by one, every feeling trying to persevere . . .

Every departure causes a leak inside the self.

This family left New Caledonia to return home to Tahiti. Ten years earlier, the parents had left paradise for Noumea. Somewhat like Adam and Eve thrust out of Eden after having sinned.

And just as Adam then had to work for a living, the father had to leave Tahiti for the nickel mines in Noumea.

We lived in a tiny Tahitian house made out of cheap wood. It belonged to Maman's aunt, a big, devout woman who spent every day worshipping in church and every night telling lies. This big woman scared me. She said that my father was an asshole and that my mother was only good for the nuthouse. She also said we were too poor and would be better off leaving. Our mother repeated to us every

night that it was just a matter of time before we'd build a house farther up in the neighborhood and that we'd leave soon.

She also said that the Lord was good and that he didn't want little children to be injured and would protect them. But I lost faith in her god because the big lady got even meaner. She ate more and more, and I was hungry.

We went to the closest Catholic school and hated it right away because we were made fun of. One day, my older sister came home from school covered with bites. Maman felt bad for her and was also afraid for her. How could children be so cruel? Were they only imitating adults? How awful to not accept someone because she used a guttural *r,* like the people in Paris. In Tahiti, *r*'s are rolled as in Spanish and with a lot of pride.

First rip, first wounds. The children had been ripped from their first universe, their games, their house, and their school in New Caledonia.

We later had another house under construction. It only had the foundation, nothing else. Maman and we children were there, seated in a circle. She was crying. We had just escaped the fat lady's house and were exhausted. The eldest child wanted to comfort her but couldn't. He felt useless.

Someone said one day, "Words are therapy." Bullshit. Words didn't help. They were too weak. My sisters and I believed it wasn't fair. We loved Maman. She was beautiful, even in distress. She did not deserve so many stains on her spirit.

"What are we going to do, Maman?"

"I don't know. It would be better if God would strike us all down right now."

Yes, it would have been better; then he would have showed us mercy. We'd all be dead and no one would have to suffer . . . So I told myself with the weak words of a four-year-old that if one day God took from me this mother who had always suffered, then he was a jerk.

"Where is Father?" the middle sister dared to ask.

"Dead, I hope!" Maman had an eerie, malicious glint in her eyes.

That night while we slept in the big lady's house, we were all awakened by loud voices. Father had come home drunk and hungry. Maman went to fix him eggs or something like that, but he turned into a demon. He couldn't tolerate her meekness and forbearance. It grated on his nerves. He wanted her to stand up to him and give him a reason to beat her.

He pulled her by the hair and threw her on the floor.

Like an animal mute with terror, Maman crawled toward the furniture to seek a place to hide. He tore off her clothes and she was naked, too naked. All she could do was hide her face. He kicked her in the ribs and in the stomach, harder in the stomach. Throughout the beating, he never stopped yelling or asking if she wanted more. She said no, but the blows increased in power.

How could we forget Father's eyes, contorted with loathing? By then, I had decided I didn't want to forget. It would make it too easy for him.

Our prayers and Maman's screams were in vain. There is something in the Tahitian language that is terrifyingly icy. I don't think the words he hurled at her would have had the same power in French or any other language. I was so afraid that she might die. At one moment, she did not move and she did not cry.

Then he picked her up by the hair and started pounding her again. We could hear muffled noises and spasmodic gasps for breath, one rapid with terror, the other with something like excitement. And blood spurted everywhere: dark red, vile.

A long time after, did words whisper fear, terror? I'm afraid that words are too weak, have no power against so much violence.

For him, it was as if she was not a woman—not even a dog. At the most, a sperm bucket.

I would have liked proof that he loved her. Perhaps I would have given a name to this "love"? I despised him.

Of course, Maman screamed and we cried. My older brother, aged twelve, wanted to intervene. He could only collapse. What to do before this man, so big and powerful? To shoot him in the back would have been the only thing we could do—even today. Not content with having beaten her like the lowliest of beasts, he told her how ugly she was with blood on her face. He even added that he'd found someone else younger and more beautiful. I didn't merely hate him; I wanted him dead, to not exist anymore. I desired the void for him, for us. It didn't matter for whom.

The little universe that I knew contained my sisters, my brother, Maman, and me, surrounded by ramparts. We had to run because these fragile walls could collapse at any moment. Of course, Maman's screams woke up the entire neighborhood, but not one neighbor acted. The big lady was crying and saying that the devil had entered her house.

Luckily, when Father was worn out and stopped to rest, Maman seized the opportunity to escape, tearing us away from the horror.

The fat lady told us that we'd better never come back.

Even today, Maman's screams are a constant hammering that often gives me a migraine. Obviously, it had not been the first time he had hit her, but that night he had a mixture of alcohol, bestiality, and God-knows-what-else in his blood. I can't remember this man having ever been so ugly. After that, no violence could have surpassed it.

As soon as they were married, he got into the habit of hitting her. At that time, some Polynesian families were so driven by their sense of endangered solidarity that they arranged marriages or forced people into them. It was often a matter of land. There was no love in Maman's heart on her wedding day—not even for profit. For Father, the marriage was but an opportunity to prove that he would be master of her life, of our lives. She had to acknowledge that he was the master, and to never forget it.

We walked away from the skeleton of the little house, groping along in the dark. Maman was almost naked. Her face swollen, she talked about death for twenty minutes. It frightened us. She was losing her mind, though others would have lost theirs long before. I believe that for her, this moment was a headline: MOTHER KILLS HERSELF AFTER MURDERING HER CHILDREN. She really thought that death was the answer.

Later on, she admitted that she would have killed herself had T., a neighbor, not followed us and intervened. When he offered to put us up, Maman didn't hesitate to accept. After all, nothing could be worse than Father finding us . . .

In this man's house, a happier time arrived. He had children our age whom we played with.

But Father's shadow loomed, especially at night, and wouldn't let me sleep. I needed Maman's warmth to prevent me from falling into the black hole that threatened to suck me in. Even when I feel a pressing need today, I ask my memory to give me the scent of Maman and the warmth of her heavy, reassuring breasts.

Eventually she managed to get a divorce, even though divorces were almost unheard of in Tahiti. A woman who didn't accept her state was shameless and obviously loose, attracted by the freedom of being single. At least this is what the family thought. The court ordered Father to pay Maman child support every month, but we never saw a dime. For us, however, the most important thing was that he stayed away from us.

Translation from French by Kareva Mateata-Allain

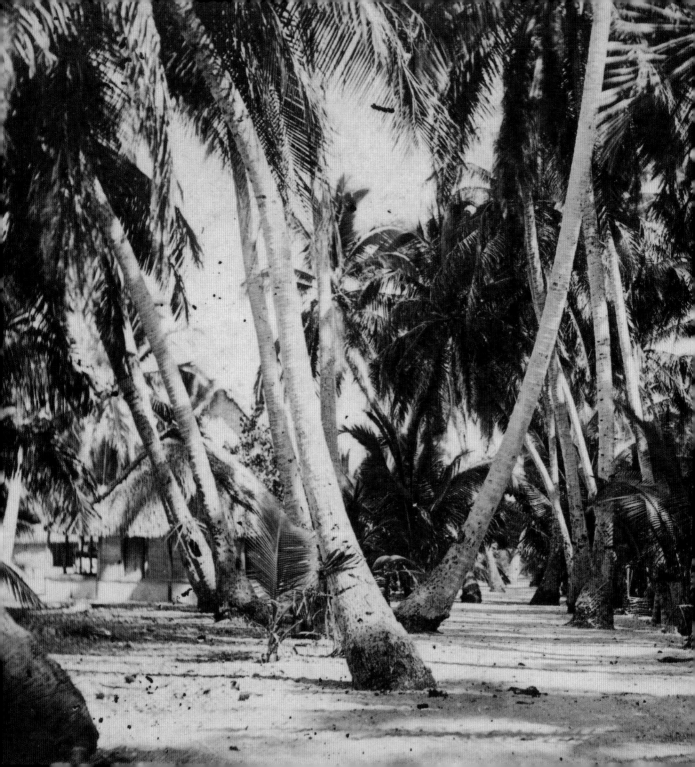

THE ARRIVAL

KAREVA MATEATA-ALLAIN

"**TRAGEEEEDIE . . .**" The shrill voice of Barry Gibb of the Bee Gees rings through my head. My energy sinks even deeper into the bus seat. I remember where I am, though I barely recollect the details of the long excursion through canyons and wide desert spaces dotted with mobile homes and mesquite bushes. Has it only been four days, or four years, four decades, four lifetimes?

My spirit wanders through a fog, numb from shock and cold winter desertscapes that speed past the window. I wonder what my best friend, Hinano, is doing now.

She is from Ra'iātea, the island where my grandfather was born. For Hawaiians and New Zealand Māori, the tiny island of Ra'iātea is their Havaiki, the sacred place of their beginnings.

An image of Hinano flits in between the electrical poles to my left. Slightly built, her complexion a creamy cappuccino, she refuses to wear breeches and has perpetual saddle sores on the inside of her bare knees. Keeping her black, wavy hair in a short ponytail, she wears cheap rubber flip-flops, polyester Adidas shorts, and striped Hang Ten T-shirts several sizes too large.

We loved to train horses in the valley of the district of Pīra'e on the island of Tahiti, and we spent every day after school and all day on weekends at the stables. We worked hard at the track, feeling that being part of that horse community was not evidence of elitism, but rather proof of perseverance, hard work, and possessing our own reality. We loved the trainers: P'tit Frè, Dumond, Papa Adams, Cou Cou. Many an evening after the horses were rinsed off and fed and the stalls were mucked out, trainers and jockeys like me and Hinano, Hono, Caroline, Titaina, Julien, and Teragni stood around Cou Cou, who was always shoeing, even at night. In the light of a butane lamp, we watched, sweaty and covered with dust.

It's hard to believe that only a few weeks ago Cou Cou, tall and lanky, bent over a rear hoof held snuggly between his knees, a cigarette dangling out of the right corner of his mouth, and said, "*Alors,* so . . . How'd it go tonight?" He pinched off an aluminum racing shoe with huge nippers. He had no mustache, but an Amish beard carpeted his chin.

"Whew. *J'ai mal au dos.* My back is killing me," I responded.

"Yeah, but you're tough. How many did you ride tonight?" He moved to the front of the horse and lifted up its foot.

"Two. I'm looking forward to this weekend, though, when we can leave the track

and go up into the mountains. I think the horses get tired of just going around in ovals."

"You mean you do." He chuckled.

It still hadn't sunk in that I would be leaving Tahiti. As usual, I lived in the absolute present, which is easy to do on a tiny island surrounded by the Pacific.

And thinking now about all I left behind, I feel a pang, a bang, a twitch on a cellular level.

"The climbing is great for them too, but I expect you guys to get up early on Sunday. Be here by six. I want Corisis and Varua to be worked in the sea." He picked up a file and briskly swiped it across the hoof. His dog, Kono, was lying three feet away, happily chewing on hoof hide.

I want to reach out and pet Kono. I want to grab Hinano and shake her, claiming that it has all been a dream. But right now, Tahiti is so far from me: a distant fragment to which I am attached by a golden thread. I can't believe I am no longer there, and I feel like I am floating, floating above myself like a trauma patient who helplessly watches her body being poked and prodded on an operating table. It is Saturday, and if I were home, Hinano and I would be riding horseback on long treks through the jungle, way up steep cliffs and past the tree line, where the jungle ends and the pine forests begin. When I think of the track, I smell wet leather, fresh manure, rancid piss. I feel the breeze and taste the salt of sweat. Horse muscles bulge under mine. Hooves beat the dirt track in cadence to the wind thudding around my ears.

And I feel joy. It is the place of all that is familiar.

By contrast, the landscape sprawling before me is an alien topographical map with no familiar landmarks. This bus is a moving tunnel, and I am trapped. Junk cars and laundry zip past me in a blur of rusts and whites. Strips of asphalt race beneath me to my left; to my right is my sister, Kahina, blankly staring ahead. Maman and Vetea doze in the seat behind us. No words ebb and flow among us. Instead, each of us remains in a separate universe, oblivious to this trek across the Southwest of America. We have never been in a vehicle for so long in our entire lives. I know we stopped along the way for food, border-patrol checkpoints, and the thrift shop in Tucson, but I haven't been able to pull myself into the present during the entire trip.

Projected on the bus seat in front of me, a vision of Hinano and me appears. We slope forward on our horses high above the clamminess of the jungle to enter

the realm of fresh pine forests. As our sweat and that of the horses dries in the cool breeze, the wind whispers little messages to me. My horse, Varua, listens too, her ears twitching in rhythm to her swaying mane. Hinano and I reach up from our saddles—keeping our balance with our knees and standing in our stirrups—to grab passion fruit, hungrily biting off an end, spitting the piece out, and then sucking the sweet, juicy seeds through the hole.

"*Tiens!* Here!" I grab Hinano's attention before launching a mango or passion fruit at her.

Riding along narrow, steep paths of the ancients, we giggle, tell stories of our crushes, and make plans to have disco dancing parties either at my house or in the betting shed at the racetrack.

"'*If ya zeenk I'm sexxxy and ya like ma bodie, /come on bebe let me know!*'" In French accents, we belt out the lyrics in rhythm to the horses' hooves pounding the trail. We love Rod Stewart, John Travolta, Olivia Newton-John, Donna Summer.

Obsessed with *La Fièvre du Samedi Soir—Saturday Night Fever* in French— Hinano and I saved the *francs* we made by bagging horse manure and selling it as fertilizer. We splurged at least ten times at the Cinéma Concorde in downtown Pape'ete to gape at John Travolta on the big screen, sliding across neon dance-floor tiles in his shiny, white polyester suit. We didn't notice that his mouth was not moving at the same time the French words were being spoken. Or if we did, we didn't care. We had disco parties just so that we could replicate his smooth moves.

The bus has screeched to a stop. The driver turns off the engine, it shudders, and then all is still.

As I take my first step on Texas soil, I can feel a chill numbing my hands. Out of a teary eye, I see a crispy bundle of weeds spin and bounce in front of the Greyhound bus. I look around me at the bleakness of the landscape, my eyes stinging with tears, wind, and anger and my teeth clenched against the dull pain of a black bag so heavy that it forces my shoulder down. Another carryall is draped over my left arm, and I have a pack strapped to my back. *Why did she have to do this— where the hell has she brought us?*

The sky above the dusty, fifties-style bus station is overcast and so much colder than the one back home. For the first time in my life, I am wearing blue jeans and a heavy jacket—specials from a Goodwill store in Tucson. My blistered heels,

unaccustomed to socks and hiking boots, burn and bleed. I feel overburdened with more than just clothes and luggage. I can still hear the echo of the drums and I can't believe I am so far away from home.

Auē, I hate Maman at this moment.

I glance back and see my brother, Vetea, struggling along the sidewalk with his luggage. He is always sullen, distant. His dirty blond hair contrasts with his dark skin. Ten years old and already five feet six, he is going to be tall like his uncles. He is headed toward our fourteen-year-old sister, Kahina, who has found a rickety bench under a leafless tree. Her glasses lie crooked across her nose. Tendrils of baby-fine hair fall over her eyes and across her mouth like a curtain. She is biting her lip and studying her shoe. She looks so much like me that we are often mistaken for twins, except that I am dark. People always mistake her for me, but never me for her. We both have long, thick hair, hers a dirty blonde and mine a deep auburn. We have strong bone structure, deep-set eyes, arched brows, tiny waists, flat stomachs, and powerful, muscular legs. Her legs are bowed, though, arched like parentheses, so she thrusts out her pelvis as she centers her weight on her lower back. At five feet three, I am taller by an inch or so, but we both have sturdy, wide Polynesian feet. Mine are a size ten-wide, so it's hard for me to stuff them into these thrift-shop boots. I'm used to my feet being bare. I approach her. I haven't said much to her; I haven't wanted to. But I force myself.

"*T'a finis ton livre?* Finished that book yet?"

"*Ouais* . . . Yeah."

I can hardly hear her. "Huh?"

"Yeah."

"What was it about?"

She just mumbles.

I'm trying to loosen the tension between us, but that would take more strength than I have.

I give up. All I want to do is escape this place, and I can only do that by remembering. Talking takes too much energy at this point. I know Kahina is in as much shock as I that Maman has dragged us along on this absurd pilgrimage: a 747 jet from Tahiti to Los Angeles; a Greyhound across four states; and our arrival in cold and dusty San Angelo, Texas.

I glance behind the bus to where Maman is talking to a lady with soft pink objects

in her hair that look like spongy toilet rolls held together with toothpicks. Her skin, leathery like bleached coconut husk, reminds me of an old bridle forgotten on our patio during rainy season and left to dry in the sun.

"Where ya'll frumm?" Her accent is a garbled twang—nothing like the voice of our English teacher at the *lycée* back home. Confused by the sound, I recall Hinano warning me that Americans swallow their words.

"Tahiti?" She looks at Maman in awe, a cigarette dangling from the gap in her lower front teeth. "Whereabouts in Texas is that?"

Maman is too tired to explain the details of the last four days. She mumbles something back to the lady, who points us to a café across the street.

I feel Maman looking at me. I catch her jerking her head in the direction of the café. Teeth clenched, right eyebrow arched—this is her wordless command for us to follow.

And everything is silent.

Not one iota of dialogue. Just the buzz of memory slapped together with heartache melded with grieving. But I reluctantly drag my feet, lumber over to the café, and plunk myself down in a booth. I am still shivering from the cold air and my hands are numb, so I order tea. I can hardly wait for the soothing warmth of something familiar.

I think back to my cousin Maeva and me in tropical downpours during our Wednesday-afternoon jaunts around Pape'ete. We'd dash into the closest *pâtisserie,* giggling, our long, dark hair sopping wet and our rubber flip-flops squeaking with each step, and then we'd slide into a window seat to watch the hard rain cleanse the town. "*Iyahhhh . . . Nous sommes trempées!* We are soaked!" And we'd laugh and wring our hair, drops falling on the floor. Maeva's jet-black hair reached down to her butt and was always in a braid as thick as a boat rope. She always wore a red hibiscus flower in her hair. "What shall we order with our hot tea?" we would ask each other. "*Mille feuilles* or *petits pains au chocolat?*"

Our idea of cold was certainly not like this numbing chill from the winter desert sky. I bite my lip to return to reality.

The American waitress brings me a tall glass filled with ice cubes and brown water. "What is that?" I inquire, my eyebrows knitted.

"Tea." She slams it down in front of me. "You ordered tea." Brown water oozes over the glass rim.

Tears well up in my eyes, but I try to stay calm. Where is the cup of hot tea I am craving? The waitress is shaking a pencil at me with one hand while placing the

other defensively on her left hip. I get a whiff of her breath: bubble gum mingled with stale cigarette smoke and old coffee. This woman is rude, brash; but in my naiveté, it doesn't occur to me that my non–West Texan accent and looks are what trigger her contempt. I am shy in this vast, foreign space and don't have the guts to tell her to take the tea back, so I keep the gross drink and gulp it down. This is my initiation to America.

Over the laminated orange tabletop I look at Maman. She appears thin and weary. Strands of hair are slipping out of her ponytail. As if searching for direction, she is staring down into the coffee cup hugged between her long fingers. I manage to swallow my resentment for a full twenty-one seconds and am struck by the thought that maybe this move is just as hard on her as it is on us.

I recall our kitchen table back home: coffee in bowls, warm *baguettes de pain* waiting for butter. One day, I was sitting with the newspaper, *La Dépêche de Tahiti*, occasionally sneaking tidbits of bread and *pâté* to my dog, Barney, who was in his usual place under the table.

Maman walked in, all smiles, and said, "Guess what . . . We're moving to America to a place called Texas. It's all arranged. I've been accepted into a university, which means we'll get in on a foreign-student visa."

Silence.

"What . . . ? When . . . ?" I gulped in a whisper.

Maman leaned toward me, placed both hands on the table with her palms down and her elbows straight, and looked me directly in the eye. "We leave in three weeks."

I stared. I swallowed hard . . . once . . . twice. America had looked fine on TV, but that's where I wanted to keep it: something to entertain me, to talk about with my friends—but not to be my reality. "What about Mama Kina? Moana? School? Our lives?"

Numb, I look at Maman sitting across from me in this San Angelo café. As my right foot taps a rhythm against the steel table leg, I grit my teeth, and then I withdraw into my booth and my resentment and rock, nurturing my animosity as if it were a newborn baby. I take in Maman's weary, chiseled beauty and assess her. She no longer has the spark of excitement that she did when she walked into the kitchen back home and made her announcement. "I need to take steps to broaden your horizons," she had said as justification. "The world is large. I don't want you living

on this island all your life with limited options." I remember smirking because, from my favorite spot on the beach at Tautira, my view was endless, limitless.

I vaguely remember her meetings with a religious sect that predicted a tidal wave was going to engulf the islands, swallowing up Tahiti and everyone with it. Soeur Paulina, a friend of hers also in the sect, was a French Canadian nun known in Tahiti for her Catholic radio and TV programs. I remember Maman and Paulina sitting at the dining table and pouring over the thick *Urantia Book*. I didn't pay attention to their ramblings—I was too busy with the horses and my friends—but apparently, fellow believers had shown Maman a map of the States and Canada, pointing out a section that, they predicted, would be safe from the world's destruction. Maman decided to place her trust in *The Urantia Book*'s powers and move to America. When she shared her decision, Mama Kina and Tonton Gaston told her she was crazy, nuts, *taravana*. But as always, she was stubborn—and proud.

She had pulled out a Webster's dictionary. I still have a vivid image of her pouring over the list of colleges and universities in the back. She applied to all those in the area deemed safe by the sect. Eventually, Soeur Paulina caused a huge scandal within the Catholic community. Under the counsel of the sect, she left the Church and moved back to Canada. The last I heard of her, she was married and pregnant. The sect's charismatic prophet and leader was a French Canadian who called himself Malkizedek. He planned on changing the world. Instead, he changed mine.

By the time we leave the café, Maman's walk has lost its usual briskness and *umph*. We are all on the side of the curb waiting for a taxi. None of us speaks. The streets are deserted, except for the occasional tumbleweed or battered pickup truck roaring by without a muffler.

I look over at Kahina. Her glasses, as usual, are sliding off her nose, her shoelaces are untied, her blouse isn't tucked in, and she has a coffee stain on her skirt. She has been so quiet this entire trip. She is always withdrawn, her nose plugged in a book—now she has one under her arm—but she is more quiet than usual. She leans back to rest and escape her confusion. Vetea has a finger entwined in his hair and is intently stubbing a path in the gravel with his left toe. The taxi pulls up.

"Hey, Kahina . . . *Ça va?* Are you OK?"

No response.

Mateata-Allain

"Can you come help me load this stuff in the trunk?"

I am ignored.

Kahina always escaped any kind of physical labor. I remember her swearing that she was going to marry either a rich man who could afford a maid, or a man who would do all the cooking and cleaning.

She was a goddess, or so she thought.

Kahina's favorite place was in the mango tree, off the ground and out of reach. It was two stories high and as wide around as six or seven people, arms outstretched, holding hands in a circle. She had built a treehouse high in the branches, and hid there with a book when there was housework to be done. I'd stand under the tree with a broom, screaming threats. And she'd look down at me and smirk, knowing that I was afraid of heights.

"Come get me if you need me that bad," she'd say. *Snicker. Snicker.*

She set my teeth on edge. She used a rope dangling from the first branch—at least nine feet off the ground—to hoist herself up. The last time I tried to climb up, I froze and was stuck up there for hours. The entire neighborhood—all my cousins—came out to see me, laugh, and offer me words of encouragement. Eventually, our neighbor Alfred drove to the rescue with his forklift, his three-year-old son, Willie, proudly perched on the orange hood. Alfred maneuvered the forklift under the mango tree and shifted the gears, and the welcome arms of the forklift rose up to save me. I gladly reached out for the wooden crate platform, the cheers from the crowd picking at my fear like little claws.

And I can't reach Kahina now, though she is but two feet to my left.

Sullenly, silently, she and Vetea slump into the back seat while Maman and I help the driver load the only possessions we hauled across the planet to America: three cardboard boxes and a bulky coffee table. But it isn't just any coffee table. It is made of dark teak wood and has a thick glass top. Tiers are carved out of the center and lined with cobalt-blue velvet. Maman displays her shells on these tiers. I am so glad that this is the last time we'll have to haul this heavy reminder that we have left Tahiti. Like us, it sat for a time on a Texan sidewalk, looking out of place, bereft of everything familiar, corralled by desolation.

The view during the taxi ride is a window on flatness. Everything is yellow. The trees are naked and sad. I do not recognize the landscape, and I look in vain for the mountains and deep valleys where the *tūpāpaʻu e tupuna,* spirits of our ancestors, live. I have been taught that the earth is our mother. But this mother is alien to me.

On treks with friends through the lush mountains of Tahiti, Varua and I were always in front, in tune with the landscape and the songs of the ancestors on the wind. I knew the trees by reading their leaves. Dry, rocky creek beds through the valleys and up the ridges led to sacred spaces and fresh springs where we watered the horses. Their lips pursed, Adam's apples pulsing, eyes closed, the horses gulped the sweet, clear liquid.

Deep in the jungle, it was damp, cold, and shady. The foliage was so thickly layered that sunlight couldn't push its way through. The sweet smell of drizzle caressed my neck; goosebumps tickled their way up my spine to my scalp. We were in the domain of the *tupuna.* They floated on the mist sliding in between the *māpē* chestnut trees. Silver vapors coiled around Varua's ankles and gently slid through my hair. Birds chattered incessantly, and occasionally, the smell of a wild boar drifted our way, blending with horse sweat and wet leather.

On one of our Saturday jaunts, Varua slipped off the trail and stumbled down a ravine while Hinano watched us, frozen with fear. Varua's back legs went down first, struggling in the damp mud around sacred ʻ*autī* plants. She tried to find root stumps on the slope to help her regain her footing. I was crouched in a jockey position, trying to get my weight off her lower back while she struggled. Mud and leaves whirled around me as if in the wash of a propeller. There was grit in my mouth, and long, spindly branches scratched my cheeks and pulled my hair. Varua kept sliding down the mountain on her belly. And then she stopped.

The *tupuna* had saved us.

There was an entanglement of wild bamboo and thick, wide jungle leaves shaped into a ledge halfway down the ravine. It slowed us. Varua managed to regain her footing, pushing her back legs off the bamboo. I had a second to gather my reins, regain my seat, nudge her gently with the insides of my legs, and urge her toward the dimly lit footpath. She leaped over the last hurdle of foliage and landed on the trail, her left flank against a mossy cliff wall that covered my leg with green slime. We were both

Mateata-Allain

trembling—she with fear, I with relief. And I muttered, *"Māʻuruʻuru, māʻuruʻuru,"* thanking the *tupuna,* who had held us in their embrace and led us to safety.

But what if the *tupuna* can't find me here in Texas?

There are no *bananiers, manguiers,* or *cocotiers.* No lush ravines. No waterfalls to my left. No blue waters of the Pacific from every view. My lungs are not filled with the aroma of *tiare Tahiti,* but rather that dull pain of blue cold that pounds the chest and freezes the nose. The streets are not lined with the pinks, violets, reds, and purples of bougainvillea and plumeria bushes. Women are not walking the streets in flip-flops and bright *pāreu.* In fact, I don't see anyone at all.

I cannot smell salt and fish or feel the energy of the harbor at Papeʻete. I search for colorful characters on Vespa scooters with fish strung to the handlebars. I listen for *les trucks,* the vividly painted buses from whose speakers blare Tahitian music or disco.

Back home, passengers tie their wares on a ladder by the rear entrance of the bus: the catch-of-the-day, pineapples, coconuts, bundles of fragrant flowers, or rolls of *tapa* to make dresses. Here, all I see is an endless expanse of mesquite bushes lined up behind shops and nondescript houses. Where are the jagged, lush mountain peaks? The rivers full of rocks and translucent cool water? Grapefruit trees, bougainvillea, hibiscus? I want to see an outrigger *pirogue* lying on the beach. Here, instead of the sea, yellow dirt and gray sky stretch as far as the eye can scope. No Moorea in the distance. No fishermen bobbing on the horizon.

I stare out of the taxi, my right cheek pressed against the window, seeking solace in its chill. I imagine that I am Lucy about to enter Narnia, and that the window is a secret corridor to another dimension.

Instead, the taxi pulls up to a set of white, two-story buildings: university housing. In this barren place, the structures look like army barracks. Our apartment is on the top floor.

Maman goes to get a key. Vetea, Kahina, and I each grab an edge of the coffee table and drag it up the stairs, huffing and puffing.

"*Ow!* My fingers!" Kahina drops her edge, and the table slams into my toe.

"*Merde,* Kahina. Hold the damn thing properly!"

"I can't. I'm tired. It's too heavy."

"These stairs are steep," Vetea whines. "I don't wanna do this. I need to pee."

"*Allez*. Come on, guys. Let's just have this up here before she gets back with the key." I try to be reassuring, but I'm just as tired, just as fed up. The table is awkward, bulky. It has never been up a flight of stairs. After heaving and grappling with the relic from our living room at home, we finally make it to the top.

I hear a familiar *thump, thump* coming up the stairwell. Maman is back with the key. She slips it into the deadbolt lock, and as we enter the kitchen, we are greeted with a strong whiff of chlorine and cockroach dung.

The apartment is huge and bare. There's not even a fridge or a stove. The only piece of furniture we have is the coffee table. Enclosed within these walls, I feel even lonelier.

"Where do we sleep? There are no mattresses, no *pēʻue* mats," I tell Maman.

"On the floor for now. Get some clothes out of the suitcase and pile them on the floor. That'll have to do until Uncle Gaston wires me the rent," she says, referring to the money she'll get for leasing our house to the *gendarmerie*, military police.

"Maman. *J'ai faim*. I'm hungry," Vetea whines.

"You ate at the café. Go brush your teeth and get to bed."

"I want to read my book. Why is it getting so dark?" asks Kahina.

"The electricity isn't turned on yet. I have to take care of it tomorrow. Just go lie down and get to sleep." Maman is weary. She has bags under her eyes, and her shoulders are hunched; however, she still has an aura of determination and stoicism. I wonder what she thinks about all this, but I don't dare ask. To do so would invite shark energy: fin slicing through water; beady eyes in a calculating head; jagged teeth bared and menacing, ready to bite, chew, and swallow.

I keep silent.

That night, I lie with my ear against the dusty wood floor. It all seems like a dream—my life in Tahiti an elusive spirit. I cover my face with my *pāreu* and cry myself to sleep.

I dream long and hard about Grand-mère Mama Kina. She is very tall in the dream, at least nine feet, and next to her I am so tiny. I look up at her and hug her knee. Wearing her talk-story face, she sits down on a *pēʻue* mat and sets me down beside her. I start designing patterns with shells for her to sew on her weaving. I look down

at my right hand cupping a glossy cowry shell in shades of black and brown. Its design is very much like a turtle's back. I hold it to my ear, and the sea surges through me. I place it on the *pē'ue,* and with other little shells, I design a turtle for Mama Kina to sew on the hatband she is making.

Her body rocks as her nimble fingers braid the pandanus bark. Her *māmā rū'au* dress is hitched above her swollen knees, and her bare feet hold down the reel of pandanus. As she speaks, her one gold tooth and her white hair glisten in the sun. She bends over the pandanus, intricately weaving the plant with her deft fingers. She never looks up, and in a sing-song voice, she speaks in Pa'umotu, telling stories in rhythm to the movement of her hands.

"You know, my grandfather was a *tahu'a,* a shaman," she begins. "He taught me about the old ways and the old days before our world was squeezed out by the people who brought the true God. His mother, Mama Kuru, was a high priestess. He and I hiked back into the sacred *'autī* bushes to gather herbs and roots for *rā'au* traditional medicine. Together with Mama Kuru, we prepared the secret recipes to dispel evil spirits from those possessed, or to heal *fefera,* fever, or *fēfē,* sores and wounds. We made coconut oils for healing massages. We waded through the sea, collecting *vana,* sea urchins, that lay in clusters on beds of sand. We used the fine black needles in our ceremony."

Mama Kina continues, "My great-grandmother, Mama Kuru, stayed home and waited for us. While Grandfather and I were gone, she cleansed the *fare* inside and out with sacred smoke. There could be no bad energy around while we made *rā'au.* And we were revered by everyone in the community for our healing powers. But we could never divulge our secrets, for then our medicine would lose its power."

Mama Kina reaches down and gently cups my little fingers with her hand. I look up at her profile; she is gazing out the window at the ocean gently lapping the white-sand beach. A fishing net is slung over an outrigger canoe whose nose faces the water. The horizon gently slices the space between the sky and the sea, and the shimmer of waterscape reflects vast spaces within my soul. I press my thumb into the palm of Mama Kina's hand—my cue for her to continue.

"Mama Kuru was very old by then. She couldn't see very well anymore, and she tired on the long hikes through the thickness of the brush. But she still had all her teeth. A pink-and-yellow frangipani flower was always in her tightly wound black-

and-gray bun. She always wore an *'autī* crown upon her head. And she loved to wear *pāreu* that were bright reds or vivid yellows, the sacred colors of our ancestors. She had radar senses of dolphin power, and she taught me how to communicate with the spirits."

I see Mama Kuru beside us, brought to life by Mama Kina's words. I feel her strong presence, and I connect her to the sea.

The words of Mama Kina keep feeding me. "When my grandfather and I got back from our gatherings, we sat outside our *fare* with our baskets full of plants. Mama Kuru sat by us on her *pē'ue* as we sorted them, making sure we did everything properly. Otherwise, the ceremonies wouldn't work.

"Our *fare* house on the Tuamotu atoll of Katiu had walls of braided coconut fibers. It rested on five-foot stilts planted firmly into the ground so that when the winds and storms came, the floods passed under the *fare* without sweeping us into the sea. The roof was of *nī'au,* and I remember my grandfather braiding it out of pandanus palms. Once a year, we did repairs, all the village stopping by to pitch in, then had *tāmā'ara'a,* big feasts. Full from the pig, plantains, taro, and breadfruit that we roasted in the ground, we told stories and jokes, then danced and sang to the deep voice of the *pahu* sharkskin drum." Her voice pauses.

The sea combs the sand back and forth. And her hands continue to weave.

"But that stopped when the nuns found me. They said I was a savage and that my grandfather and great-grandmother were devil worshippers. I was twelve by then. They sent me to Tahiti to school, hoping I would forget all my knowledge.

"But I had to remember. So that I could pass it on to you." Swaying gently, my eyes closed, I stroke a corner of her navy-blue dress between my right thumb and forefinger as she continues to swathe me in her words.

"You are the firstborn of a firstborn," she reveals. "I feel the *mana* in you that allows a close connection to the gods and the ancestors. Anytime you need the *tupuna,* they are there for you, Kareva. All you have to do is acknowledge that you know that. You will always be safe, for they will always be with you.

"And you must never untie the fiber that links you to the *tupuna.* Your name is the fire that shoots toward the sky, and the *tupuna* will always be there for you.

"If an entire ocean and continent separate you from the *fenua,* the homeland, it is only an illusion of the physical world. You will be a bridge between the worlds,

and your life will be about bringing teachings and understanding to and from both worlds."

Mama Kina's dark-brown eyes catch mine, and I feel her energy slither through me. Electricity seeps through my toenails, travels to my scalp, and hums through my ears.

I move on from my turtles, and I am now designing a sacred *manu* bird in flight. But Mama Kina is not done with me yet.

"You must learn to let go of the physical worlds and embrace the internal worlds that exist within. The islands and the mountains, the ocean and desertscapes all live within you.

"I am there with you as soon as you summon me with your thoughts. And so are the spirits who live within you. You carry them with you now, and they hold you in their eternal presence." I look down at my *manu,* and I gently stroke a wing.

"You have to remind yourself that space is an illusion. You can sense and visualize Tahiti from wherever you are. The islands are within you. I know you understand that. That's why I look to you and count on you to meet me there, within." A tear slides out of the corner of her eye, crystallizes on her cheek, and glimmers in the sun. I see my reflection in it. But I look older. Wiser. Beautiful.

And the image gives me hope.

Mama Kina picks me up and holds me tightly against her soft breasts. I sink my head into her warm flesh, and I breathe in coconut oil.

I shudder. My eyes snap open. At first I don't know where I am. For a second, I can still smell her. Then my heart sinks as I recognize the darkness of the four walls, the shadows of Vetea and Kahina huddled on the floor, and the moonlight seeping in through the window. I take a deep breath. The images from the dream flood my mind. And I try to gain strength from my inner landscapes, but it is not easy.

Until that delicious moment of epiphany, Mama Kina's verbs and nouns are but loose shell beads scattered through my psyche, and the frantic quest to find my place in this new culture unfurls before me like a scavenger hunt. It has taken years of groping in the dark to finally string together, but that physical landscape did not appear overnight. Majestic mountain peaks, gurgling river zigzags, towering coconut trees, fire-red corals on a sea bed . . . All evolved over time.

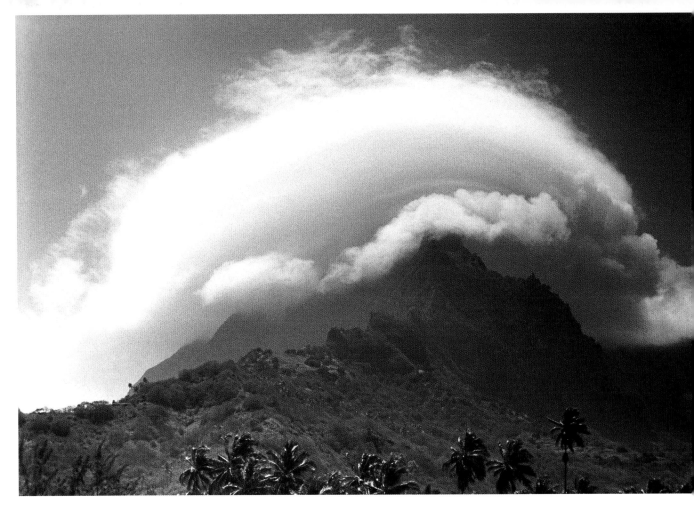

Mount Temetiu towers above
Atuona, on the southern coast
of Hiva 'Oa.

MICHEL CHANSIN MARQUESAS

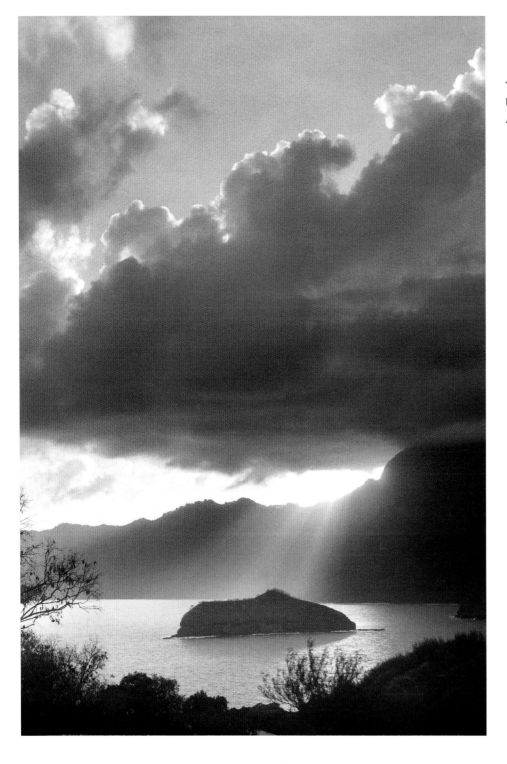

The uninhabited island of Hanakee, between the bays of Ta'a 'Oa and Atuoha (Vevau), Hiva 'Oa.

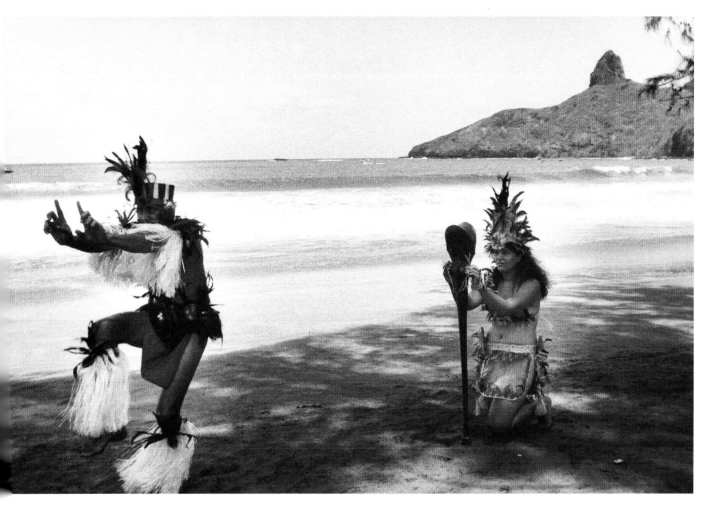

On the first day of the Sixth Festival
of Arts of the Marquesas, a seasoned
dancer gives last-minute instructions
to a young dancer on the beach.
December 2003.

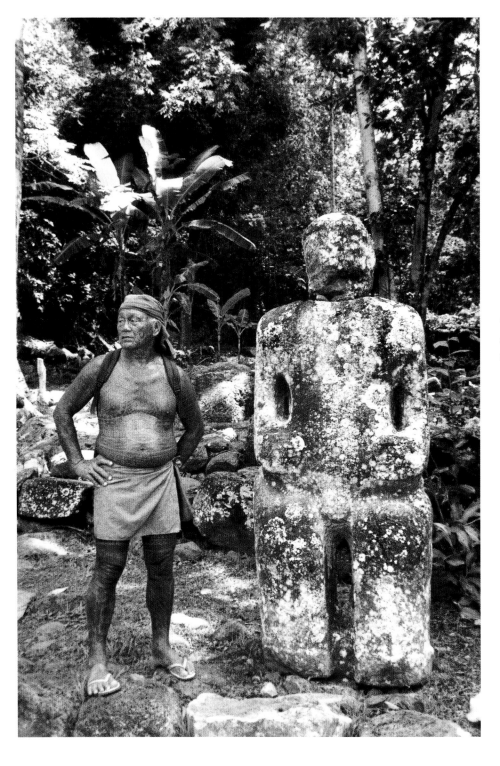

The *marae* at Puamau on Hiva ʻOa, site of the largest *tiki* found in the Marquesas. December 2003.

Young dancers from Puamau.
December 2003.

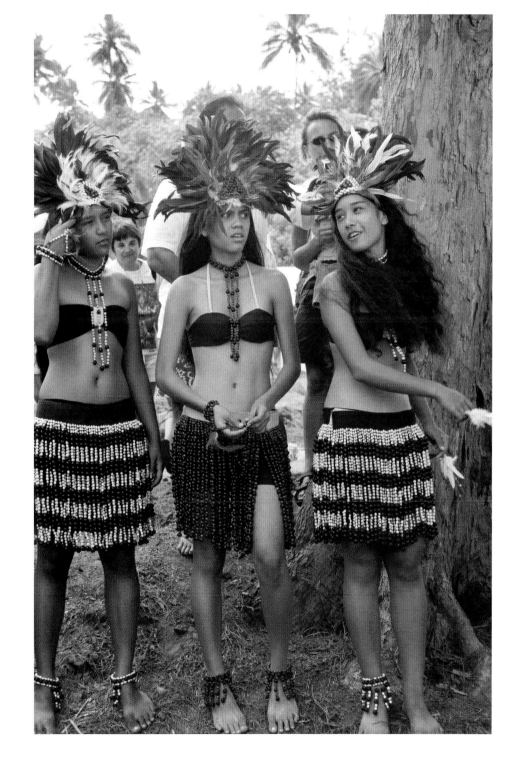

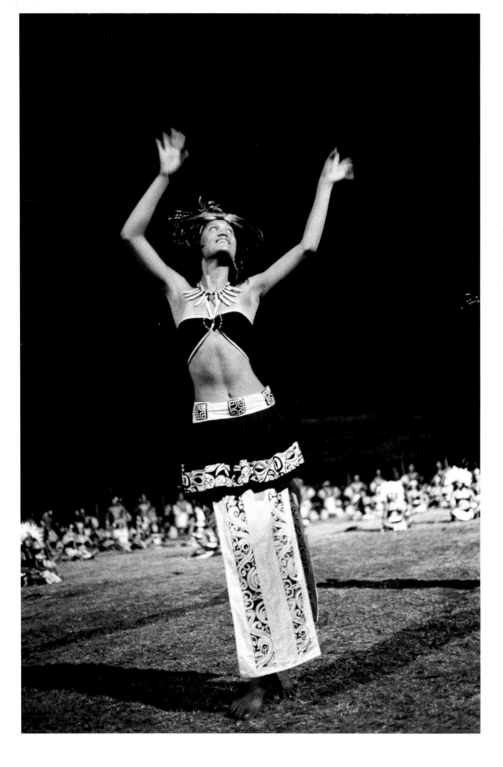

On the second evening of the
Sixth Festival of Arts, a dance
troupe from Hiva 'Oa performs
the bird dance. December 2003.

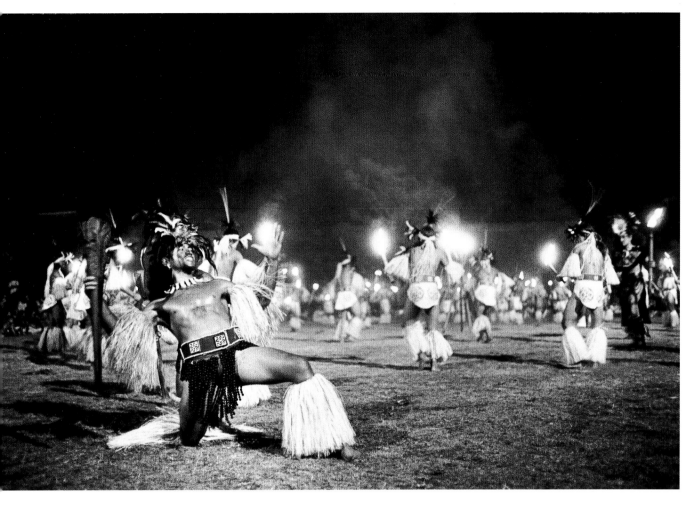

Nuku Hiva warriors.
December 2003.

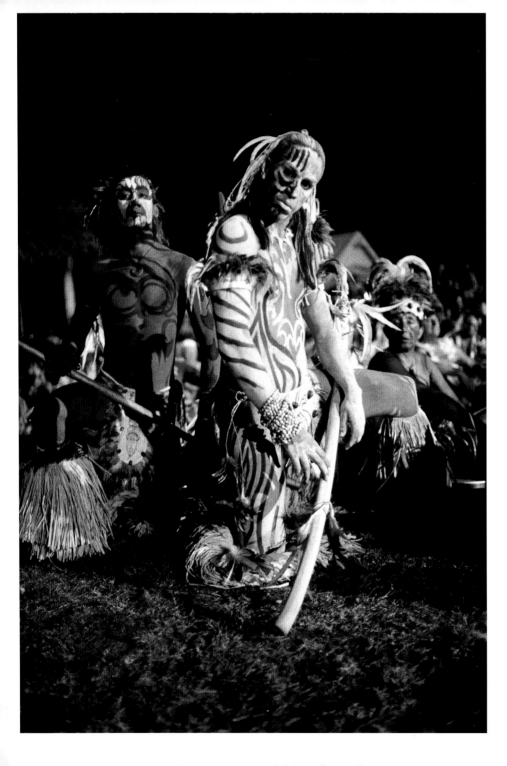

A dance troupe from Rapa Nui (Easter Island). December 2003.

MARQUESAS: These photos were taken on the island of Hiva 'Oa during the Sixth Festival of Arts of the Marquesas, held in December 2003. While Marquesans share a fundamental Polynesian heritage with Tahitians, their language and cultural practices are markedly distinct. Within the six inhabited islands that are their home, Marquesans recognize even finer shades of identity among themselves; however, they are united in the desire to protect and maintain the distinct integrity of Marquesan culture.

Dance festivals have become one of the most demonstrative ways for Marquesans to assert their cultural autonomy, as their dance and music, in particular, are stylistically distinct from performance practices elsewhere in French Polynesia. The festivals are thus occasions to display the sophistication of Marquesan music and chants—sometimes overshadowed or under-appreciated by the dance community on the more populous and cosmopolitan island of Tahiti. Marquesan presentations of chant, music, and dance are never merely aesthetic entertainments. As is true throughout Polynesia when performance rituals are presented with spiritual integrity, they invoke and strengthen a sense of community, harmony, and well-being.

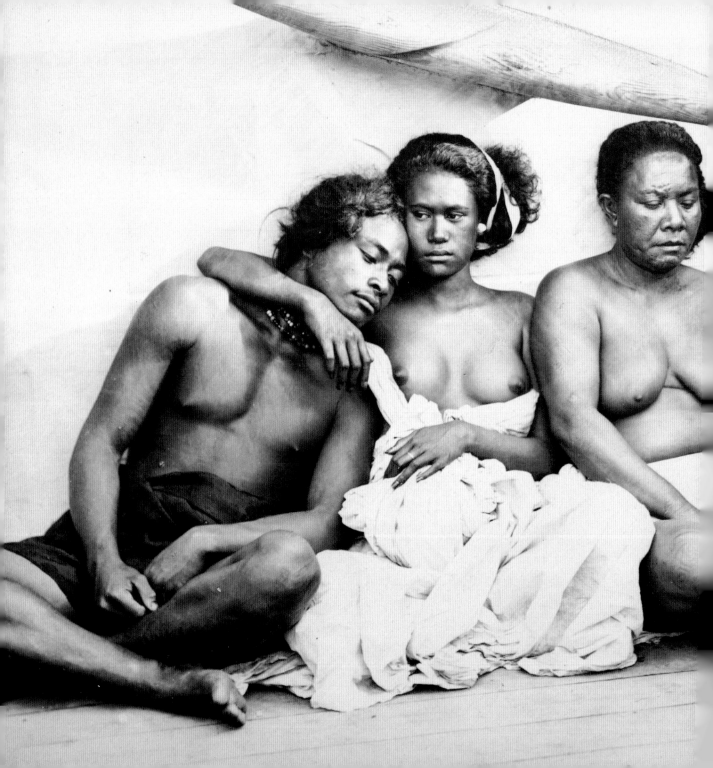

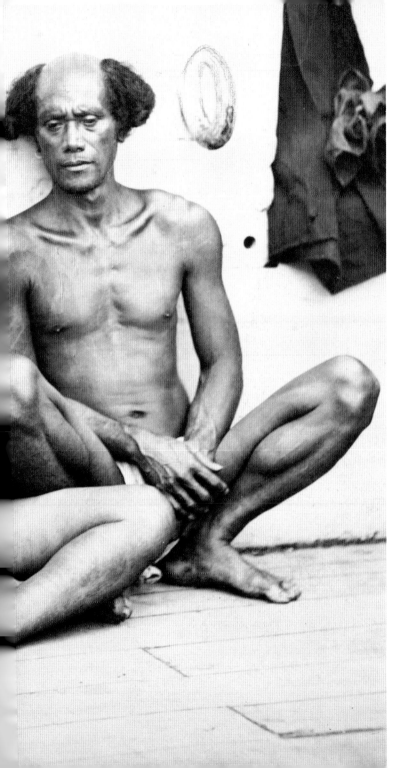

RAI A MAI TATTOO

HOW DO YOU FEEL when you meet somebody who has a tattoo stamped on his body? What do you feel, or what do you think?

The first time I heard about tattoo, I was still a little girl. My grandmother, who is a Pa'umotu, was telling me about her childhood in the Marquesas Islands. Mamie is from the island of Anaa, a very small atoll of the Tuamotu, lost between Heaven and sea in the middle of the South Pacific Ocean. But for some reason, her parents decided to migrate to the Marquesas Islands, called Henua Enana in Polynesian. They settled in Hiva 'Oa. My grandmother was telling me that the last woman in Polynesia to have the face entirely tattooed in those days was living in Hiva 'Oa.

"She was living in the valley. But she would often come down to the village by the shore. Maybe because she loved the ocean . . . Her whole face was tattooed and her hands and feet. For the body, I could not tell because she was always wrapped in *tapa* cloth. I used to play with the other village children at the shore. And she would come and just sit there, under the sun, for hours. She would stare silently at the sea. Not moving. Not talking. Not smiling. Not looking at anyone. Her eyes on the sea, as if captivated by these ever-rolling waves. Her body leaning with intensity toward the ocean, as if her whole being was listening to something we could not hear.

"I like people who can sit under the sun without moving and without talking, their eyes filled with dreams from another world . . .

"I was probably about your age when my parents decided to migrate to the Marquesas Islands. You know, child, the people over there have skin different from ours. Mine is black. This is Pa'umotu skin! Yours is white because you have in you the mixed blood of your ancestors. But theirs is a beautiful reddish color, like *ahi mono'i,* made from sandalwood and powder. The way they speak is also different. When they speak, you hear a song. They sound like the white birds that fly over the cliffs along the shoreline just before the rain.

"Yes . . . I do like people who can sit under the sun without moving and without talking, their eyes filled with dreams from another world . . .

"So, when we played *tāpō,* I would hide behind a rock not too far away from the tattoo lady and I would imitate her. I would sit against the rock and feel the pleasure of the sunrays trapped in the rock warming my back. I'd close my eyes, breathe deeply, and feel the sunrays on my eyelids. Then I would open my eyes again and just stare at the sea . . . I tried to hear what she was hearing . . .

"But you see, child, I didn't have any tattoo around my eyes, and I couldn't see what she saw. I didn't have any tattoo around my lips and on my chin, and I couldn't shut my mouth for very long. I didn't have any tattoo on my forehead, and I couldn't concentrate on the ocean's language.

"Sometimes the tattoo lady would lift her hands up toward the sky. And from her hands would dance a few words among the clouds from Heaven. See, child, her hands were beautifully tattooed on the side of the palm and along the small fingers. At times, she would catch a word and bring it back to her chest, as if to bury it in her heart.

"I would see, then, tears run along the tattoo on her face . . .

"I went to see my mother, and I asked her why didn't we have any tattoo on our body. She told me that tattoo belonged to another time, when people were ʻētene. Now that popaʻā were here, we weren't ʻētene anymore. I couldn't get anything else from her. She went into silence, her eyes turned inside, toward her soul, and her body turned away from me.

"So I went to see my father and told him that I wanted a tattoo somewhere on my body. I said that I wanted to be able to hear what others couldn't hear. I said that I wanted to catch the words from among the clouds from Heaven.

"My father looked at me, opened his mouth. But no word came out of it. Then he closed his mouth again and just looked at me. He drew me against him and sat me on his lap. With his arms wrapped around me, he chanted. He sang like the white birds that fly over the cliffs along the shoreline just before the rain.

"Then he said, 'We used to tell our story on our body. And people and heavens would know who we were. They would recognize us. But nowadays, stories and words are written in books. The words are caught directly from our memories and written with ink on paper. You don't need to catch the words in the clouds from Heaven any longer. They are here!' And he pointed a finger to my forehead.

"So you see, child," my grandmother went on, "today, no one has Polynesian tattoo on their body anymore. Well . . . some men bring back tattoo from the army. But theirs tell not of war; they speak of love and broken hearts. They draw a heart pierced by an arrow . . . They draw the name of a woman they fell in love with . . . They also bring tattoo back from their journey through prisons. Those tell of jail stories . . . They are unfinished designs. In fact, nobody knows how to tattoo the way our ancestors did. They have forgotten.

"Our word *tātau* has traveled all over the world and is known by all the nations. It has become such a part of everyone's language that people have forgotten that originally this word was a Polynesian word: *tātau!* *Tātau* has disappeared from our memories . . .

"And you know what? I was never able to catch any words: neither in books nor from among the clouds from Heaven."

As I listened to my grandmother, I looked at her naked black hands and I felt the desire for words to grow inside me.

> Give me, O my God
> Words
> As beautiful as silence
> Words
> That paint
> Like a divine brush
> Words
> That sing and dance
> Your beauty
> Words in my heart
> Words in my hands
> Words in my eyes
> Give me, O my God
> The words among the clouds from Heaven.

The year my grandmother passed away, Tavana, a cousin of mine, returned to Tahiti from Samoa. He had been adopted and raised by the Queen of Samoa. He possessed the knowledge of tattoo. He came with a group of Samoan men who also had the science of tattoo. They came to Tahiti to demonstrate their art during the Heiva festival.

Tahiti is wonderful at that time of the year. The weather is just perfect. Gentle and cool trade winds blow from the ocean. Polynesians come from everywhere to perform their dances as they used to in ancient times, when they came from the extended Polynesia to perform their arts before the King of Tahiti.

It is for everyone a very exciting and beautiful time. For weeks, the art of Polynesia is expressed through the dance, choreography, and costumes and

through the music and the poetry of the words. All the people are feverish, wearing their art in their body and soul. Their eyes are glittering with dreams and joy and shining with poetry. Poetry of the art. Poetry of the body. Poetry of the land and sea around them. Poetry of the island. Poetry in the heart.

When Tavana arrived, his tattoo show room was invaded by lines of people waiting, some to watch, others to be tattooed. I went along and watched. The crowd was quiet and attentive, as if everyone knew that something special was happening. Something of the past had returned . . .

Toc! Toc! Toc! went the inked bone as the tattoo artist hammered it into the skin. *Toc! Toc! Toc!* Wipe the blood off . . . *Toc! Toc! Toc!* The man tries to relax. To help him, another man massages his arm with *mono'i,* and a third man his legs. Someone plays the *vivo* to calm the air. *Toc! Toc! Toc!* Wipe the blood off . . .

By then I was convinced that tattoo was terrible, and I said to myself that one definitely had to be a masochist to endure such an experience. I gave up on tattoo—for the time being.

As the years went by, I saw more and more people around me getting tattoo. Tattoo no longer told a story or meant anything. But I could see everyone around me getting one tattoo or more. A turtle on the foot. A bracelet on the wrist or the ankle. An earring around the ear. Men would tattoo their legs and arms. Businessmen, having to be more discreet, would tattoo a shoulder, easy to hide underneath a shirt. Some men would go all the way and tattoo the entire body.

Every Polynesian wanted, stamped into the skin, a sign of cultural belonging.

Later on, foreigners living in Tahiti had a tattoo done as a souvenir of their time in the islands. For others it was a love bond. Tattoo were designed for every part of the body: the lower abdomen, the lower back, the chest, the neck. Wherever you could think of, and for everyone: dancers, workers, doctors, airline pilots, teachers, housewives, lawyers, fishermen, surfers, builders, carpenters, businessmen.

Everyone but me.

I had forgotten my grandmother's story, though not my longing for the words from among the clouds from Heaven. But I was not willing to tattoo something forever on my skin. Besides, I was very careful about not going against biblical teachings. Like all Polynesians, I believe in God, go to church on Sundays, and was raised

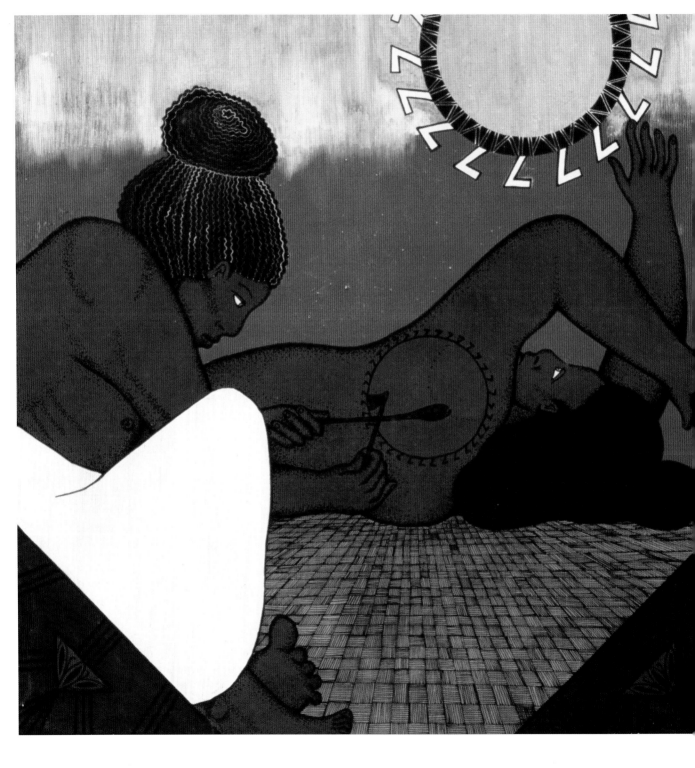

with religious precepts. "Thou shall not get a tattoo!" had said the pastor. "This is what the Bible says!" "That belongs to the past," had said my *tupuna*, "when we were still ʻ*ētene*..." "Only for prostitutes and prisoners," said the establishment, "for bad girls..."

All my friends tried to talk me into getting one. But what if I went to Hell because I got a tattoo? What would I say? How would I plead my case?

My friend Bobby said that I should have one on my forehead, like a crown, right below the hairline. Another friend said it would be nice on my feet. Another suggested I have one on the hip. How sexy! If I was going to get a tattoo, it should be discreet but not hidden, so I thought that an earring would be nice and lovely. I love earrings. From wherever I travel to, I always bring back a pair of earrings. Earrings! That would be neutral! No heathen connotation in an earring, right?

My daughters, who were both tattooed, introduced me to a young tattoo artist. They drove me to his house. He lived on the north shore of Tahiti and was known as the surfers' tattoo artist. He showed me different designs in his book—very professional! He worked with an electric machine. We made an appointment, and he came to my house.

When he arrived, I put some Hawaiian music on to help me relax. I was still preoccupied with the question of whether this was going against the Bible or not. Was this really ʻ*ētene* and *pōiri?* And I don't know what happened, but all of a sudden I just knew where the tattoo should be done. It would be stamped on my hands, on the side of the palm and along the fingers...

"I have never done this kind of tattoo at this kind of place!" said the tattoo artist. "Never! But why not? This is really going to be a first!"

Aloha! sang the singer.

I had no one to massage me. I just lay my head on the table, closed my eyes, and gave my hand to the tattoo artist. The machine drilled into my flesh... Drill... drill... drill... Wipe the blood off... Drill... drill... drill... Wipe the blood off... ʻ*Auē!* It hurts—really hurts! "A tattoo was always a sign of strength," I told myself. Very soon, I felt like I was walking in the steps of an ʻ*aito*... ʻ*Auē!*

"Are you all right? I can stop whenever you want me to. But it is better to do the tattoo all at once, without pausing."

As the young man continued, I felt less and less pain. Soon, I didn't feel the pain

any longer . . . I didn't feel the drill of the machine over the raw and bleeding skin. I didn't feel any pain at all . . . I felt words . . . just words. The words of a verse being deeply, profoundly written into my flesh, my bones, my heart . . . my life:

For the One who is in you is greater than the one who is in the world.

Mamie, I haven't forgotten your story. I have remembered the tattoo lady, whose hands danced the words from among the clouds from Heaven.

Mamie, I will try, for you,
to dance the words
from among the clouds from Heaven!
Some I will catch,
and hug them tight against my heart
until they want to come out,
alive,
on the pages of books.

GLOSSARY

'ā'ano, coconut shells that hold water

ahi, sandalwood

ahimā'a, traditional underground oven

'aito, warrior, hero; also, ironwood tree

ari'i, chief or chiefly class

'ārue, praise

atua, god

auē, lament

'auē, interjection

'aumoa, toy boat

'autī, ti plant

'Eimeo, ancient name of Mo'orea

'ētene, savage, heathen

fare, dwelling

fare putuputura'a, structure used as gathering place

fē'ī, plantains

fenua, the homeland; land in general

fēti'i, family, relatives

fiu, fed up

Havaiki, legendary Polynesian homeland; Marquesan proto-form of Hawai'i

'Ia ora na, a greeting

māmā, affectionate and respectful term for an older female, generally a relative

mana, power

manunu, fatigue following a great effort

mā'ohi, indigenous to Polynesia

Mā'ohi, ethnonym for Polynesians

mara'ai, southeast wind

marae, sacred ceremonial site

Matari'i, Pleiades constellation

mā'uru'uru, thank you

mei'a, a kind of banana

moana, ocean

mono'i, perfumed oil

moto'ī or moto'oi, ylang-ylang

motu, small sand island

Mou'a Tapu, Huahine's sacred mountain

mūto'i, policeman; police

nī'au, palm leaves; coconut palm

'Oro, an ascendant war god at the time of European contact

pahī, ship

Paratane, Britain

pāreu, traditional cloth wrap

Pa'umotu, alternate name for Tuamotu

pē'ue, woven pandanus mat

pito, umbilical cord

pōiri, unintelligent, ignorant

popa'ā, white foreigners

reo mā'ohi, Polynesian language

revareva, a strip of decorative white cloth from very young coconut leaves

rōfa'i, sudden gust of wind

Ta'aroa, supreme god

tahu'a, priest, expert

taio, friend

tapa, cloth made from bark

tāpō, hide-and-seek

tāporo, citrus fruit

tapu, sacred; also, prohibition

tārava, traditional chant

tātau, tattoo

tāvana, chief, governor, judge

teuteu, servant to the ari'i

tīfaifai, colorful quilt

tiki, Marquesan for a statue or image of a god

to'erau, north wind

tō'ere, drum; slit gong

tōrīrī, fine rain

tumu 'uru, breadfruit tree

tūpāpa'u, spirit, ghost

tupuna, ancestor, grandparent, elder

ufi, yam

'ūmara, sweet potato

'ūmete, large platter

'uru, breadfruit

vahine, woman

vai, water, river; also, the verb "to be"

vārua, spirit, soul

vivo, nose flute

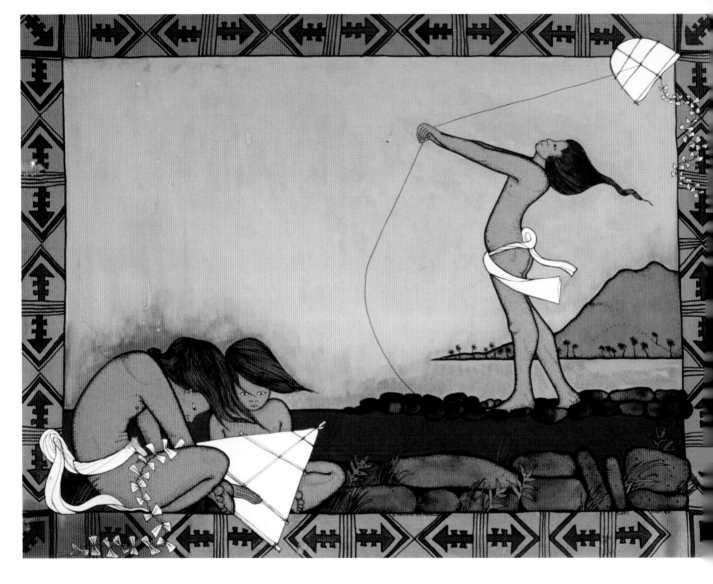

The Kites of Mataʻirea
Kite flying was a popular game in ancient Māori
times. The kites of Huahine often were in the
shapes of turtles, birds, and humans.
BOBBY HOLCOMB

Nola Accili teaches French at the University College of the Fraser Valley in Canada. Recently, she appeared in the anthology *Down in the Valley* and the journals *Room of One's Own* and *Jones Av.*

Patrick Araia Amaru is a poet and scholar. He received the first Prix Littéraire du Président from Te Fare Tauhiti Nui/Maison de la Culture in 2000.

Michel Chansin is a self-taught photographer and author who was born in Tahiti. His most recent book of photographs is *Te ata mau: c'est une terre māʻohi* (Au Vent des Îles, 2001). He is the subject of a 2004 film, *Un chinois de Papeʻete,* which was selected for the 2006 International Oceania Festival of Documentary Films.

Anne-Marie Coéroli-Green has played an important role in the repatriation of *ivi tupuna*, the skeletal remains of ancestral Māʻohi, from American museums. Her writing has appeared in the journal *Littéramaʻohi: Ramées de Littérature Polynésienne/Te Hotu Maʻohi.*

Flora Devatine was born in Tautira, Tahiti. She is a retired professor of Spanish and Tahitian at the Lycée-Collège Pomare IV in Papeʻete and a member of l'Académie Tahitienne/Te Fare Vānaʻa. For many years, she has been interested in all aspects of Polynesian culture and has participated in numerous colloquia and publications addressing the preservation of culture, memory, Tahitian poetry, written language, and oral and written literature. With five other Polynesian writers, she founded the first Polynesian literary journal, *Littéramaʻohi.* She has published *Humeurs* (Polytram, 1980) under the name Vaitiare and *Tergiversations et rêveries de l'écriture orale/Te Pahu a Honoʻura* (Au Vent des Îles, 1998).

Henri Hiro was a poet, teacher, filmmaker, pastor, and activist and the founder of l'Office Territorial d'Action Culturelle. Born on Moʻorea in 1944, he was raised in Punaauia by parents who spoke only Tahitian. He traveled to France to study, then returned to the Islands and became one of the first *Māʻohi* artists and intellectuals to inspire a renaissance of Polynesian cultural identity. As part of his mission to revive that identity, he declared that Polynesians must write, and to address them directly, he wrote poetry in the Tahitian language. Many of his poems are collected in *Pehepehe i taʻu nūnaʻa/Message poétique* (Tupuna Productions, 1990). In March 1990, he died at the age of forty-six, after a long illness.

Bobby Holcomb was born in Hawai'i in 1947. Of Hawaiian, African American, Native American, and Portuguese ancestry, he became interested in art and the legends of Polynesia at a young age. He traveled to Tahiti in 1976 and settled in Maeva, a village on Huahine, where he immersed himself in Polynesian culture and became a celebrated painter and musician. His house became a gathering place for young and old, who were drawn by his generosity, good humor, and zest for life. He died of cancer in 1991.

Michel Ko lives and works on Tahiti.

Claire Leimbach is a photographer, filmmaker, and publisher. For the past twenty years, she has been involved with Polynesian culture, particularly in Tahiti. The founder of the publishing company Pacific Bridge, she published *Bobby: Polynesian Visions* in 1992; this book was a homage to the paintings by Bobby Holcomb that were inspired by Polynesian mythology. This was followed by *Tahiti: Celebration of Life,* which renders the beauty of the culture through photographs of men's activities. Leimbach lives in Australia but travels widely.

John Lind is a writer and filmmaker who was born in Calcutta, India, of Anglo-Russian parentage. A dramatist and script editor, he is most interested in the ancient wisdom of pre-Christian cultures. *Beyond the Dreamtime,* his documentary about artist Ainsle Roberts and Australian Aboriginal spirituality, received international awards. His current project is developing a Viking movie epic.

Rai a Mai (Michou Chaze) was born in Pape'ete, Tahiti, in 1950 and lived in the United States for eleven years. An activist, journalist, and artist in several media—including photography, dance, and painting—she wrote *Vai: la rivière au ciel sans nuages* (Cobalt/Tupuna Productions, 1990), a collection of vignettes. Her other writing includes a book of poetry, *Tōrīrī: Prières, murmures, chuchotements* (2000). A founding member of the literary revue *Littérama'ohi,* she works in the office of the French Polynesian presidency.

Kareva Mateata-Allain is of Tuamotu and British ancestry and grew up on Tahiti. She holds a doctorate from the University of New Mexico in Oceanic literature with an emphasis on French Polynesian literature in translation. She is also a writer and translator; her essay in this volume is from a book-length work.

Alexander Dale Mawyer is a recipient of Fulbright-Hays and Wenner-Gren grants for the study of language, culture, and new media in French Polynesia. Fluent in Mangarevan and French, he holds a doctorate in anthropology from the University of Chicago.

Contributors

Louise Peltzer was born in 1946 on Huahine. The author of many books, she is a scholar, historian, novelist, poet, and renowned authority on the Tahitian language. She received a doctorate in linguistics from the Sorbonne in 1986. In 1985, she published a book of legends, *Légendes tahitiennes,* in Paris, and a book of poetry, *Pehepehe: Te Hiaʻai-oa,* in Papeʻete. Her other books include *Lettre à Poutaveri* and *Hymnes à mon île,* both published in 1995. She was Minister of Culture in the territorial government of French Polynesia and is now the president of the Université de la Polynésie Française and an active member of l'Académie Tahitienne/Te Fare Vānaʻa, whose goal is to preserve and conserve the ancestral language.

Titaua Peu published her first novel, *Mutismes* (Haere Po Tahiti, 2003), at the age of twenty-six. Set in the years leading up to the 1995 anti-nuclear-testing riots that engulfed Papeʻete, the book explores social problems, such as domestic violence and substance abuse.

Bruno Saura was born in Metz, France, in 1965. The author of much scholarly work on French Polynesia, he is Maître de conférences: Civilisation polynésienne in the Département des Lettres, Langues, et Sciences Humaines at the Université de la Polynésie Française.

Jean Toyama is a poet, scholar, translator, and writer of fiction. She lives in Hawaiʻi, where she was born and raised.

Célestine Hitiura Vaite was born in Tahiti in 1966. The daughter of a Tahitian mother and a French father who went back to his country after military service, she grew up in her big extended family in Faʻaʻā, Tahiti, where storytelling was part of daily life and women overcame obstacles with gusto and humor. Her first novel, *Breadfruit,* won the 2004 Prix littéraire des étudiants in French Polynesia and was translated into German and French. Her second, *Frangipani,* was shortlisted for the NSW Premier's Award/Christina Stead prize for fiction, with foreign rights having been sold to over ten territories. Her third novel, *Tiare,* will be released in 2006.

Marie-Hélène Villierme was born in 1966 in France. She had a Polynesian father and Italian mother and grew up in Tahiti, traveling to France at age eighteen to study at the school of Beaux Arts in Nice and Toulon. She went to Brussels for three more years of study, then returned to Tahiti. She now teaches photography at the Institut Supérieur de l'Enseignement Privé de Polynésie Française. Her books include *Tataʻu,* published in 1992, and *Visages de Polynésie,* published in 1996. Works from *Visages* were exhibited between 1997 and 2001 in Tahiti, France, Germany, Austria, and Hawaiʻi.

Taaria Walker (Mama Pare) was born in 1930 on Rurutu, one of the Austral Islands. She studied nursing in the 1950s and worked in various hospitals in Papeʻete and Rurutu. In 1980, she founded l'Amicale des Artisans Polynésiens/Tamatea and l'Association Artisanale/Tiare Porea. In 1987, she organized l'Association Artisanale et Culturelle/Taurama. She has served in many governmental capacities, including as a member of the Conseil des Sages de Rurutu. Her autobiography, *Rurutu: Mémoires d'avenir d'une île Australe* (Haere Po Tahiti, 1999), expresses her hopes for the preservation of her homeland culture.

Contributors

CREDITS AND PERMISSIONS

Historic Photography Credits and Permissions

PAGE 12. *The northwest coast of Tahiti, undated.*
Photograph by Charles Georges Spitz. Cliché Musée de Tahiti et des Iles / Te Fare Manaha.

PAGE 22. *River of Tautira, circa 1889.*
Photograph by Charles Georges Spitz. Cliché Musée de Tahiti et des îles / Te Fare Manaha.

PAGES 30–31. *"Spearing Ponitas," undated.*
Photographer unknown. From an album of photographs of Tahiti. Pacific Collection, University of Hawai'i Library.

PAGE 36. *Women waiting for appointments at a hospital, 1932.*
Silver-salt print by Roger Parry © Ministère de la Culture, France.

PAGE 70. *Young Tahitian drinking water (detail), 1887.*
Photograph by Charles Georges Spitz. Collection of the Musée de Tahiti et des îles / Te Fare Manaha.

PAGES 82–83. *"Council House at Tautira," undated.*
Photographer unknown. From an album of photographs of Tahiti. Pacific Collection, University of Hawai'i Library.

PAGES 90–91. *Papeete, 1859.*
Calotype by Gustave Viaud. Collection Jean-Yves Tréhin, France.

PAGE 96. *"Native Girls," undated.*
Photographer unknown. From an album of photographs of Tahiti. Pacific Collection, University of Hawai'i Library.

PAGES 104. *A Tahitian Choir, undated.*
Photograph by Charles Georges Spitz. Pacific Collection, University of Hawai'i Library.

PAGE 116. *"Native Boys," undated.*
Photographer unknown. From an album of photographs of Tahiti. Pacific Collection, University of Hawai'i Library.

PAGE 126. *Portrait, Tahiti (detail), 1932.*
Silver-salt print by Roger Parry © Ministère de la Culture, France.

PAGES 146–147. *Quarter of Si-Ni-Tong, Papeete, 1932.*
Silver-salt print by Roger Parry © Ministère de la Culture, France.

PAGES 152–153. *Tuamotu, circa 1875.*
Photograph by L'Atelier Hoare. Cliché Musée de Tahiti et des îles/Te Fare Manaha.

PAGE 178–179. *King Vaitehu of the Marquesan Islands, 1870.*
Albumen print by Paul-Émile Miot. Courtesy Département Marine du Service Historique de la Défense, France.

INSIDE FRONT COVER. *River of Tautira, circa 1889.*
Photograph by Charles Georges Spitz. Collection of the Musée de Tahiti et des îles/
Te Fare Manaha.

INSIDE BACK COVER. *Market in Papeete, circa 1887.*
Photograph by Charles Georges Spitz. Collection of the Musée de Tahiti et des îles/
Te Fare Manaha.

Text Permissions

Our thanks to the following contributors and publishers for permission to reprint from their publications.

Chaze, Michou (Rai a Mai). "Tattoo." *Littérama'ohi: Ramées de Literature Polynésienne/ Te Hotu Mā'ohi*, no. 2 (December 2002).

―――― *Vai: la rivière au ciel sans nuages*. Pape'ete: Cobalt/Tupuna Productions/Les éditions de l'après-midi, 1990.

Hiro, Henri. *Pehepehe i ta'u nūnaa/Message poétique*. nlle éd. bilingue Tahitien-Français, entièrement revue et corrigée. Pape'ete: Tupuna Productions, 1990; Editions Haere Po Tahiti, 2004. © Tupuna Productions and Editions Haere Po Tahiti.

Leimbach, Claire and Bruno Saura. *Bobby: visions polynésiennes*. Sydney/Pape'ete: Pacific Bridge Publishing/Tupuna Productions, 1992.

Peltzer, Louise. *Hymnes à mon île*. Pape'ete: Polycop, 1995.

―――― *Lettre à Poutaveri*. Pape'ete: Scoop/Au Vent des Îles, 1995.

Peu, Titaua. *Mutismes*. Pape'ete: Editions Haere Po Tahiti, 2003. © Editions Haere Po Tahiti.

Vaite, Cèlestine Hitiura. *Frangipani*. Melbourne: Text Publishing, 2004.

―――― *Breadfruit*. Sydney: Bantam, 2000.

Villierme, Marie-Hélène. *Tangata: A Polynesian Communty*. Pape'ete: Éditions le Motu, 2005.

Walker, Taaria (Mama Pare). *Rurutu, mémoires d'avenir d'une île Australe*. Pape'ete: Editions Haere Po Tahiti, 1999. © Editions Haere Po Tahiti.

Chansin, Michel. *Te ata mau: c'est une terre mā'ohi.* Preface by Jimmy Ly; text by Jean-Marc Tera'ituatini Pambrun. Pape'ete: Au Vent des Îles, 2001.

Chaze, Michou (Rai a Mai). *Tōrīrī: Prières, murmures, chuchotements.* Pape'ete: privately printed, 2000.

Devatine, Flora [sous le pseudonyme de Vaitiare]. *Tergiversations et rêveries de l'écriture orale/Te Pahu a Hono'ura.* Preface by Bernard Rigo. Pape'ete: Au Vent des Îles, 1998.

Gobrait, Valerie. *Te 'Ā'Ai Nō Matari'i.* Pape'ete: Fa'aterera'a hau nō te Ta'ere, nō te Ha'api'i-ra'a teitei e te ha'afaufa'ara'a ō te Reo Mā'ohi, 2000.

Henry, Teuira. *Ancient Tahiti.* B. P. Bishop Museum Bulletin No. 48. Honolulu: Bishop Museum Press, 1928. Reprint, New York: Kraus Reprint, 1985.

Hiro, Henri, Hubert Brémond, and Charles Manutahi. "Tahitian Poetry." *Mana: A South Pacific Journal of Language and Literature* (Fiji) 7, no. 1, 1982.

Ly, Jimmy M. *Hakka en Polynésie.* Pape'ete: Association Wen Fa, 1999.

—— *Bonbon Soeurette and Pai Coco.* Pape'ete: J. M. Lys, 1997.

Mairai, John. *Tavi roi et la loi.* Unpublished.

Manutahi, Charles Teriiteanuanua. *Contes et légendes de la Polynésie.* Pape'ete, 1982.

—— *Poète du temps passé.* Pape'ete, 1979.

Pambrum, Jean-Marc Tera'ituatini [sous le pseudonyme d'Étienne Ahuroa]. *Les parfums du silence: une pièce en trois actes et un épilogue.* Pape'ete: Éditions le Motu, 2003.

—— *La nuit des bouches bleues, pièce en vers octosyllabiques d'un acte.* Moorea: Éditions de Tahiti, 2002.

Peltzer, Louise. [sous le pseudonyme de Rui a Mapuhi]. *Pehepehe, Tutava.* Pape'ete: privately printed, 1993.

—— *Légendes tahitiennes.* Paris: Conseil International de la langue française, 1985.

Raapoto, Turo a. *Tama: e mau pehepehe ri'i tei fatuhia na te tamari'i.* Pape'ete: Tupuna Productions, 1991.

—— *Te rautiraa i te parau a te atua e te iho tumu maohi.* Pape'ete: privately printed, 1988.

Spitz, Chantal. *Hombo: transcription d'une biographie.* Preface by Jimmy Ly. Pape'ete: Te Ite, 2002.

—— *L'île des rêves écrasés.* Preface by Jean-Marius Raapoto. Pape'ete: Au Vent des Îles, 2003.

Teissier-Landgraf, Marie-Claude. *Tahiti, racines et déchirement.* Pape'ete: Hutu Painu, 2004.

Villierme, Marie-Hélène. *Visages de Polynésie.* Edited by Dominique Morvan; English trans. Evy Hirshon and Edwin Hiu-Aline. Mahina (Tahiti): privately printed, 1996.

MĀNOA: A PACIFIC JOURNAL

EDITOR Frank Stewart

MANAGING EDITOR Pat Matsueda

ASSOCIATE EDITOR Brent Fujinaka

ASSISTANT EDITOR Leigh Saffold

DESIGNER AND ART EDITOR Barbara Pope

ABERNETHY FELLOWS Meredith Desha (2004), Tim Denevi (2005)

STAFF Alyna O'Hanlon, Julia Panko, Angela Siew

CORRESPONDING EDITORS AND ADVISORY GROUP Esther K. Arinaga, William H. Hamilton, Takiora Ingram, Barry Lopez, Joseph O'Mealy, Robert Shapard, Arthur Sze

HTTP://MANOAJOURNAL.HAWAII.EDU/

HTTP://WWW.UHPRESS.HAWAII.EDU/JOURNALS/MANOA/

Vārua Tupu is a special edition of MĀNOA; for subscribers, this is MĀNOA 17:2.

For more information about Bobby Holcomb's work and about purchasing reproductions, please contact Dorothy Levy at dorotea7@mail.pf.

For more information about any other artist featured in this volume, please contact MĀNOA.

MĀNOA means, in the Hawaiian language, "vast and deep." It is the name of the valley where the University of Hawai'i is situated.

MĀNOA gratefully acknowledges the continuing support of the University of Hawai'i Administration; the support of the University of Hawai'i College of Languages, Linguistics, and Literature; grants from the National Endowment for the Arts and the Hawai'i State Foundation on Culture and the Arts; and the support of the Charles Englehard and Mānoa Foundations.

ISSN 1045-7909

ISBN 10: 0-8248-3019-9

ISBN 13: 978-0-8248-3019-9

Designed and produced by Barbara Pope Book Design with assistance from the MĀNOA staff

Tattoo

Bodies, Art and Exchange
in the Pacific and the West

**NICHOLAS THOMAS,
ANNA COLE &
BRONWEN DOUGLAS,** EDITORS

The history of tattooing is shrouded in controversy. Citing the
Polynesian derivation of the word "tattoo," many scholars and tattoo
enthusiasts have believed that the modern practice of tattooing
originated in the Pacific, and specifically in the contacts between
Captain Cook's seamen and the Tahitians.

Tattoo demonstrates that while the history of tattooing is far more
complex than this, Pacific body arts have provided powerful stimuli to
the West intermittently from the eighteenth century to the present day.

The essays collected here document the extraordinary, intertwined
histories of processes of cultural exchange and Pacific tattoo practices.
Art historians, anthropologists, and scholars of Oceania provide
a fascinating transcultural history of tattooing in and beyond the
Pacific.

Objects/Histories
256 pages, 135 illustrations (including 40 in color), paper $27.95

DUKE UNIVERSITY PRESS

toll-free 1-888-651-0122 www.dukepress.edu

The *Objects/Histories* series is published with the assistance of the Getty Foundation.